IMAGES OF

BRISTOL, SOMERSET AND DORSET RAILWAYS

IMAGES OF
BRISTOL, SOMERSET AND DORSET RAILWAYS

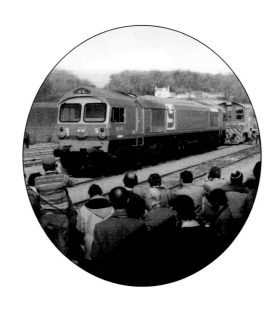

CLASSIC PHOTOGRAPHS FROM
THE MAURICE DART RAILWAY COLLECTION

HALSGROVE

First published in Great Britain in 2008

British Library Cataloguing-in-Publication Data
A CIP record for this title is available from the British Library

ISBN 978 1 84114 735 2

Halsgrove House
Ryelands Industrial Estate, Bagley Road,
Wellington, Somerset TA21 9PZ
Tel: 01823 653777
Fax: 01823 216796
email: sales@halsgrove.com
website: www.halsgrove.com

Printed and bound by CPI Antony Rowe, Wiltshire

CONTENTS

INTRODUCTION

Most Saturday afternoons my parents would take me with them to either Devonport, reached by tram, or Plymouth, to which we caught a 'motor train' to Millbay. So my interest in railways steadily developed. During the summers of 1937, 1938 and 1939, the three of us spent a week travelling by train to Torquay, Paignton or Goodrington, with sometimes a venture to Kingswear and across to Dartmouth on the 'MEW' or to Dawlish Warren. We used a family holiday runabout ticket for the week and set out from St Budeaux on an excursion train that ran daily from Saltash to Paignton and which, from memory, was usually hauled by a Castle class locomotive to Newton Abbot. From our front downstairs and bedroom windows at Higher St Budeaux I was able to watch trains in the distance as they climbed towards the Devon side of the Royal Albert Bridge. They could also be seen as they ran around the curves west of Saltash station. I asked my father on one occasion why we did not go to Cornwall instead of to Paignton and he replied that it was better to go up the line. This was probably because there was a daily excursion train from Saltash to Paignton although we frequently had to change trains at Newton Abbot and cross over the footbridge. My father would bring home books about railways. They had been loaned to him for me to look at and they contained many photographs of railway subjects. During the Second World War, following the second batch of blitz raids on Plymouth when many schools were damaged, I was evacuated to Bude by train from Friary. I stood in the corridor for most of the way to "see where I was going" much to the consternation of the WVS ladies who were accompanying us. I recall seeing a tank engine, at what I later learned was Meldon Quarry, carrying 500S on its tank side. This was the T class 'Service loco'. Whilst at Bude I began to hear about places such as Holsworthy and Okehampton, which I had passed through on the train. Evacuation to Bude was followed by a short period back at St Budeaux after which I spent two years at St Austell, using trains to and from North Road. Whilst there, at the evacuated Grammar school, I met many older boys who were railway enthusiasts and my 'railway education' commenced properly.

My father had been transferred from Devonport to the Dockyard at Gibraltar during 1944, and in the summer of 1947 I went there by sea for a holiday for several weeks. My father was an amateur photographer and whilst there he taught me to use a box camera. I immediately started taking photographs of Gibraltar Dockyard locomotives from a balcony! On returning to St Budeaux I found my father's two old cameras and managed to obtain a film for each. A large folding Kodak that used A-122 film turned out to have a pin hole in the bellows, only discovered when the results of the first film were seen. This made it unusable. The other was an old Box Brownie which had a push-over lever shutter release and had one good and one faulty viewfinder that showed two images, one above the other. I persevered with this but did not know enough to achieve much success. I tried to record trains passing through St Budeaux and went to Laira shed late in September and took photos, some against the low evening sun. Still, we all had to learn by experience. With those which I had taken at Gibraltar, this was the start of my collection of railway photographs. I saved my pocket money and managed to go on a few Saturday trips to Exeter and as a holiday treat I was allowed to make a trip to Salisbury but I had passed through Taunton and Bristol on the way to London in 1947 on the way to Gibraltar. So later in 1947 I did a day trip to Bristol and visited the LMS shed with

a permit and I 'bunked' around Bath Road by following some railwaymen over the crossing from Temple Meads! There was no time to find my way to SPM shed. I remember seeing two rows of 4500/4575 class 2-6-2Ts inside Bath Road shed furthest from the station one of which was 5555. In 1950 I did day trips to Taunton and Weymouth but I was not permitted to go around the sheds, unlike Laira. Later, my employment took me to lodge at St Austell where I finally took up permanent residence.

As time progressed I was able to buy better cameras and commenced longer railway trips to places further afield. My railway interest widened from purely collecting engine names and numbers to encompass signalling and railway history. This was progressed by meeting more very knowledgeable older railway enthusiasts and railwaymen, many of whom became lifelong friends of mine. I developed a desire to obtain photographs of some of the locomotives that I had seen in my early years, so the process of searching for and purchasing photos commenced. As my interest and knowledge grew, so likewise did the quest for more photos. This now encompassed all of Devon and Cornwall and large sections of Wales, along with various classes of locomotives from all over the country. An interest in narrow gauge and industrial railways developed. So the 'Archive' steadily grew from filling an expanding suitcase to occupying a considerable expanse of shelf space in two rooms.

When it was suggested that I compile some books making use of some of these images I thought that it would be a great idea as many of them, to the best of my knowledge, had not previously been used in publications.

The first three books covered Devon and Cornwall. With so many photos available the choice has been difficult but constraints such as Copyright and previous use have been considered. This is not an attempt to include every location or type of locomotive that has worked in the areas but is simply a selection from my collection. Some older historic images are included but I have attempted to give a good overall coverage of the area from around 1900 to the present day. I have included a representative selection of diesels and some industrial locomotives to attempt to cater for all interests. So many photographs of the preservation era have been published that I have avoided this period. I have also included some items which are not photographically perfect but are worthy of insertion because of their content. These images may be of great interest to modellers of historic locomotives with period layouts.

As this book features images from my personal collection, the layout follows the order in which the collection is arranged. This follows locomotive wheel arrangement and types from the largest downwards in decreasing order of size, with a few exceptions. It is a system that was used in the past by several notable authors that presents a markedly different layout to the now standard practice of following routes geographically. Readers seeking photos at specific locations should refer to the index of locations at the end of the book. I have attempted to make the captions detailed without delving too deeply into railway history or becoming too technical. Any errors that are discovered are purely attributable to myself. I trust that within the contents there is material to cater for most railway interests and that memories of a bygone age of railways will be recalled.

ACKNOWLEDGEMENTS

I express special thanks to my friend of many years, Mike Daly, and also to Kenneth Brown for permission to reproduce photos taken by them. Likewise I express thanks for permission to use photos which I have purchased from the collections of the Stephenson Locomotive Society, The Locomotive Club of Great Britain (Ken Nunn collection) and Rail Archive Stephenson (Photomatic). Also my thanks and apologies are proffered to other photographers whose work has been used and not credited. Where no credit is given the photographer is unknown. I also extend my thanks to Steve Jenkins for advice when describing some of the carriage and wagon stock and to Gillian Searle for checking the proofs and for suggesting amendments. I am also indebted to Simon Butler of Halsgrove for suggesting the idea for this series of books.

REFERENCE SOURCES

A Detailed History of British Railways Standard Steam Locomotives. RCTS.

An Illustrated History of LMS Locomotives. Essary and Jenkinson.

A Regional History of the Railways of Great Britain. Vol.1. The West Country.
David St John Thomas. David & Charles.

British Railways Locomotive Stock Changes and Withdrawal Dates. 1948 –1968.
Michael McManus.

British Railways Steam Locomotives 1948 – 1968. Hugh Longworth. OPC.

GWR Locomotive Allocations. J.W.P.Rowledge. David & Charles.

Locomotives of the Great Western Railway. RCTS.

Locomotives of the LSWR. D.L.Bradley. RCTS.

Locomotives of the Southern Railway. D.L.Bradley. RCTS.

The Allocation History of BR Diesels & Electrics. Roger Harris.

The Directory of Railway Stations. R.V.J.Butt.

Track Layout Diagrams of the GWR/BRWR. R.A.Cooke.

War Department Locomotives. R.Tourret.

My personal notebooks dating from 1945.

1

EIGHT COUPLED LOCOMOTIVES

This section starts with a couple of GWR 2-8-0s followed by a good representation of the popular S & D 2-8-0s. Next comes some views of the little photographed WD 2-8-0s and the section ends with one of the SR's 0-8-0Ts.

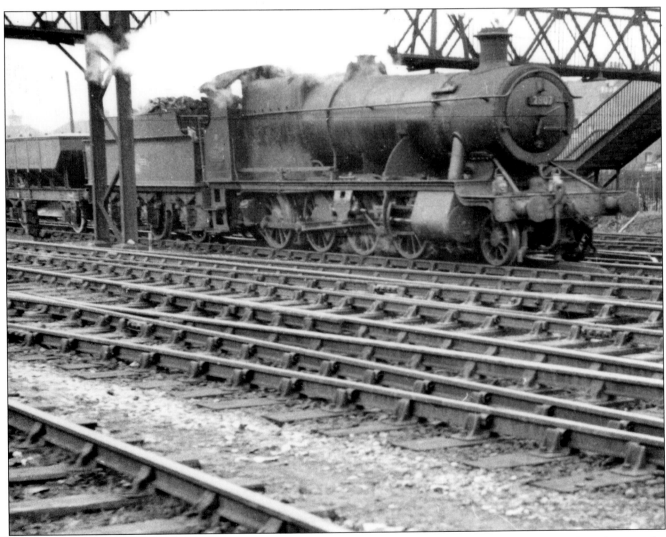

One of the GWR's superb 2800 class 2-8-0s, 2807 from Newton Abbot shed brings an Engineer's train past the west end of Taunton shed yard on 22 March 1959. The footbridge provided a good vantage point from which to view the shed yard. Maurice Dart

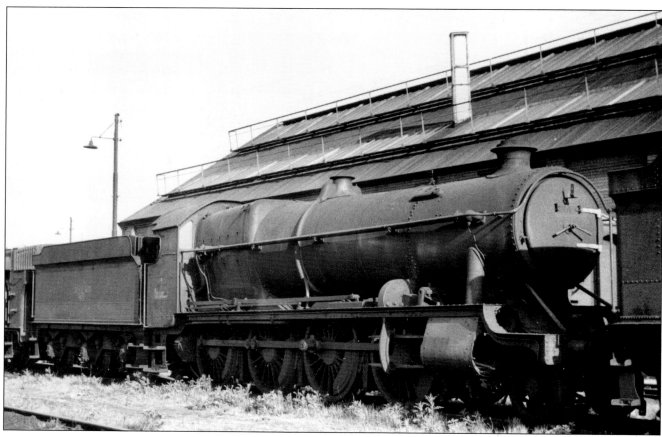

Looking in a woebegone state in a string of locomotives alongside the shed building at St Phillips Marsh, Bristol on 19 May 1963, is GWR 4700 class 2-8-0 4700. This loco had been withdrawn from Southall shed on 6 October 1962. It was one of the small class of nine which were designed to haul heavy perishables trains which mostly ran overnight. On summer Saturdays some of them could be found handling relief passenger trains. R.J.Leonard.

Now we come to a batch of the much-loved Somerset and Dorset 2-8-0s and see 53801 in front of 53806 in the yard at Bath LMS shed on 25 May 1958. The first six were built at Derby for the S & D Rly and the LMS ordered another five from Robert Stephenson. These locos carried Tablet Exchangers which can be seen in some of the photos protruding the bottom front of the tender. They were all shedded at Bath. The shed code changed with ownership from 22C to 71G to 82F.

Maurice Dart/Transport Treasury.

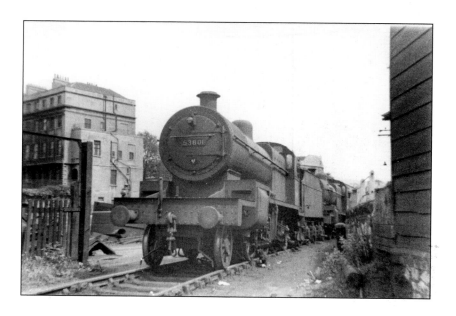

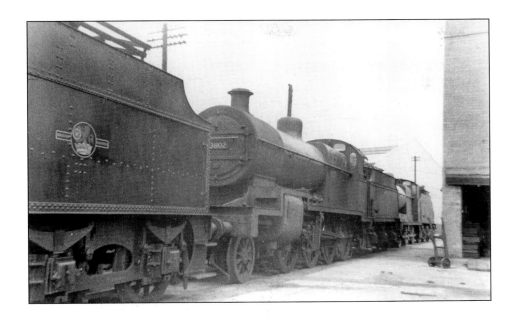

Also in Bath shed yard on 25 May 1958 was 53802 behind which is Bath's 4F 0-6-0 44558 which was built at Derby for the S & D Rly. Maurice Dart.

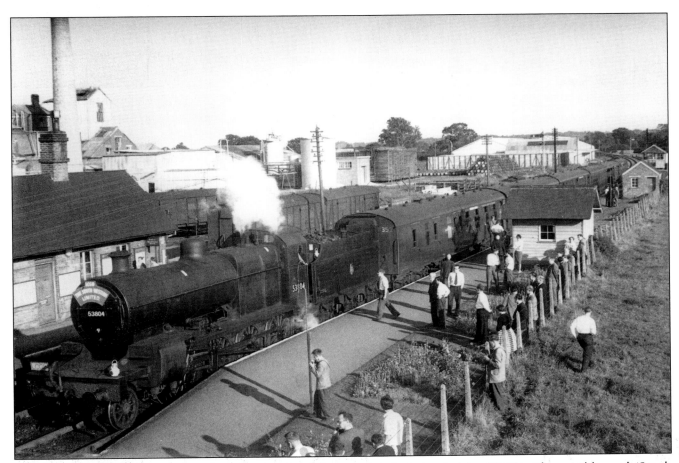

A railtour organised by the The Locomotive Club of Great Britain is hauled by 53804. The northbound 'South Western Limited' is stopped at Bailey Gate on 11 September 1960 with the United Dairies factory in the background.

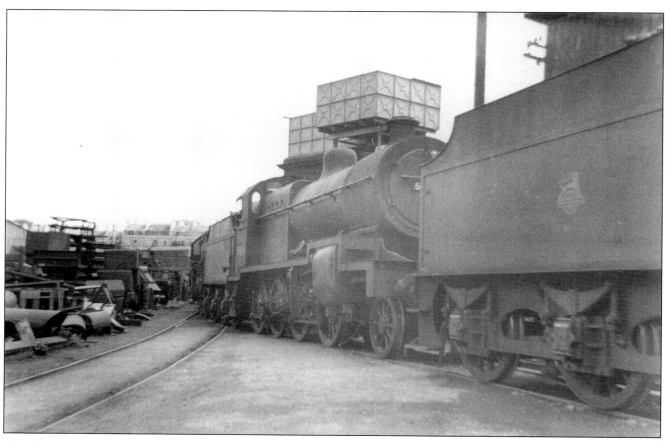

The line of locos in the yard at Bath shed on 25 May 1958 also contained 53806 with the shed's water tanks prominent above it. Maurice Dart

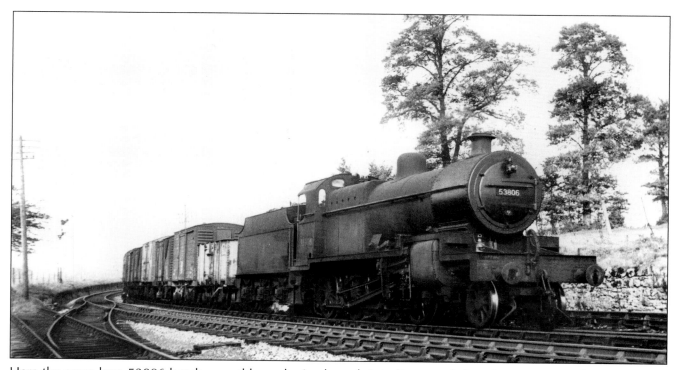

Here the same loco 53806 heads a southbound mixed goods into Evercreech Junction on 15 October 1962.

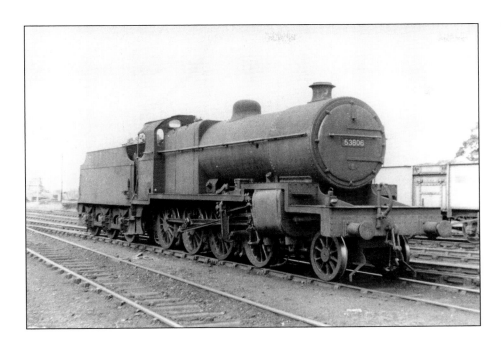

The same loco 53806 is in a less than clean condition in the S & D yard at Templecombe Lower on 2 September 1953. The engine is still fitted with a large boiler.

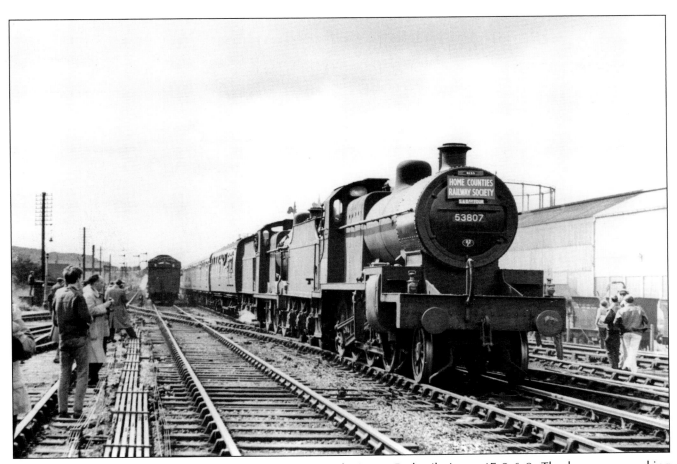

On an unspecified date 53807 is slowly drifting into Bath Green Park piloting a 4F 0-6-0. The locos are working The Home Counties Railway Society's S & D Rly Tour. Another loco is standing on the main departure line waiting to back on to the train. An ancient locomotive tender can be seen on the right hand side of the lines.

Standing outside the Goods shed at Evercreech Junction on 30 September 1962 is 53808 in a remarkably clean condition.

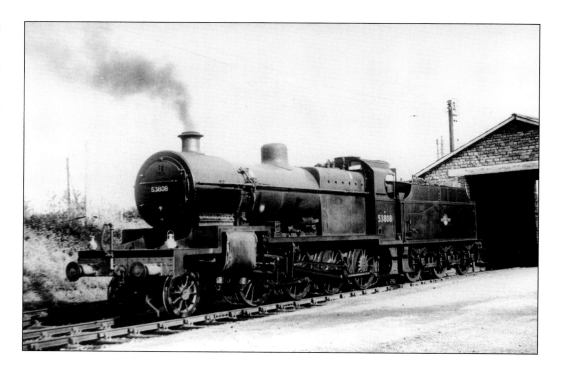

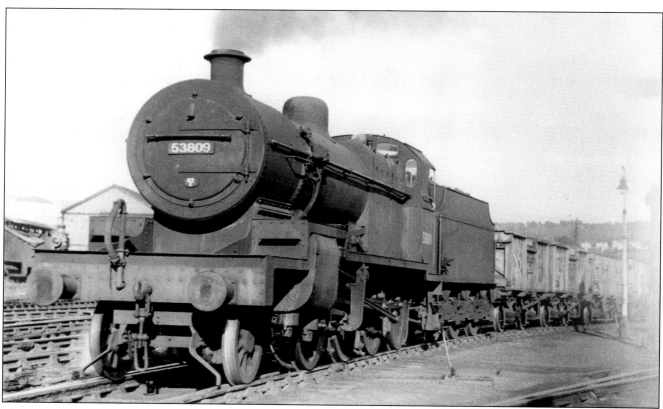

The Midland Bridge Road goods yard at Bath was on the opposite side of the line to the loco shed. In August 1963 53809 is at the head of empty coal wagons ready to depart from the yard. R.K.Blencowe collection

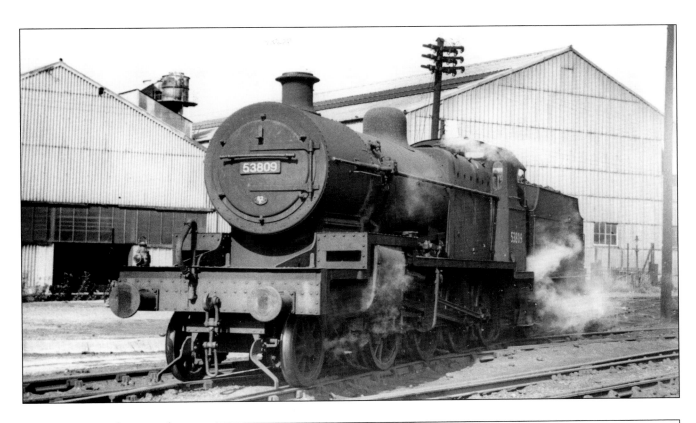

In August 1963 the same loco
53809 waits to exit the shed
yard at Bath.

R.K.Blencowe collection.

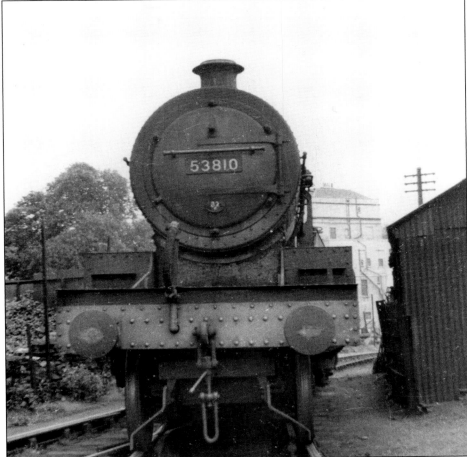

Here is a full frontal shot of
53810 in Bath shed yard on
25 May 1958.

Maurice Dart/Transport Treasury.

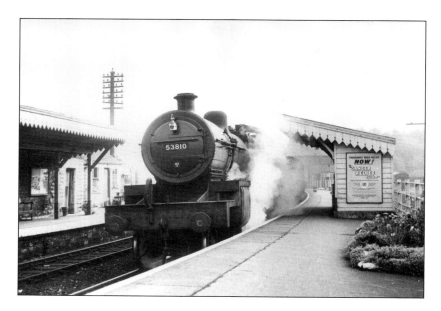

The 11am southbound mixed Goods from Bath passes through Radstock North hauled by 53810 on 15 October 1962.

Next we look at a few shots of WD 'Austerity' locos some of which worked from GWR/BRWR sheds. An Up Goods passes through Bristol Temple Meads hauled by 77026 from Shrewsbury shed on 8 July 1949. Under the BR renumbering scheme this loco became 90123.

W.H.Stone

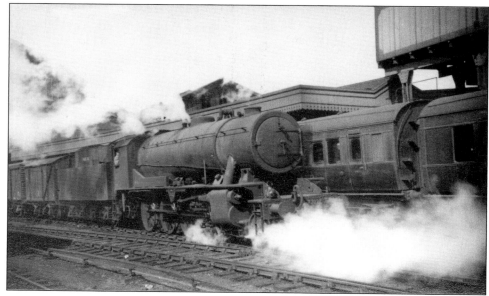

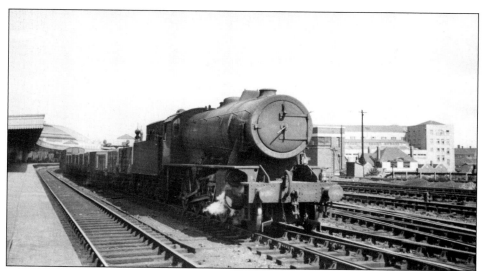

A Down Goods passes Bristol Temple Meads on 6 September 1948 hauled by WD 78542 which became 90413. This loco was shedded at Gloucester. Immediately to the right of the engine is Loco Yard Signal Box. W.H.Stone

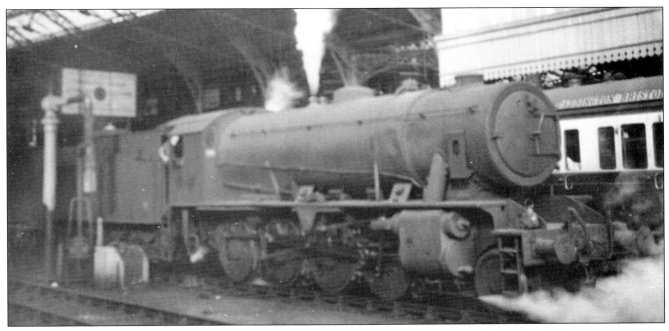

Another Up Goods passes through Temple Meads on 7 July 1948 hauled by Laira's 78717 which became 90658. The author saw this loco when it first came to Laira shed. W.H.Stone

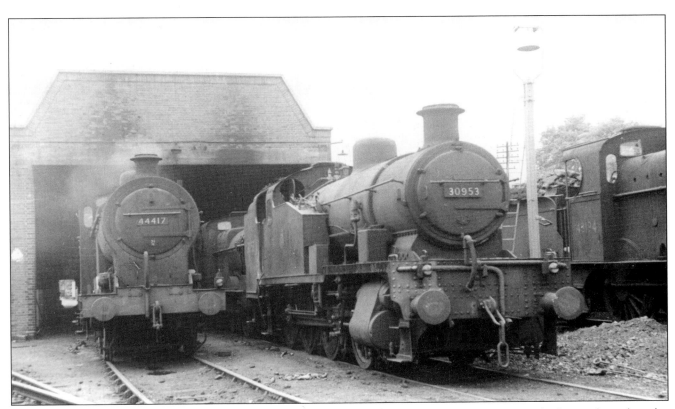

In the centre in this undated view of Templecombe shed is ex SR Z class 0-8-0T 30953 which was based at the shed from December 1954 until April 1957. This engine was used for shunting the exchange traffic in the Upper yard. On the left is 4F 0-6-0 44417 with Johnson 3F 0-6-0 43194 on the right. All of the locos were shedded at Templecombe. The shed code in turn was 22D, 71H, 82G and 83G. Another 3F 0-6-0 is behind the Z.

2
PACIFIC 4-6-2s

Merchant Navy class Pacifics together with the Bulleid Light Pacifics worked on the SR main line from their introduction in the 1940s. Under British Railways the Light Pacifics appeared on passenger trains on the S & D route. From the 1950s a few Britannia class locos worked through the area on WR trains.

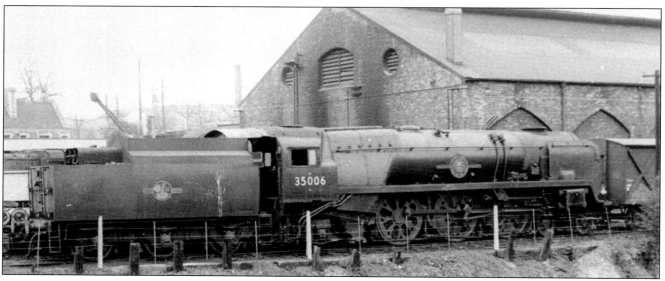

We start this short section with Salisbury's rebuilt 'Merchant Navy' class 35006 'PENINSULAR & ORIENTAL S.N.CO'. It is standing in the long siding on the east side of Yeovil Town shed on 18 April 1964. The loco started life numbered 21C6 and was rebuilt during October 1959.

'West Country' class 21C116 'BODMIN' brings an Up express through Templecombe on 17 August 1947. The number is just readable above the buffer beam. Under BR it was renumbered 34016 and was rebuilt during April 1958. The loco was allocated to Exmouth Junction shed and is preserved on the Mid-Hants Railway.

R.J.Buckley/ Initial Photographics.

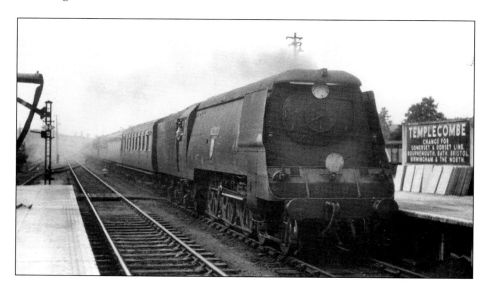

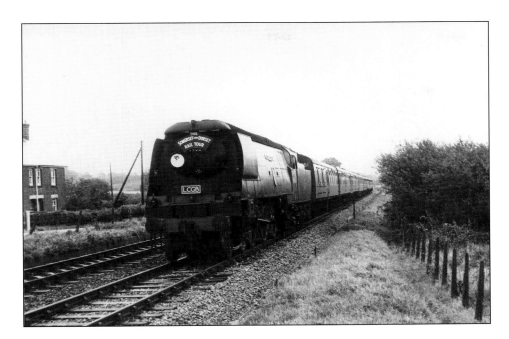

'Battle of Britain' class 34064 'FIGHTER COMMAND' from Nine Elms shed approaches Wimbourne with the LCGB's 'Somerset & Dorset Rail Tour' on 30 September 1962. The loco was originally numbered 21C164.

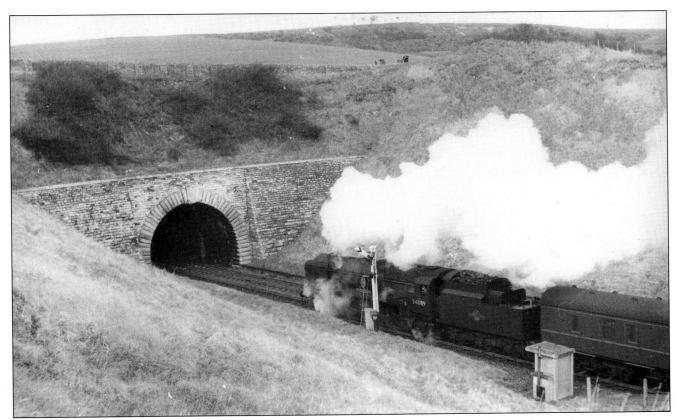

Salisbury shed's rebuilt 'Battle of Britain' 34089 '602 SQUADRON' is climbing the bank and is about to enter Bincombe tunnel on 26 March 1966. The train is the 15.50 Weymouth to Waterloo. Rebuilding took place in November 1960. Michael Messenger

3

KING AND CASTLE CLASS 4-6-0s

From their appearance in traffic these famous GW classes worked the principal expresses and many other passenger trains on the company's main lines through the area and the Castles also penetrated to Weymouth.

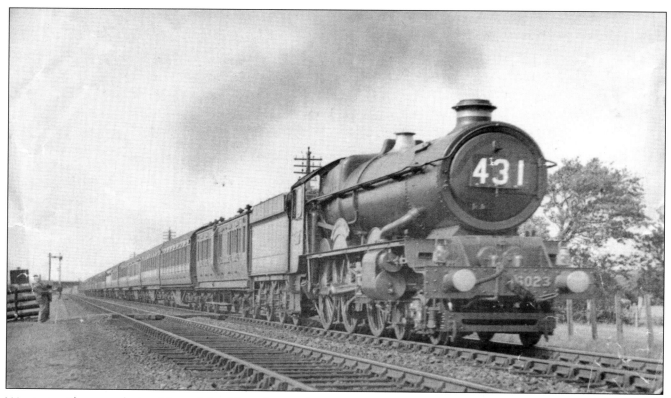

We start with some shots of the mighty King class and see 6023 'KING EDWARD II' at Worle Junction in June 1937. The loco which was shedded at Newton Abbot is working a Down Relief to the Devonian. It is fitted with the modified bogie that had a slotted front stretcher. Over the years this bogie appeared on several members of the class. This engine is undergoing restoration at the Didcot Steam Centre.

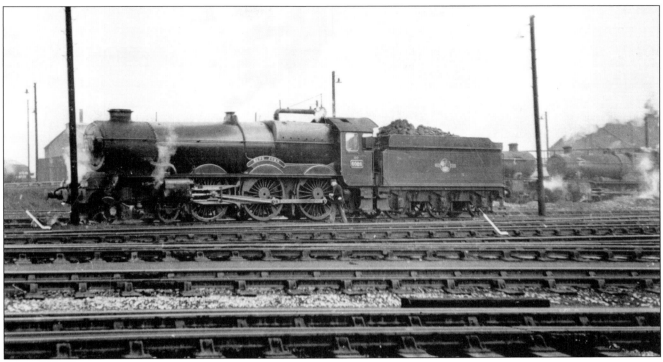

Now we see 6026 'KING JOHN' in the yard at Bath Road shed, Bristol in the early 1960s. This Old Oak Common loco gained a double chimney in the late 1950s. In the background a grubby Castle and an equally grubby Grange await coaling alongside piles of clinker.

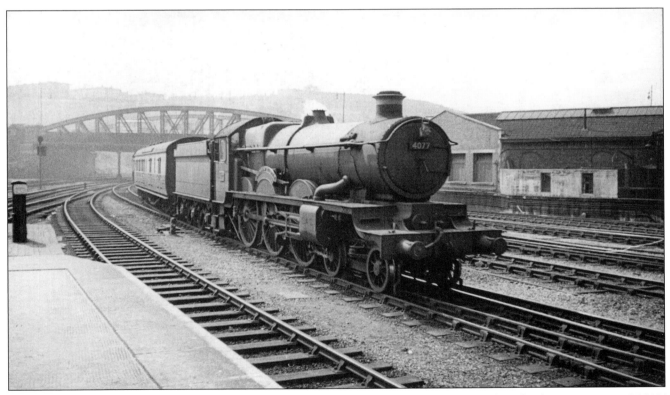

Next we look at a good selection of Castles and commence with a shot of Newton Abbot shed's 4077 'CHEPSTOW CASTLE' entering Temple Meads on an Up express in the early 1950s.

A Down express pulls away from Taunton past the carriage sidings and yard on 11 August 1962 headed by 5000 'LAUNCESTON CASTLE' from Gloucester shed. This shot was taken half looking into the sun from a passing Up train. The long footbridge that spanned the tracks and small gantries with semaphore signals are included.

Maurice Dart

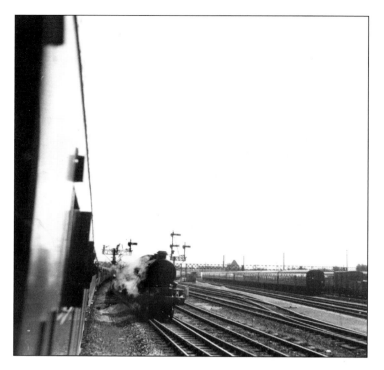

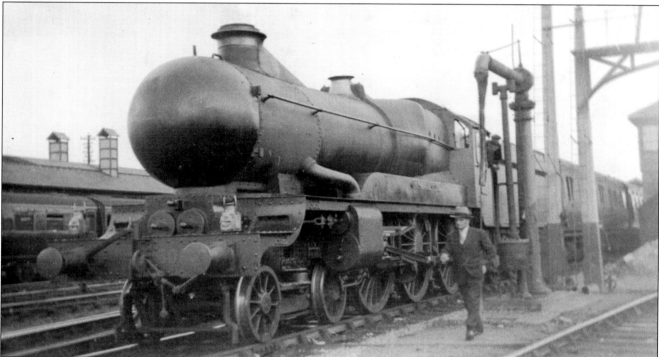

Now we have 5005 'MANORBIER CASTLE' at Weymouth on an Up express to Paddington in 1935. This loco together with King 6014 were partly streamlined in 1935 and this photo was most likely taken soon after it re-entered service, although the cowling over the outside cylinders, steam chests and steampipes had already been removed. A Locomotive Inspector is striding purposefully towards the front of the loco. The streamlining was applied as an experiment to help reduce resistance to wind when travelling at speed and hence reduce coal consumption. It was removed at the outbreak of the Second World War. In this period the loco was shedded at Old Oak Common. The author luckily saw this loco in this form on the coaling line at Newton Abbot shed in 1937.

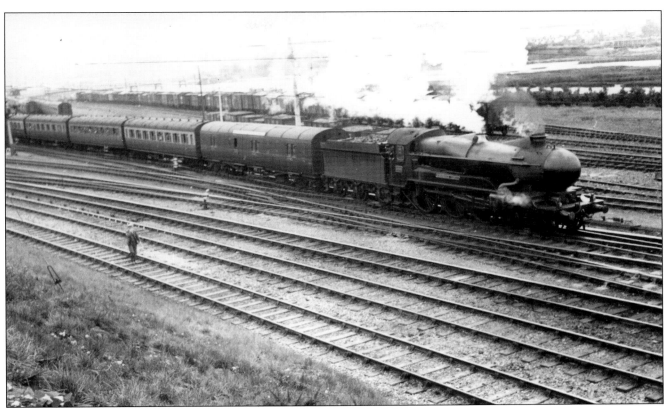

Here is another shot of 5005 'MANORBIER CASTLE' pulling out of Weymouth around 1937 with an express for Paddington. It has just passed the extensive carriage sidings and Goods yard.

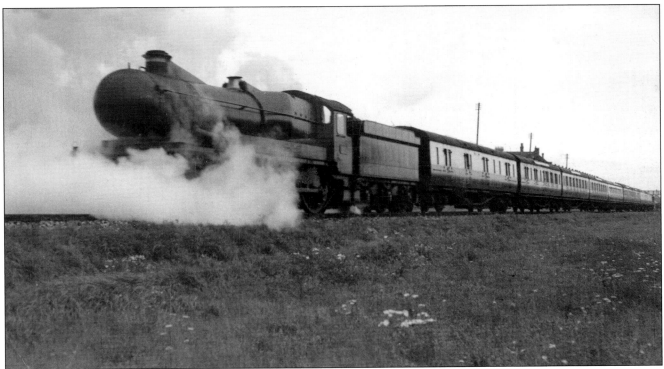

I make no excuse for including a third shot of 5005 'MANORBIER CASTLE' as this is an excellent action shot from around 1937 as the loco starts to climb Upwey bank, again on express to Paddington from Weymouth.

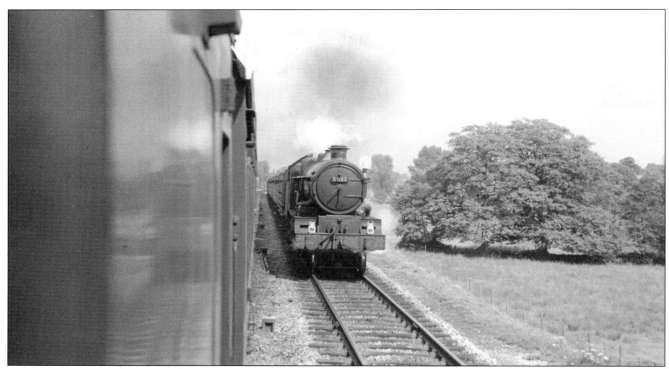

This is a shot taken on 12 August 1961 from an Up train descending Wellington bank. It is a head-on shot of 5032 'USK CASTLE' from Old Oak Common shed on a Down express at Red Ball as it approaches Whiteball tunnel.

Maurice Dart/Transport Treasury

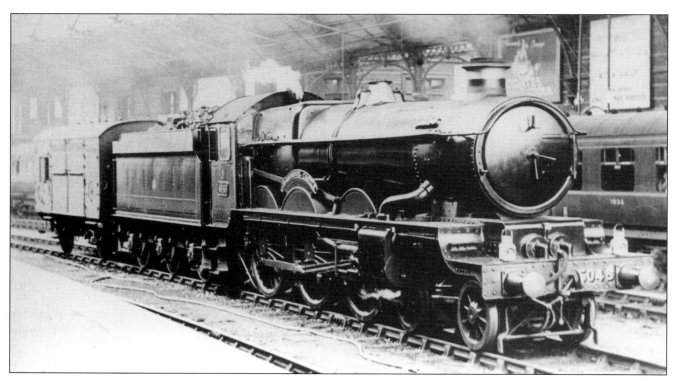

Now we see 5048 'CRANBROOK CASTLE' waiting on the centre road at Temple Meads in 1935. It is coupled to a GW Horse Box which it will attach to an Up service which it will then work forward. In August 1937 this loco was renamed ''EARL OF DEVON'. It was from Bath Road shed.

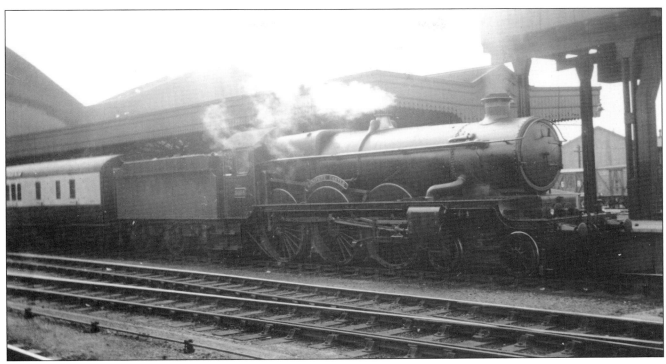

Awaiting departure from the east end of Temple Meads with an express in 1936 is Old Oak Common's '5054 'LAMPHEY CASTLE'. This loco was renamed 'EARL OF DUCIE' in September 1937. Transport Treasury

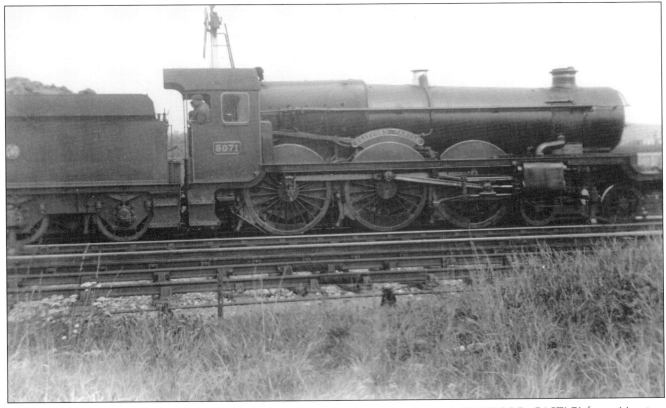

Stopped at Weston-Super-Mare General on an Up express in 1939 is 5071 'CLIFFORD CASTLE' from Newton Abbot shed. This is yet another Castle class loco that changed its name as it became 'SPITFIRE' in September 1940.

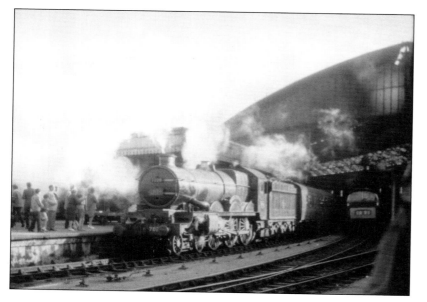

On 4 September 1965 7029 'CLUN CASTLE' worked a return special train from Temple Meads where it is awaiting departure. This occurred after the Paddington train hauled by D1071 'WESTERN RENOWN' had left. The loco which was from Gloucester shed is one of the preserved Castles. Maurice Dart

Standing in the yard at Bath Road shed on 9 May 1964 is 7032 'DENBIGH CASTLE' from Old Oak Common shed. It was waiting to take over an Ian Allan special which 7029 was working from Plymouth and take it on to Paddington.

Terry Nicholls

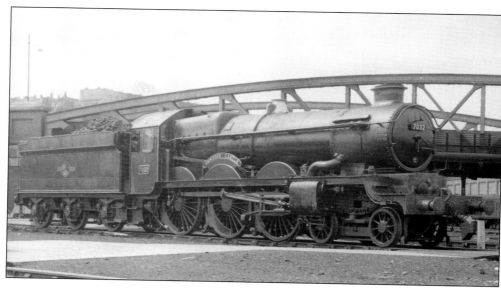

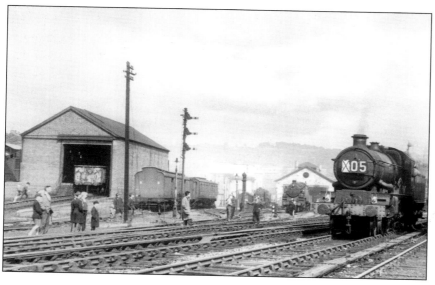

This undated view has a Castle which is probably Worcester shed's 7023 'PENRICE CASTLE' waiting outside Bath Green Park to take over a special excursion. The shed yard on the left contains a 9F 2-10-0 and Bath's 2-6-2T 82004.

4

GWR HALLS AND GRANGES

These mixed traffic locomotives worked over the company's main lines throughout the area on passenger and goods trains.

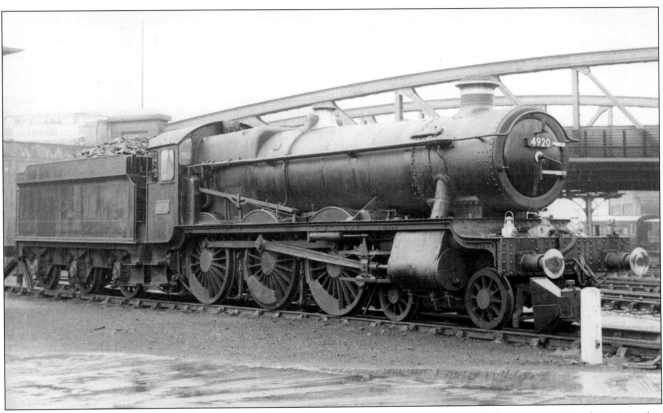

We start with a selection of Halls and see de-named 4920 in the yard at Bath Road shed on 22 March 1965. This loco which had been named 'DUMBLETON HALL' was still in traffic working from St Phillips Marsh shed. It is one of the preserved Halls. Terry Nicholls

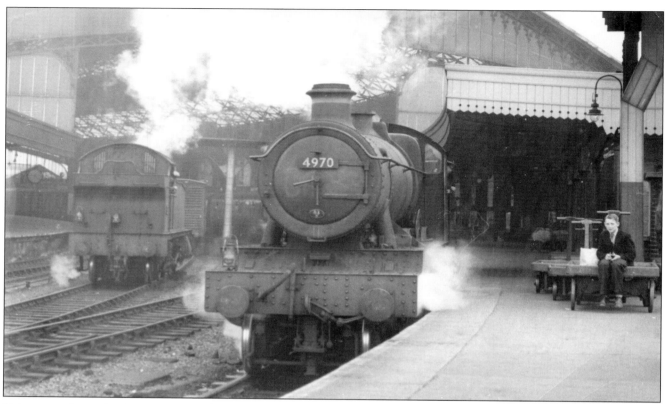

This scene from the 1950s at Temple Meads has 4970 'SKETTY HALL' from Taunton shed detaching from an Up passenger working as a 4575 class 2-6-2T brings a train of vans eastwards through the station. A young engine spotter sits on the platform trolley with his bag of food.

This panorama of Temple Meads dates from 1934 and from left to right shows the parcels platforms, the main station and part of Bath Road shed yard with its signal box. A Castle is on a passenger train deep inside the station under the awnings as a Hall brings a short train of vans out towards the road bridge. Nearest to the camera Old Oak Common shed's 5940 'WHITBOURNE HALL' is shunting Loco Coal wagons.

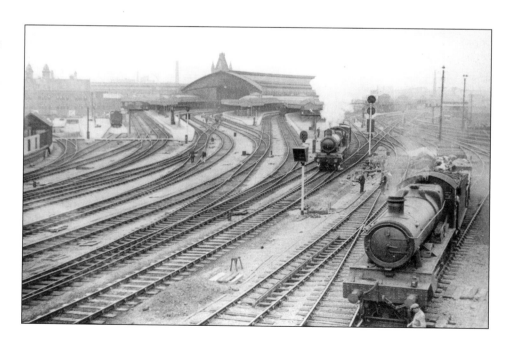

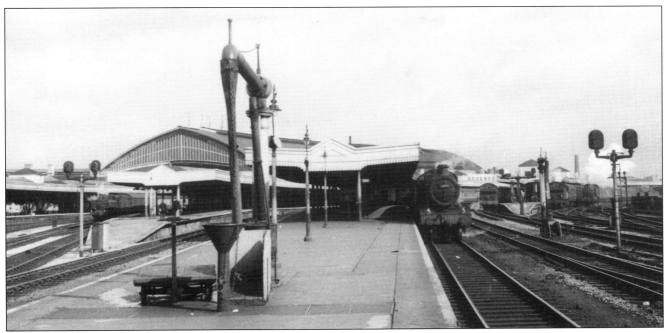

This scene at the west end of Temple Meads dates from 26 August 1956. On the left a 8750 class 0-6-0PT is on a train of vans. Nearest to the camera 5971 'MEREVALE HALL' from Worcester shed has arrived with a Down express. This would have been quite a scarce loco at Bristol. Next to the right two 4575 class 2-6-2Ts wait to depart on local passenger trains as a 5101 class 2-6-2T approaches Bath Road shed. H.C.Casserley

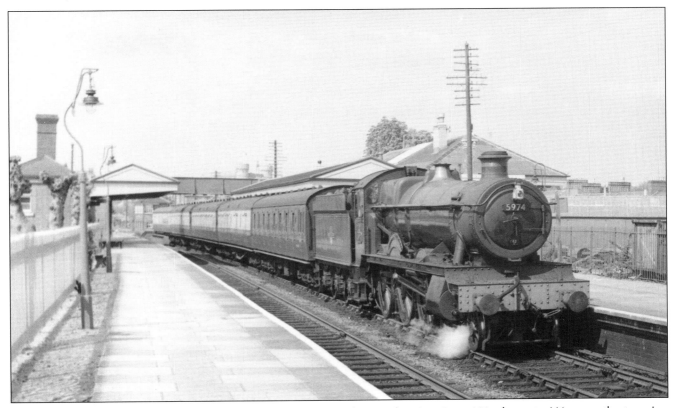

Westbury shed's gleaming 5974 'WALLSWORTH HALL' brings the 12.50pm Westbury to Weymouth stopping passenger train into Dorchester West on 21 April 1957.

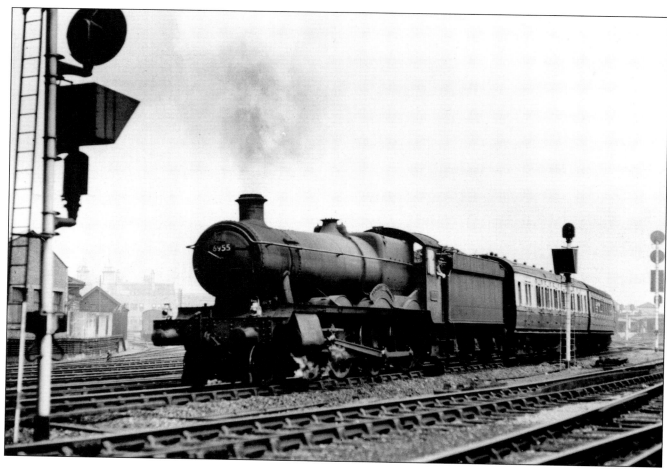

In this shot from the early 1950s 6955 'LYDCOTT HALL' takes a Down express out of Temple Meads. The loco was shedded at Westbury. P.Ransome-Wallis

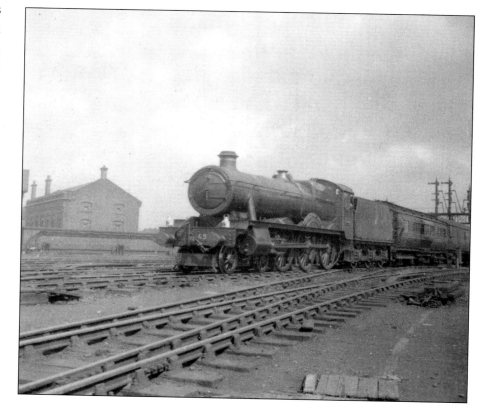

Next we see Modified Hall 6990 'WITHERSLACK HALL' from Old Oak Common shed taking an express eastwards out of Temple Meads in about Summer 1948.

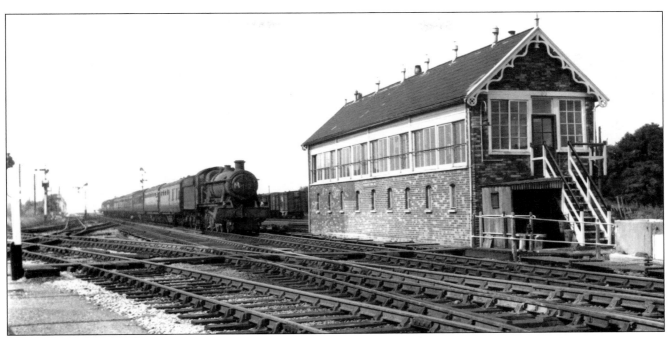

Another Modified Hall 7901 'DODDINGTON HALL' from Bath Road shed passes the magnificent Yatton West Signal Box with an Up express in 1960. The lines curving left led to the Cheddar Valley branch. R.S.Carpenter photos.

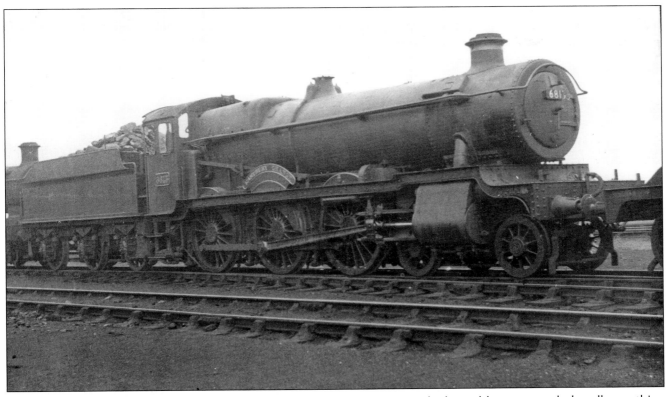

We follow the Halls with some photos of the well-respected Granges which could competently handle anything they were called on to perform. This shot from 27 May 1951 shows Newton Abbot's 6813 'EASTBURY GRANGE' in the yard at St Phillips Marsh shed. In addition to carrying a 83A shedplate the loco retains the NA shed stencil on its frame. The tender has been very well replenished with coal. This engine incorporated parts of Mogul 4351.

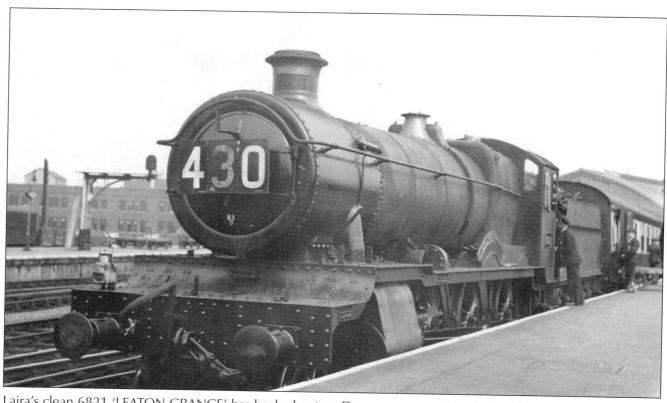

Laira's clean 6821 'LEATON GRANGE' has backed onto a Down express at Temple Meads on 5 June 1954. It will work the train to Plymouth North Road. This engine incorporated parts of Mogul 4372. L.B.Lapper

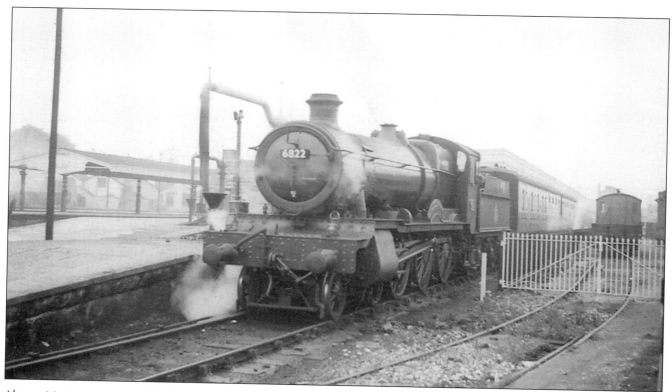

About 1951 6822 'MANTON GRANGE' from Newton Abbot shed is ready to depart from the Up Bay at Taunton with an express. This engine incorporated parts of Mogul 4334. Kenneth Brown

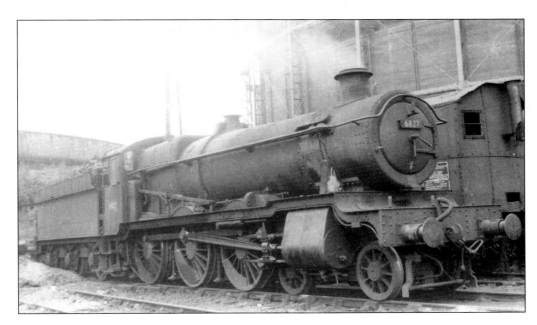

De-named Grange 6827 is at the back end of one of the sidings alongside the gas works and Barrow Road shed, Bristol in 1965. After St Phillips Marsh and Bath Road sheds closed to steam traction, steam locos were serviced at the LMS shed. The 2B code represented Oxley shed at this time. This loco had formerly been named 'LLANFRECHFA GRANGE' and incorporated parts of Mogul 4346. The shed's crane is partly visible behind the engine.

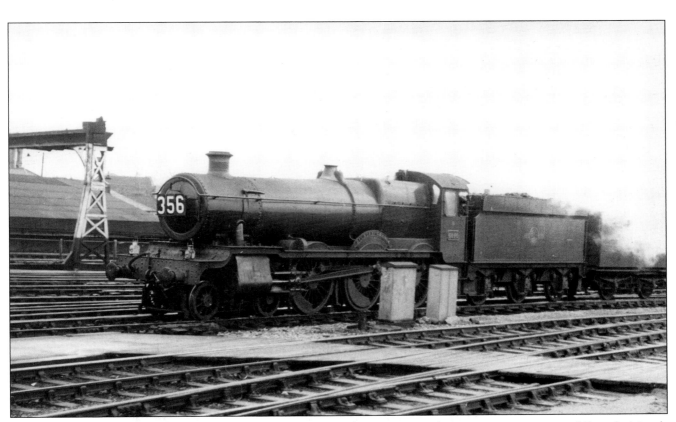

A surprisingly clean St Phillips Marsh engine 6846 'RUCKLEY GRANGE' takes an Up express out of Temple Meads in the late 1950s. This engine incorporated parts of Mogul 8354. Most engines from SPM shed were usually grimy as it was primarily a freight loco shed.

Running past Temple Meads towards Bath Road shed in the late 1950s is 6847 'TIDMARSH GRANGE' from Ebbw Junction shed, Newport. This engine incorporated parts of Mogul 8389.
Mike Daly

Here is another shot of 6847 'TIDMARSH GRANGE', by now shedded at Cardiff Canton, taken about 1960 The loco which has arrived at Temple Meads on a Stopping Passenger train would appear to be recently 'ex works'. South Devon Railway Museum

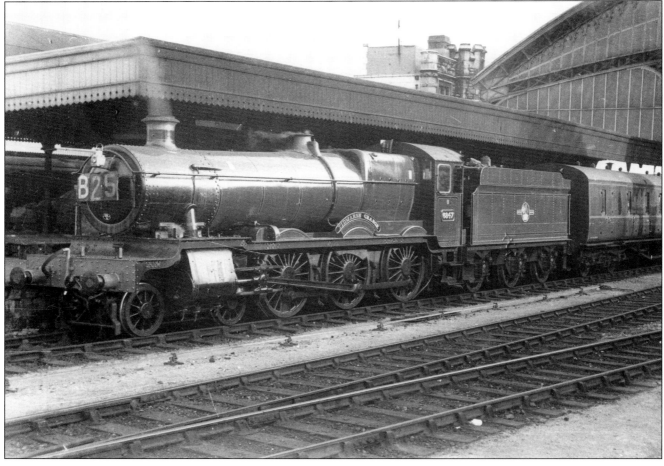

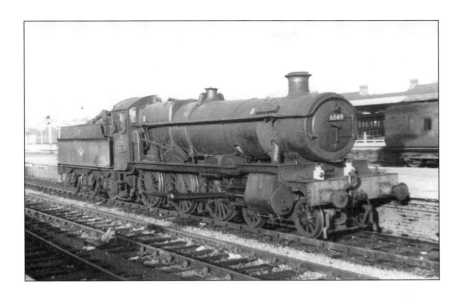

St Phillips Marsh shed's 6849 'WALTON GRANGE' backs out of Weymouth to run to the shed on 12 December 1961. This engine incorporated parts of Mogul 4306. The author had an exhilarating run behind this loco southbound over Llanvihangel summit when it was shedded at Pontypool Road in 1952

Here is Taunton shed's 6871 'BOURTON GRANGE' on an express waiting to depart from the east end of Temple Meads early in 1960. The engine appears to have a 'painted on' shed code of 83B. This engine incorporated parts of Mogul 4363. The water supply in the tender has been 'topped up' in the time-honoured GWR fashion and the driver is using his oil–can to ensure all runs smoothly. The train will probably soon be climbing Filton incline which will present no trouble to a Grange.

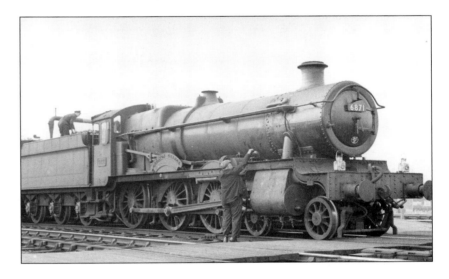

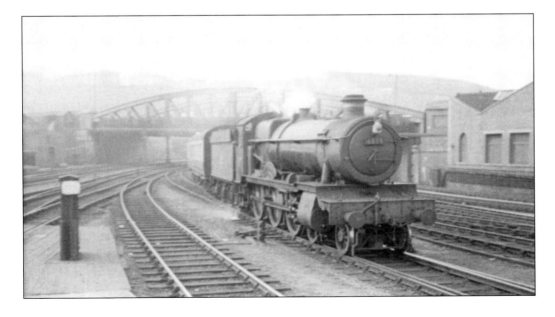

In the early 1950s 6875 'HINDFORD GRANGE' brings a Stopping Passenger train into Temple Meads. The engine from Taunton shed incorporated parts of Mogul 4385.

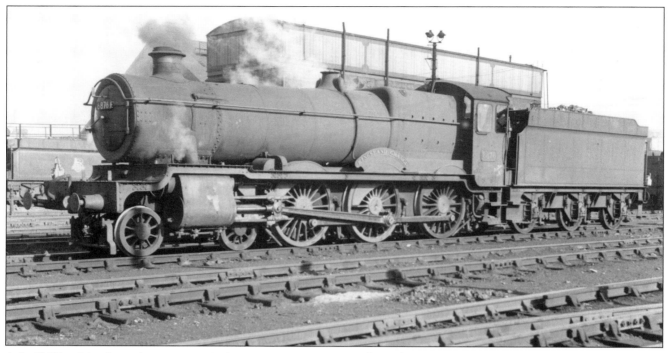

A St Phillips Marsh engine 6876 'KINGSLAND GRANGE' stands in the yard at Bath Road shed on 19 September 1954. This engine incorporated parts of Mogul 4354. The shed's large water tank is prominent behind the engine.
F.M.Gates

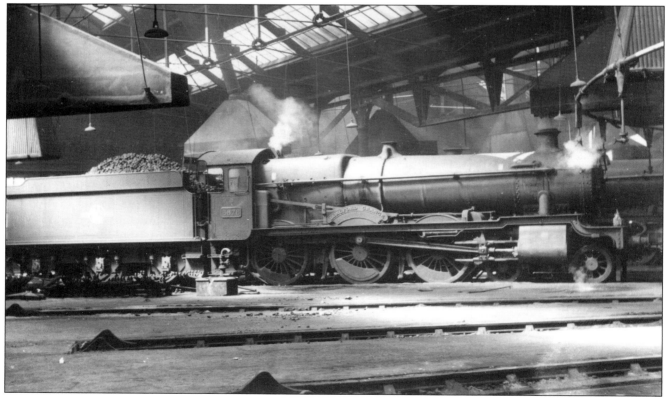

We end this section with a shot of Ebbw Junction shed's 6878 'LONGFORD GRANGE' which incorporated parts of Mogul 8366. It is inside one of the two roundhouses at St Phillips Marsh shed in May 1964.

5

STAR, SAINT and COUNTY CLASS 4-6-0s

Before the arrival of the Halls and Castles, Saint and Star class engines worked most of the passenger trains in the area. Even in the 1930s and 1940s they were utilised on slower easier timed passenger services. The Counties arrived in the mid 1940s and worked some of the heavier expresses.

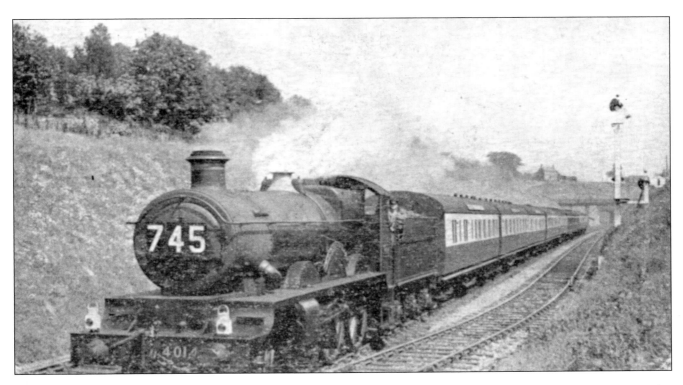

Star class 4014 'KNIGHT OF THE BATH' heads a Wolverhampton to Paignton express through Flax Bourton in the late 1930s. The engine gained the elbow steampipes in 1935. The author saw this engine which was shedded at Shrewsbury, at Newton Abbot in 1938. C.R.L.Coles

This shot shows Star class 4016 'KNIGHT OF THE GOLDEN FLEECE' starting a Down express from Temple Meads on an unknown date. However, as the engine was withdrawn in October 1925 to be converted to a Castle class, this photo pre-dates that time. The engine was built in October 1910 and this photo was probably taken soon after it entered service.

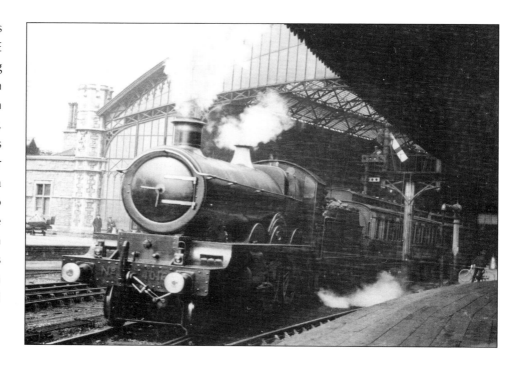

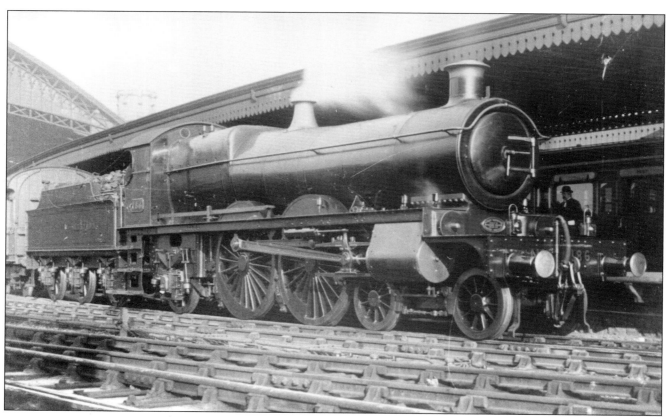

Now we see un-named Saint class 186 running as a 4-4-2 at Temple Meads where it has just backed onto a Down passenger train. It was built in July 1905 as an Atlantic and was converted to a 4-6-0 in May 1912 so this shot was taken between those dates. However, as the engine was named 'ROBIN HOOD' in September 1906 that narrows the date of the photo down to within the first fourteen months of the engine's life. W.Beckerlegge/R.S.Carpenter photos

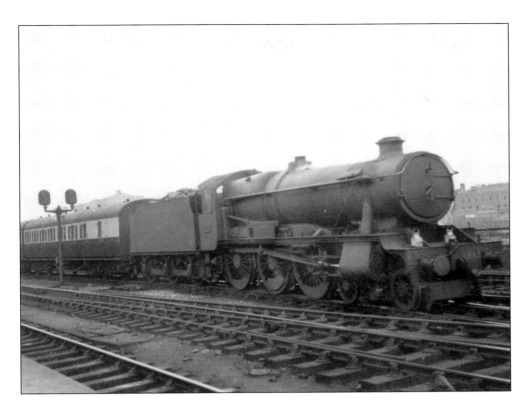

This shot from 1947 shows Bath Road's County 1013 'COUNTY OF DORSET' bringing a train of empty coaching stock past Temple Meads probably bound for Malago Vale carriage sidings.

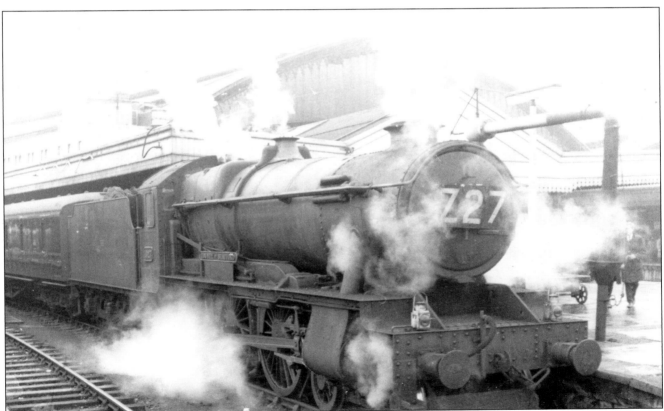

This is an undated shot of Shrewsbury shed's 1027 'COUNTY OF STAFFORD' waiting to depart with a northbound express from Temple Meads. As the engine is carrying an 89A shed plate the photo must have been taken between March and September 1963. P.Triggs

6

SR and LMS 4-6-0s

SR 4-6-0s of the King Arthur, S15 and H15 and earlier types worked trains through the area between Exeter and Salisbury as did BR Standard class 5s. LMS 4-6-0s worked south to Bristol and at times beyond with special trains.

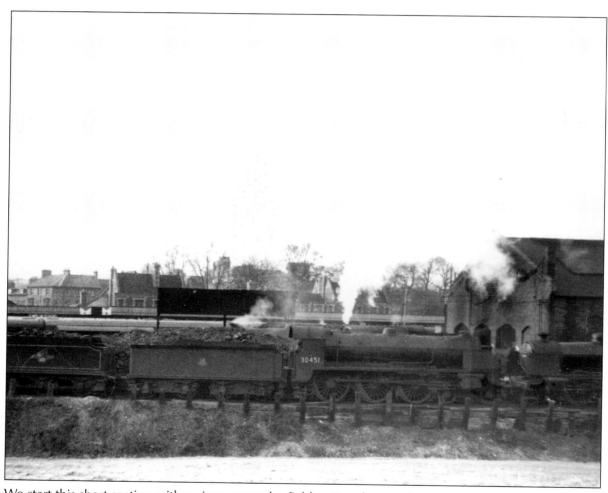

We start this short section with a view across the field to Yeovil Town shed on 4 April 1958. Included in the line of engines is King Arthur class 30451 'SIR LAMORAK' from Salisbury shed, to the right of which the front of Yeovil based U class 2-6-0 31796 can be seen. The photographer accompanied the author on this trip. Denis Richards

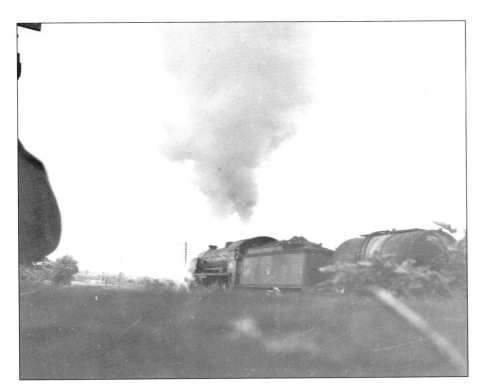

Salisbury shed's S15 class 30823 starts the Up afternoon milk train away from Chard Junction on 11 June 1962. The engine is blowing off well at the Safety valve. The author had to interrupt consuming a pint of cider in the adjacent pub, along with some fellow enthusiasts to obtain this shot.

Maurice Dart/Transport Treasury.

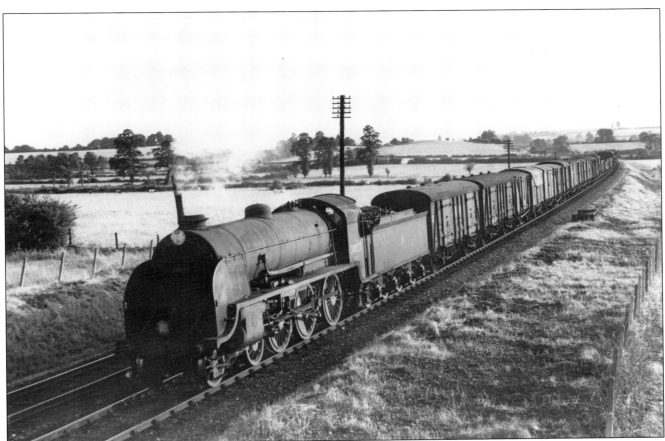

Another of Salisbury's S15s heads a Down Fitted mixed Goods and Parcels train towards Templecombe on 14 July 1959. Two PMV vans are at the front of the train.

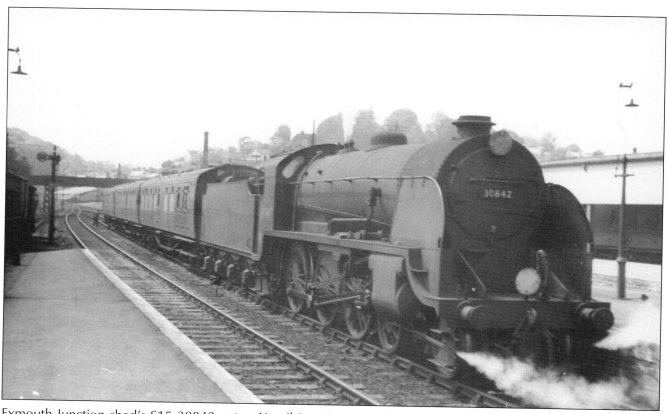

Exmouth Junction shed's S15 30842 enters Yeovil Junction on an Exeter Central to Salisbury Stopping service in 1960. The leading vehicle is a SR Bulleid Brake.

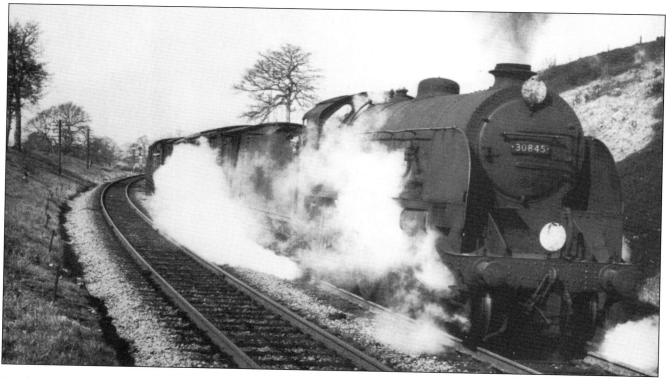

Another Exmouth Junction S15 30845 blasts up the bank towards Gillingham on a heavy Up Goods in the 1950s.
G.A Richardson.

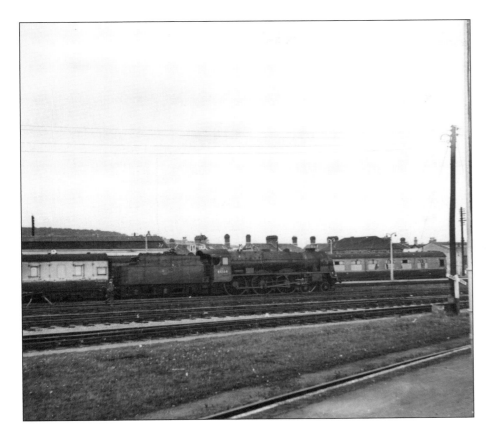

This sight surprised the author on 11 August 1962 so he promptly nipped out of his train to record it. Royal Scot 46164 'THE ARTISTS RIFLEMAN' is waiting on a train in Weston-Super-Mare Locking Road station. The engine had been transferred and was working from Darnall shed, Sheffield. The front carriage is Stanier Brake Third M26380M.

Maurice Dart

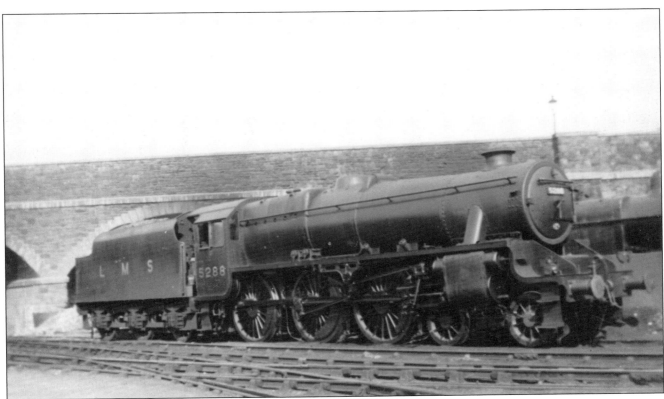

We end this section with a shot of Black Five 5288 in the yard at Barrow Road shed in September 1937. With a powerful magnifier it appears that the engine is carrying a 17A Derby shed plate. A.T.Locke

7

2-6-2 PRAIRIE TANKS

These versatile engines worked branch passenger and goods trains and local main line stopping services all over the area covered in this volume. We will see a large selection of the GWR 'small tank' and 'large tank' 45s. They were synonymous with Bath Road shed where in 1947 there were 7 small tank and 20 large tank locos allocated. Some of these were sub-shedded at Weston-Super-Mare, Bath and Wells. There were several at Taunton for branch line work and a few at Yeovil Pen Mill, which on closure of that shed transferred to Yeovil Town. GWR 'Large Prairie' tanks worked over the main and branch lines and LMS Ivatt tanks worked on the SR and S & D lines

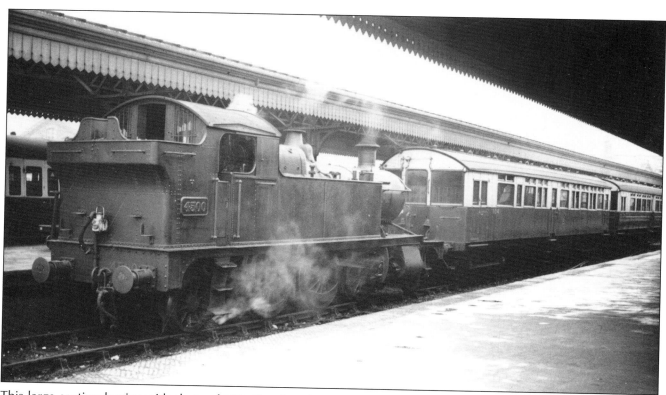

This large section begins with shots of GW 'Small tank' 4500 class engines and 4500 itself is at Temple Meads on an unknown date on a train composed of two Auto coaches, the leading one of which is matchboard sided 104. Now as 4500 was shedded in Devon and Cornwall for many years this photo presents us with a query as to the date. The engine retains inside steampipes and square drop ends. Locomotive & General Railway Photographs

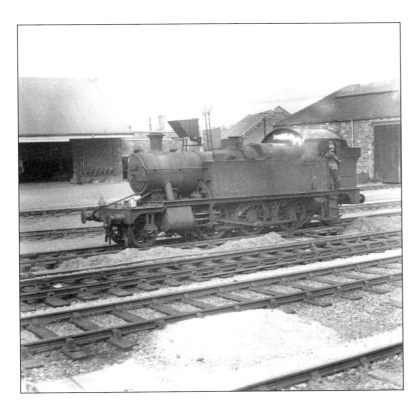

This is a shot taken from a train in April 1957 of Bath Road shed's 4524 shunting in the van sidings at Pylle Hill west of Temple Meads. This loco has received outside steampipes and curved drop ends. Mike Daly

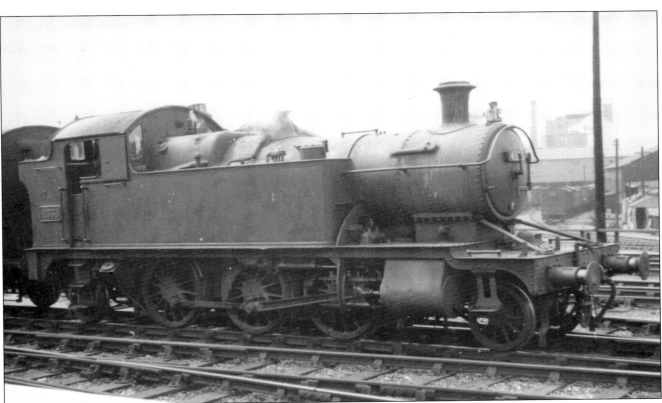

On 14 June 1952 Bath Road's 4535 waits to depart from Temple Meads on what is probably an Avonmouth service. This engine was built with curved drop ends but retained inside steampipes. Part of the large Goods depot can be seen to the right of the engine. A.C.Roberts

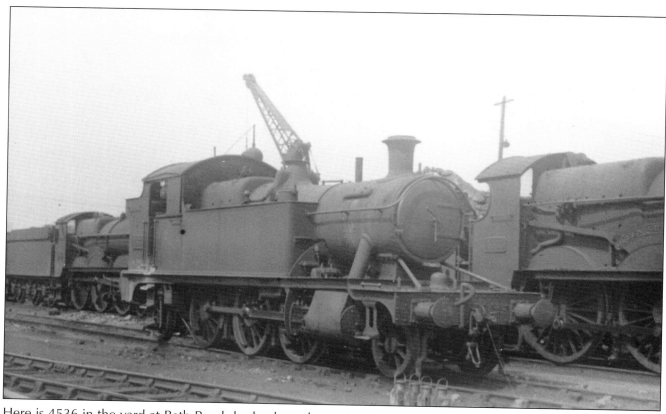

Here is 4536 in the yard at Bath Road shed, where the engine was allocated, on 12 June 1949. Two Stars, one of which is 4055 'PRINCESS CHARLOTTE' from Swindon shed, are on the line behind 4536. A.C.Gilbert

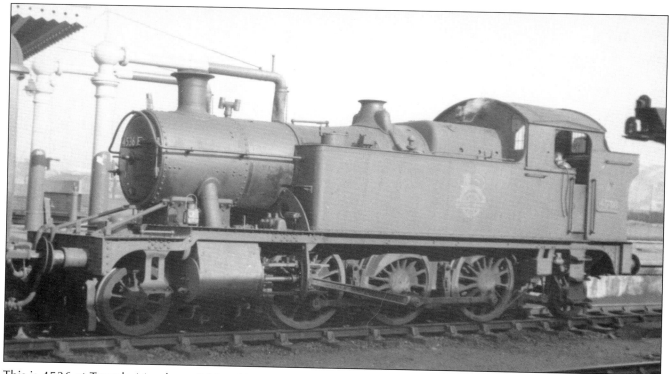

This is 4536 at Temple Meads on 2 May 1953 waiting to depart on a train, probably to Westbury where the engine was now allocated. Its route could have been via Trowbridge or Frome.

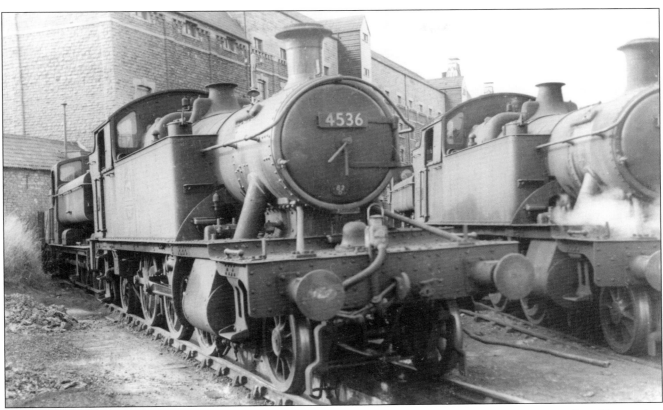

This shot of the shed yard at Frome dates from the late 1950s. Nearest to the camera is 4536 again with another of the class, possibly 4567 on the right. Behind the two Prairie tanks are 8750 and 5700 class Pannier tanks.

R.K.Blencowe collection

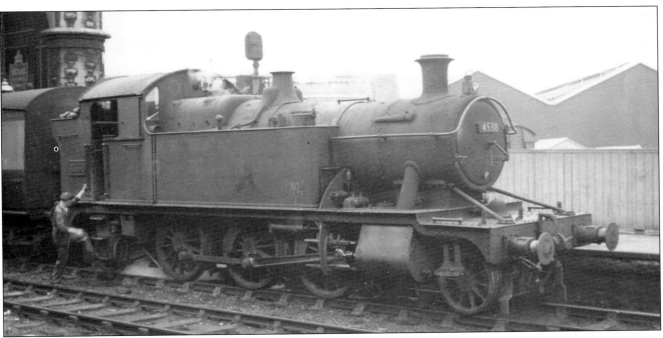

Waiting to depart from the old part of Temple Meads on 12 August 1950 on a local service is 4538 from Swindon shed. The fireman appears to be examining some detail and the roof of the Goods station forms a backdrop.

A.C.Roberts

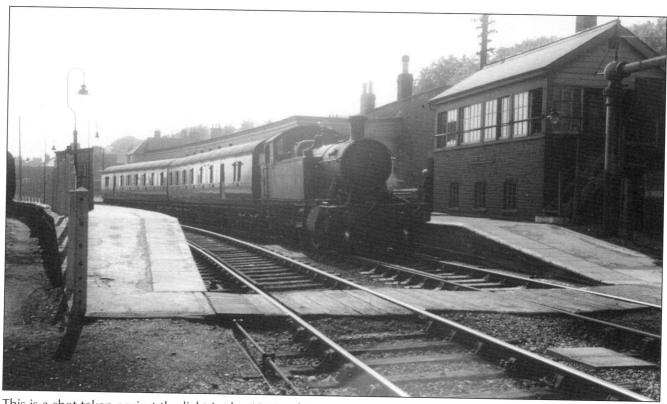

This is a shot taken against the light in the 1950s of Weymouth shed's 4562 with a GWR 'B' set waiting to depart from Bridport on a return working to Maiden Newton. T.G.Wassell

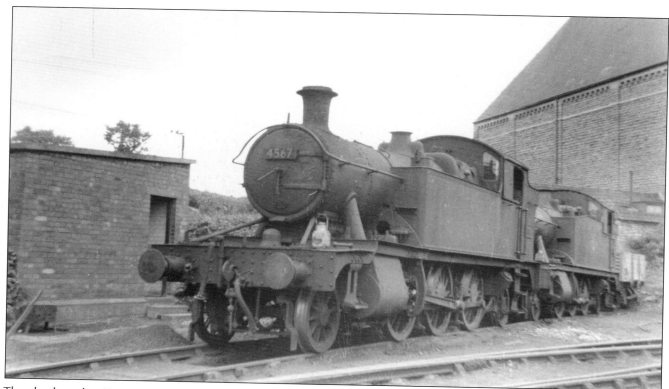

The shed yard at Frome on 22 May 1958 contained 'small tank' 4567 and 'large tank' 5554. Both locos were sub-shedded out from Westbury. Maurice Dart/Transport Treasury

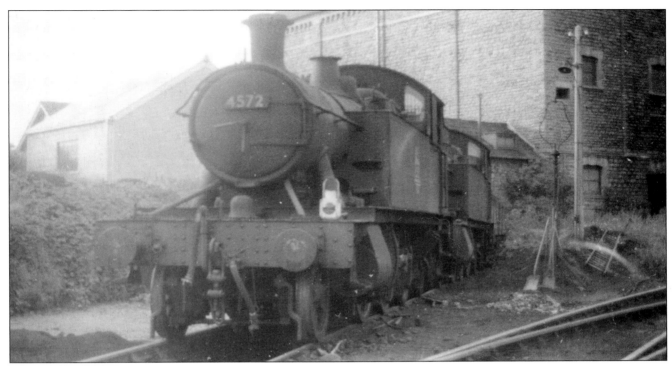

Another shot taken in Frome shed yard in the 1950s has Westbury's 4572 in front of another member of the class.

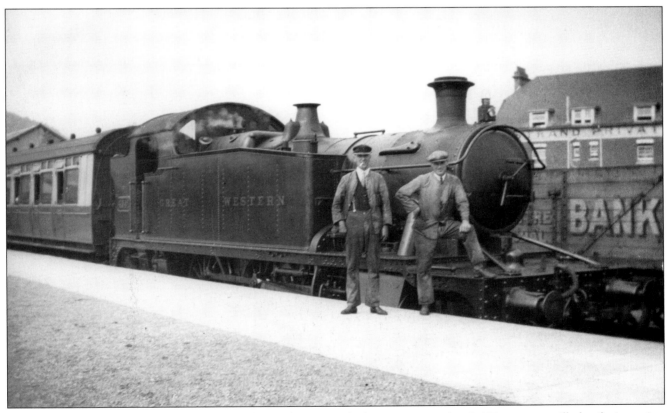

Now we progress to the 'large tank' 4575 class. The crew of what appears to be 4577 pose proudly by their engine as they wait at Minehead with a train to Taunton in the early 1930s, the first carriage of which is a GW 'Toplight' third. The engine would have been from Taunton shed.

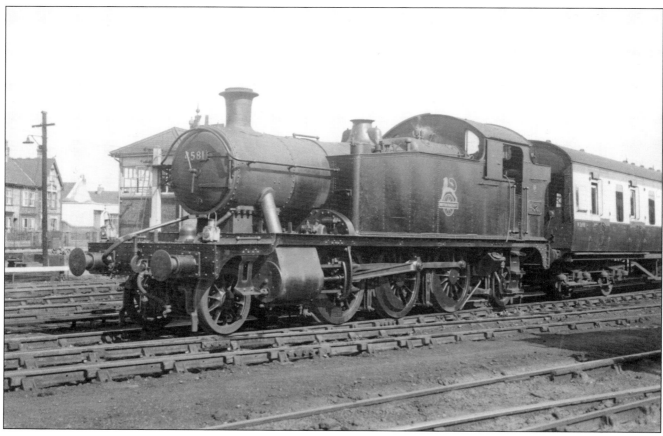

Here we see Taunton shed's 4581 on what is probably a Minehead branch train standing outside the west end of Taunton station waiting to back into one of the Bay platforms. The front carriage is Stanier Brake Third M26918. The photo was taken soon after January 1951 when the loco was transferred from Machynlleth to Taunton.

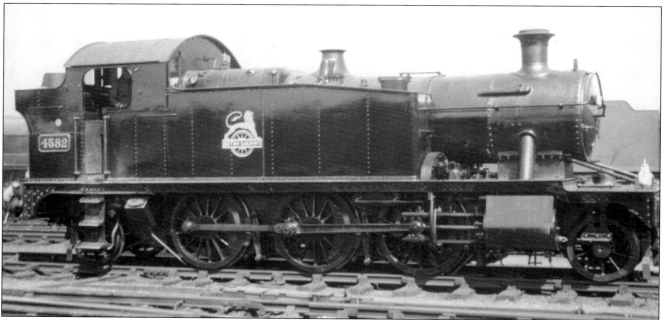

This is Newton Abbot shed's 4582 passing through Temple Meads on 17 May 1952. The engine is on the way back to its home shed after undergoing an overhaul at Swindon Works. R.Leitch

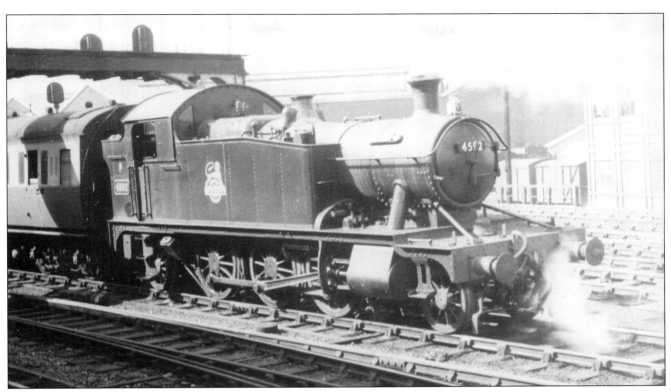

Bath Road shed's 4592 stands ready to depart from Temple Meads in the early 1950s with an Avonmouth train. The Goods station is prominent in the background.

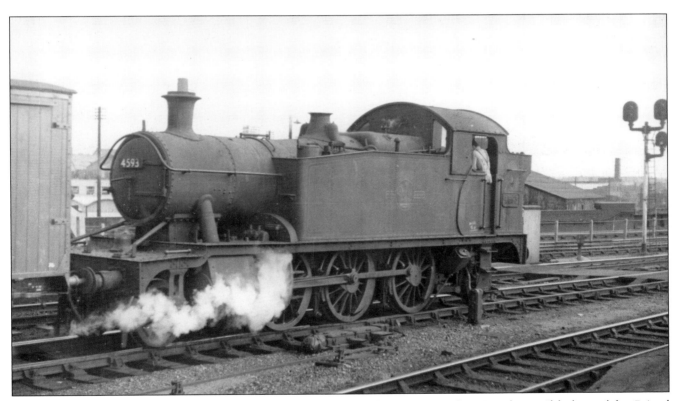

An unusually dirty 4593 from Bath Road waits at Temple Meads in 1959 with a Goods possibly bound for Bristol East Depot.

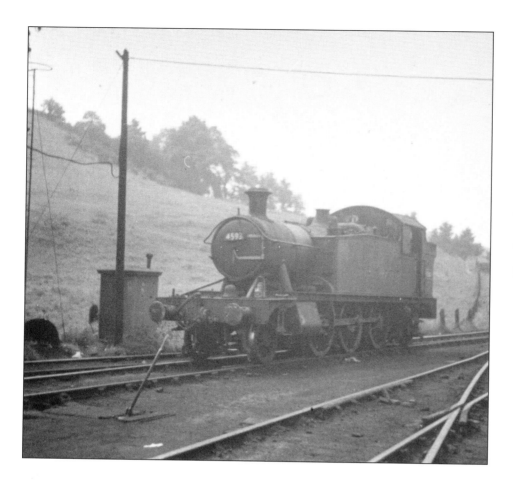

This is 4593 again but this time looking much cleaner. It was painted green and sported a red backed smoke-box numberplate on 26 June 1964. The painting was probably carried out when the engine underwent a Heavy Intermediate overhaul at Caerphilly Works in June 1961. It was shedded at Yeovil Town where it is in the shed yard. Maurice Dart

As stated earlier, Bristol was an excellent place to find both types of 45s. In the early 1950s Bath Road's 4595 is attached to a BR Cattle wagon whilst on Station Pilot duty at Temple Meads. Norman Preedy

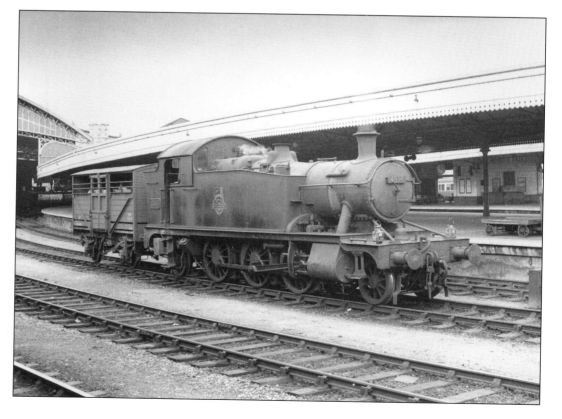

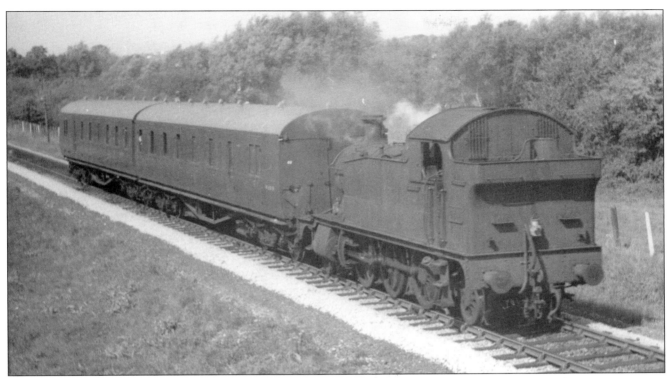

The 2.17pm from Clevedon to Temple Meads is approaching Yatton in the mid-1950s hauled by 4597 which was yet another of Bath Road's allocation of this type. The GWR 'B' set looks quite smart in its newly-painted livery.
Colin Maggs

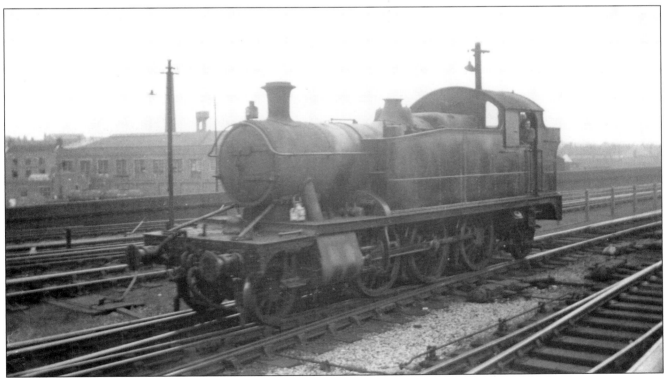

Now we have 4597 again in the mid 1950s standing 'light engine' at the east end of Temple Meads. In the background tank wagons can be seen at Avonside Wharf.

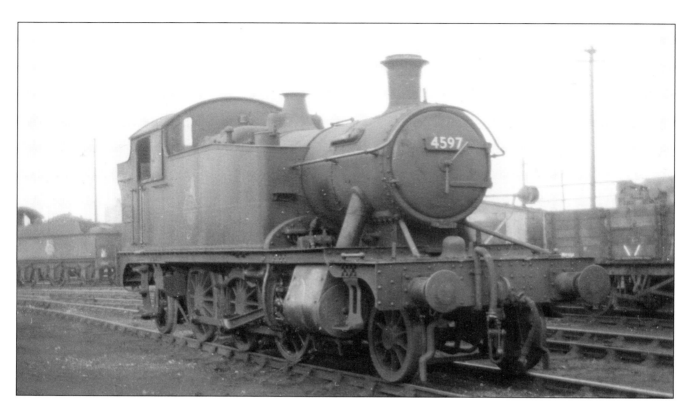

This is a third shot of 4597 in a cleaner condition in the yard at Bath Road in the mid-1950s. An ex Midland Railway 5 plank wagon is on the right.

Butterly Photo Archive

On 22 March 1959 5503 from Taunton shed was on Permanent Way train duty at Wellington and was photographed from a passing train. The engine is attached to a Ballast wagon.

Maurice Dart

Here is another shot of 5503 but this time it is ready to depart from Minehead on 11 June 1933.

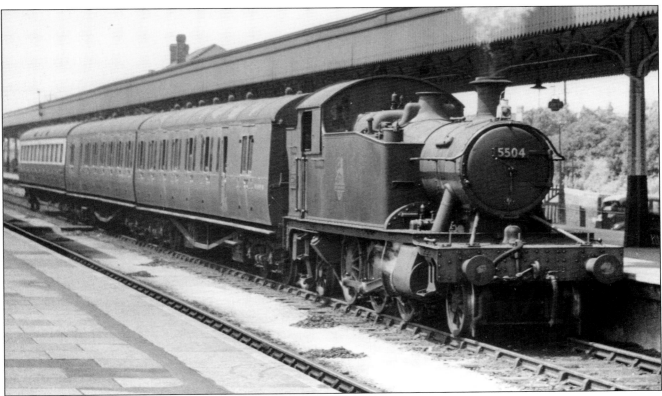

On 4 September 1960 Taunton's 5504 has arrived at Taunton with a branch line train from Chard Central. The train is composed of a 'B' set with a GWR carriage.

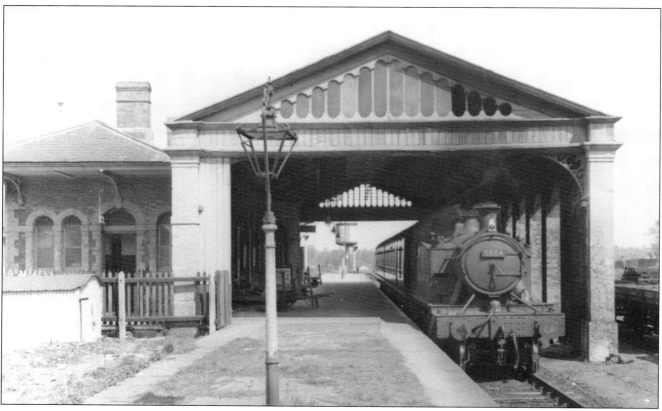

This scene at Chard Central in the 1950s has 5504 on an arrival from Taunton. The station's overall roof features prominently.

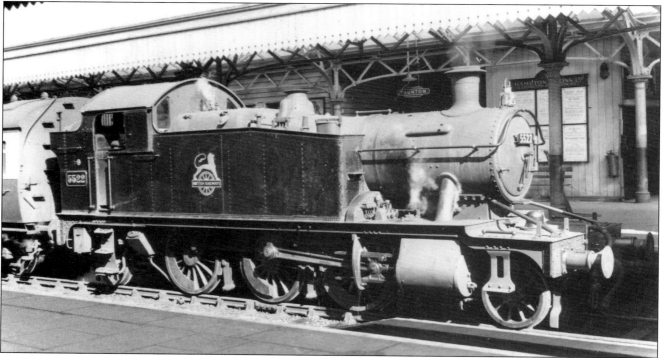

Next we look at Taunton shed's very clean 5522 which has arrived at Taunton with a train from Chard Central in the 1950s.

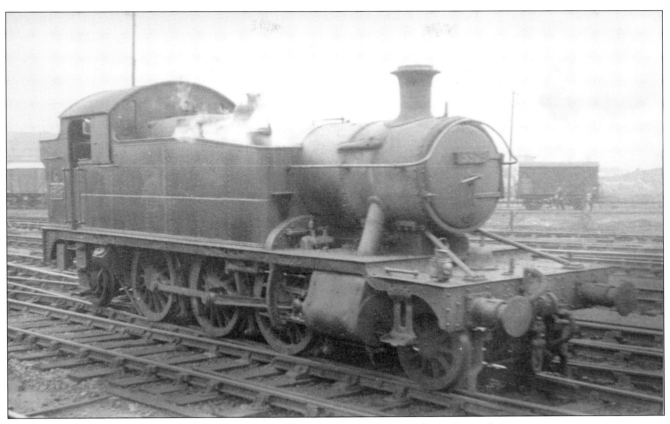

Bath Road's 5523 is opposite Kingsland Road yard east of Temple Meads in the early 1950s.

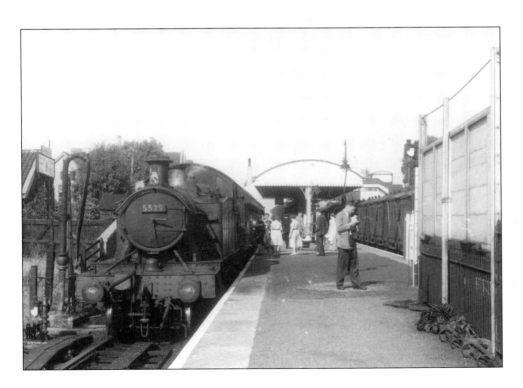

This scene at Yatton in the late 1950s has Bath Road's 5529 awaiting departure for Clevedon. The engine is devoid of a shed plate but retains its Auto train equipment so the photo was probably taken soon after the engine was transferred from Barry at the end of February 1958. Several GW 'Fruit C' wagons are on the right.

H.C.Casserley

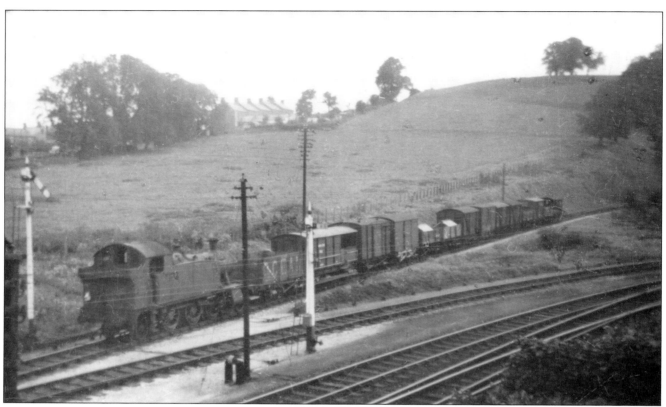

This shot of 5529 was taken on 15 September 1950 when it was shedded at Yeovil Pen Mill before it emigrated to South Wales. It is approaching Yeovil Town with a Transfer Goods from Pen Mill. The first vehicle is a former Private Owner wagon owned by the Ocean Coal Co. R.Lumber

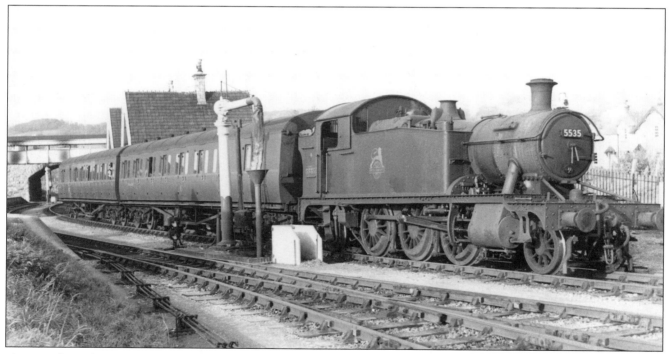

This is a shot of Bath Road shed's 5535 at Wells Tucker Street station on a train from Yatton to Shepton Mallet and Witham in the mid-1950s. The train is composed of a GWR 'B' set.

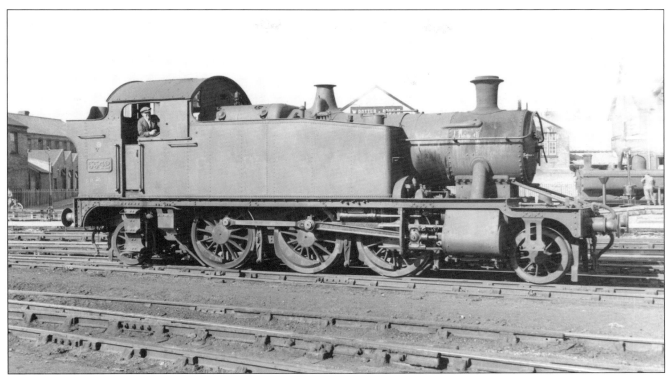

This is a shot of Taunton shed's 5542 approaching the shed on 17 September 1951. A Pannier tank of either 5700 or 8750 class is on a train in the station in the background. F.M.Gates

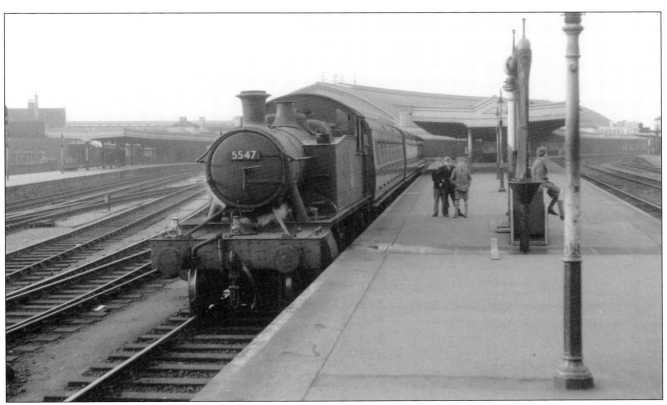

In the early 1950s another Bath Road engine 5547 awaits departure from Temple Meads to Malago Vale carriage sidings with a two coach B set. N.C.Simmons

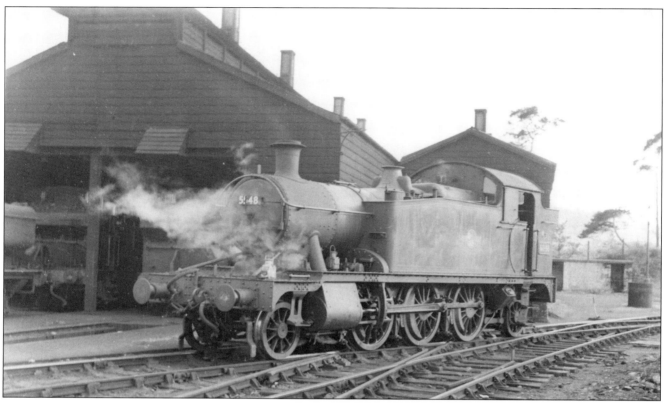

In the late 1950s Yeovil Pen Mill's 5548 stands in the yard outside a full shed. The author visited this shed only once and had to suffer the ignominy of standing in the yard looking at the bunkers of the six Pannier tanks that were inside as he was not permitted to go around. He finally managed to persuade a very obstinate shedman to identify the locos that were inside. It was Good Friday!

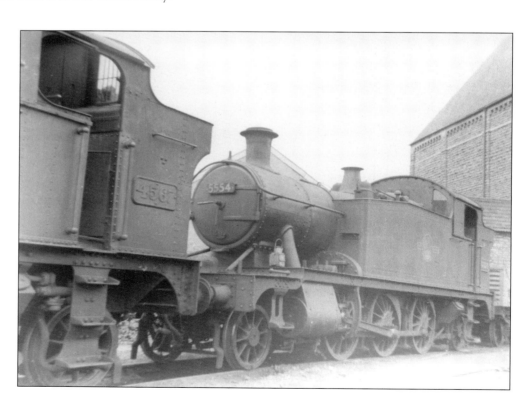

Stabled in the yard at Frome shed on 25 May 1958 was 5554 with small tank 4567 in front of it. Both locos were from Westbury shed.

Maurice Dart/Transport Treasury.

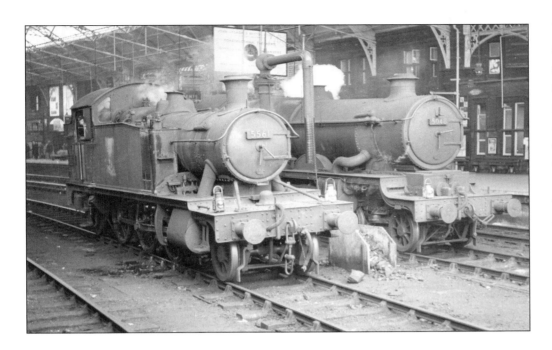

Two Bath Road engines stand side by side in Temple Meads on 6 March 1960. Nearest to camera is 5561 which was the east end Station Pilot. Castle class 5048 'EARL OF DEVON' was waiting to take over the 8.45am Plymouth to Liverpool Lime Street express.

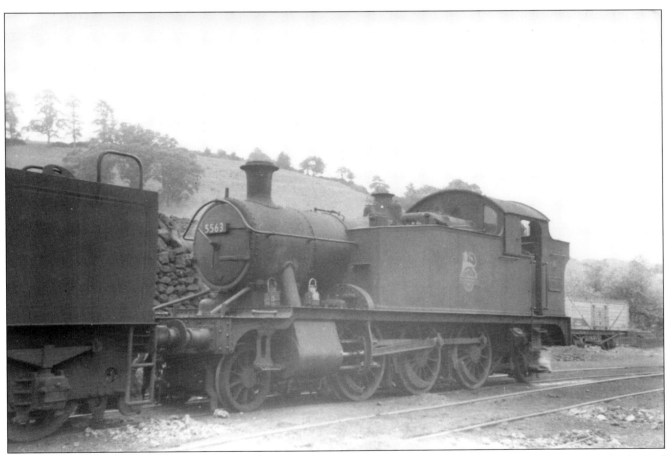

Yeovil Town shed's 5563 is at home in the shed yard on 26 July 1958. Some former Private Owner 7 plank Coal wagons can be seen. Maurice Dart

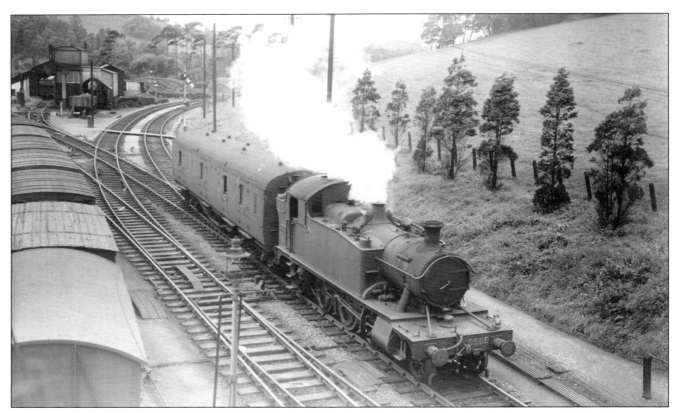

On 3 September 1950 Yeovil Pen Mill's 5565 takes a solitary parcels coach from Yeovil Town around the curve past the shed to Pen Mill station. Lens of Sutton

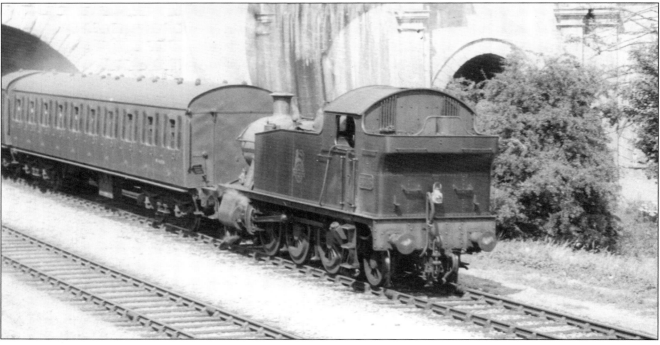

In the mid-1950s 5565 was transferred to Bath Road and here it is working a train from Temple Meads to Trowbridge and Westbury. It has just passed below the Kennet & Avon canal aqueduct and is approaching Avoncliff Halt. The leading vehicle is a BR Standard non-corridor coach.

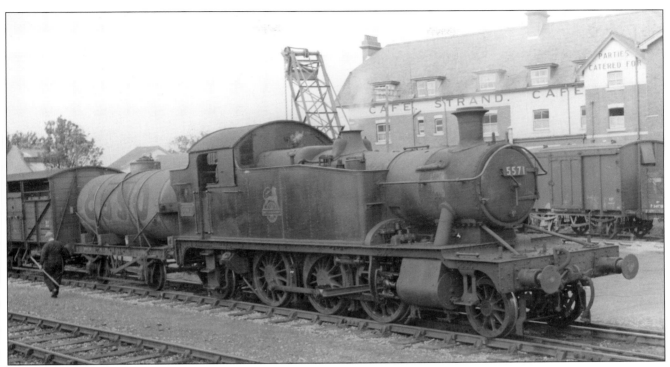

This is a shot of Taunton's 5571 shunting Goods wagons in the yard at Minehead in the 1950s. The first vehicle is an Esso tank wagon. In the background is a former LMS Plywood van and former Private owner 8 plank coal wagon P 349718.

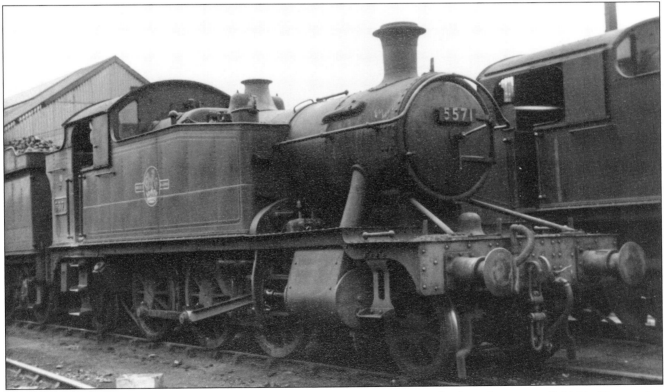

We end this series of 45s with another shot of 5571 at home in Taunton shed yard on 2 April 1961. The engine has been painted green and lined out in main line passenger livery.

Now we have a couple of shots of GW Large Prairie tanks and see 5101 class 5172 from Taunton shed alongside Taunton West Signal Box on 7 October 1946. This was soon after this engine had been transferred from Laira in exchange for 5100 class 5148. The sun reflecting off the loco's tank and bunker made the taking of the photograph difficult. The author saw this engine many times when it was at Laira.

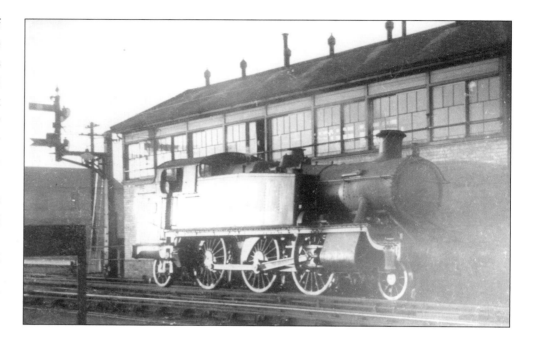

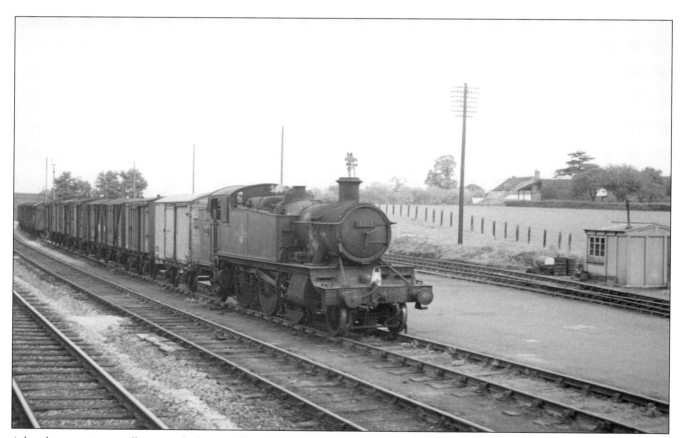

A banker was normally provided at Wellington to assist Goods trains on the climb up to Whiteball tunnel. On 12 August 1961 Taunton shed's 6100 class 6113 was on this duty and was photographed at Wellington from a passing train. The wagons behind the engine are marshalled in the Goods yard. Maurice Dart/Transport Treasury

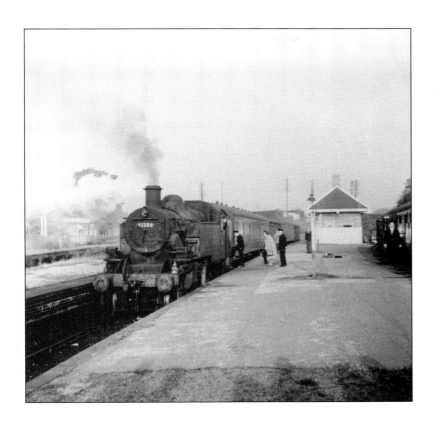

Now we see a couple of photos of LMS Ivatt 2-6-2 tanks. On 23 October 1965 41206 from Templecombe shed waits at Highbridge to depart with the 9.45am to Templecombe. Maurice Dart

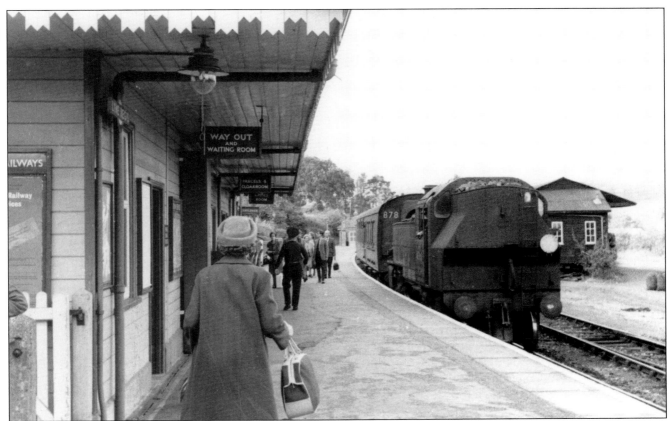

Around 1960 41302 from Exmouth Junction shed has arrived at Lyme Regis on the branch train from Axminster. R.K.Blencowe

MOGUL 2-6-0s

GWR Moguls worked over the main lines and also over the branch line to Barnstaple. Yeovil SR shed had an allocation of U class Moguls for passenger work on trains to Exeter and to Salisbury. Latterly some BR Standard 2-6-0s appeared at times.

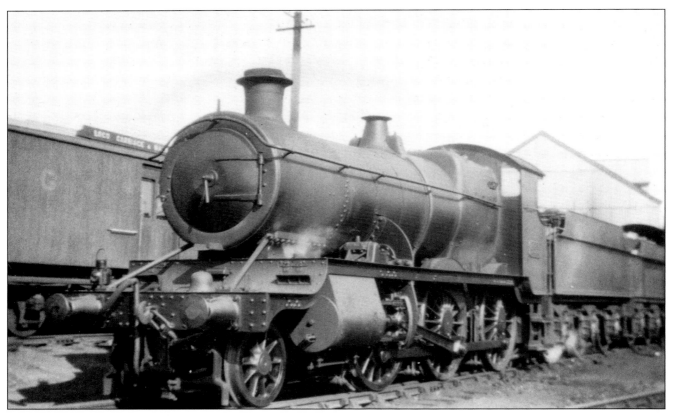

We start this section with a look at some GW 4300 class Moguls and see 4313 in the yard at Taunton where it was allocated, on 9 September 1934. The engine has a tall safety valve bonnet and inside steampipes. The upper lamp bracket is on the top of the front of the smokebox. This engine was withdrawn in February 1936 and taken into Swindon Works where parts of it were incorporated in the first of the new Grange class 4-6-0s, 6800 'ARLINGTON GRANGE' which entered service near the end of August 1936. A Breakdown van is on the left.

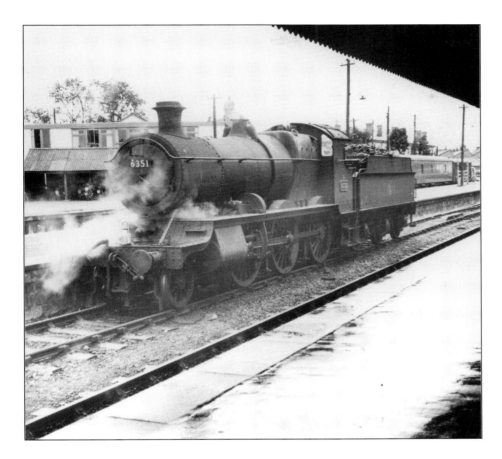

In one of the Parcel train bays at Taunton station on 19 September 1958 is St Phillips Marsh shed's Mogul 6351. This engine retained inside steampipes throughout its life.
Maurice Dart

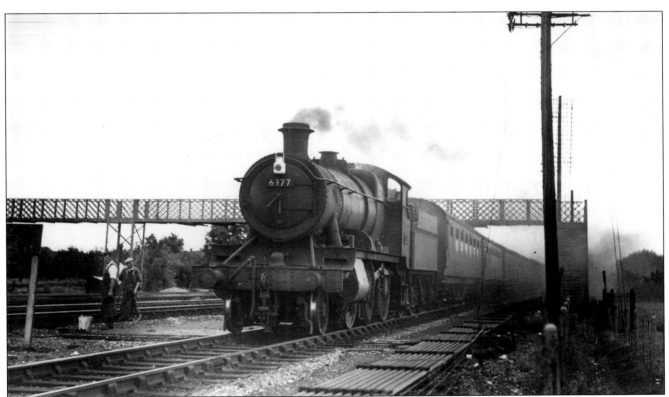

Taunton's Mogul 6377 heads a Down Stopping passenger train past Norton Fitzwarren on 5 September 1950.

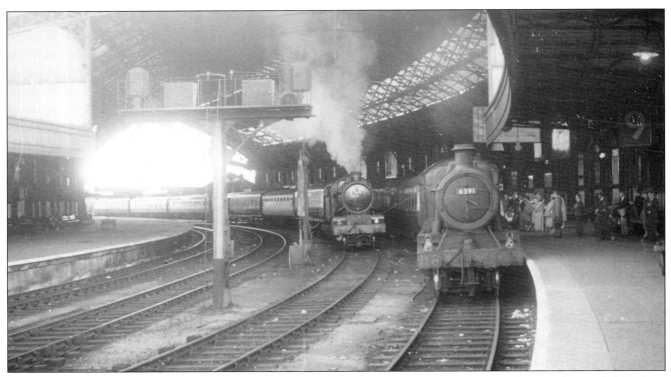

On 26 August 1956 St Phillips Marsh Mogul 6391 has brought an express into Temple Meads, probably from Weston-Super-Mare. The Mogul will be detached and the train will be taken over by Bath Road's 5094 'TRETOWER CASTLE' which is waiting on the centre road. H.C.Casserley

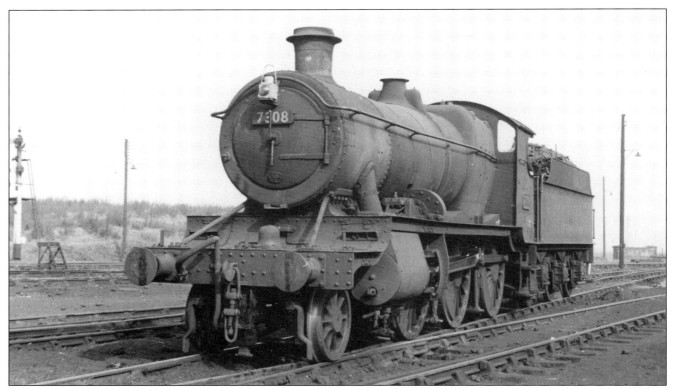

A Mogul from Severn Tunnel Junction shed, 7308 has been coaled up and is waiting to go 'off shed' in the yard at St Phillips Marsh on 14 October 1962.

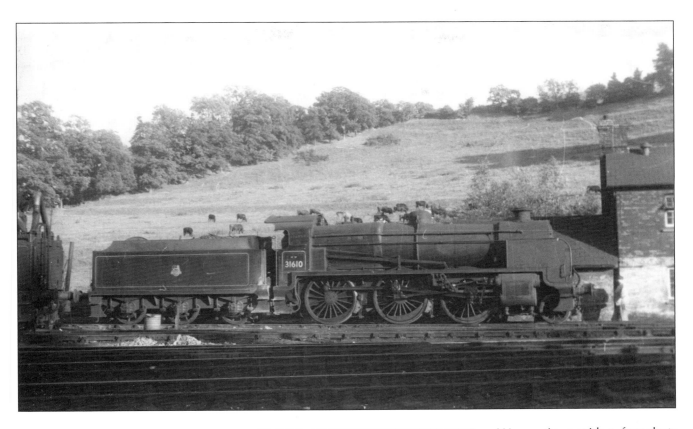

We continue with a few shots of SR U class Moguls and see 31610 at home in the yard alongside the office at Yeovil Town shed in the mid-1950s.

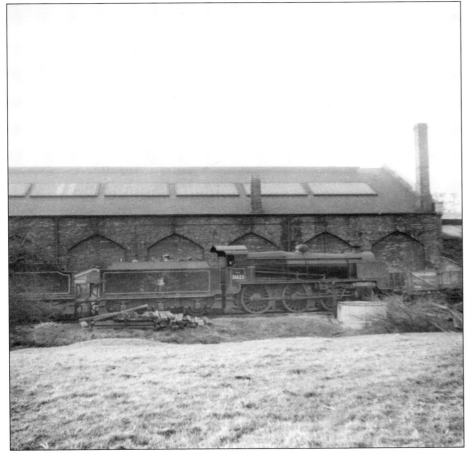

The line of engines alongside Yeovil Town shed on 4 April 1958 contained locally based U class 31623. Denis Richards

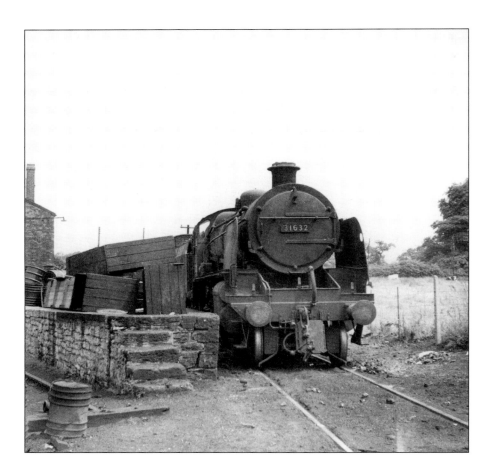

Another U class Mogul alongside Yeovil Town shed on 26 June 1964 was locally based 31632 which is devoid of a shed plate.

Maurice Dart

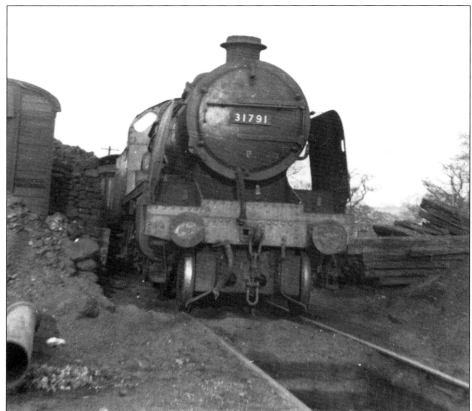

Photographed a few yards from the vantage point of the previous shot at Yeovil Town shed but on 4 April 1958 is local U class 31791.

Maurice Dart

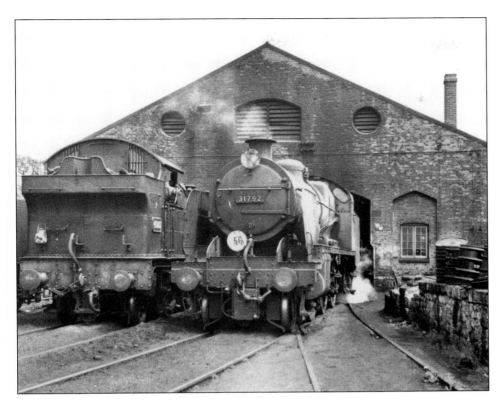

Two locally based engines feature in this photo looking towards Yeovil Town shed on 26 June 1964. On the left is 4575 class 2-6-2T 4593 alongside U class 31792.

Maurice Dart/Transport Treasury

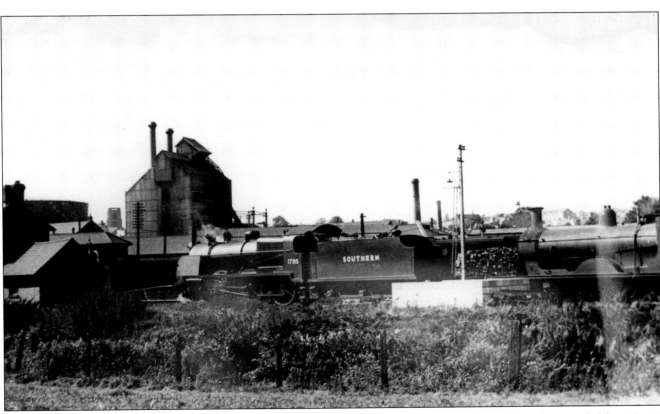

Engines were always stabled on the long line that ran between the shed building and the adjacent field at Yeovil Town. Locally based U class 1795 was recorded there in 1947. A 4-4-0, possibly a K10 class, is partly visible. The building on the left is the shed office.

This is a view taken inside Yeovil Town shed on 26 June 1964. The smokebox door of U class 31798 is open presenting a good view of the boiler tubes and blastpipe. Behind the U is 4575 class 2-6-2T 5563. On the right is BR Standard class 4 4-6-0 75001. All three engines were allocated to Yeovil Town. Maurice Dart

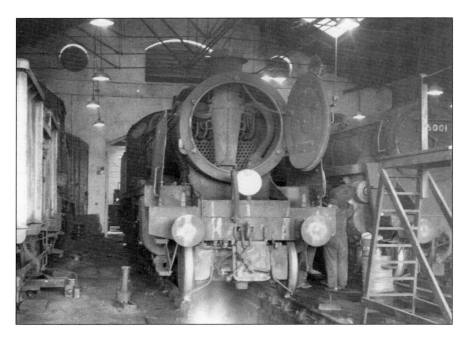

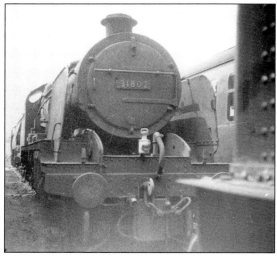

Locally based U class 31802 is in the yard at Yeovil Town shed on 26 June 1964. Maurice Dart

At the front of the line of engines alongside Yeovil Town shed on 26 June 1964 was BR Standard class 4 2-6-0 76007 from Salisbury shed. The locomotives behind the 2-6-0, in order, are U class 31632, 4575 class 2-6-2T 4591 both locally based and Rebuilt Merchant Navy 4-6-2 35004 'CUNARD WHITE STAR' from Salisbury shed. Maurice Dart

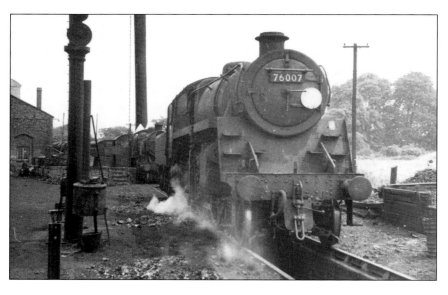

9

0-6-2 TANKS

Some examples of the GW 5600 class worked around Bristol but few locomotives of this wheel arrangement appeared on other company lines in the area.

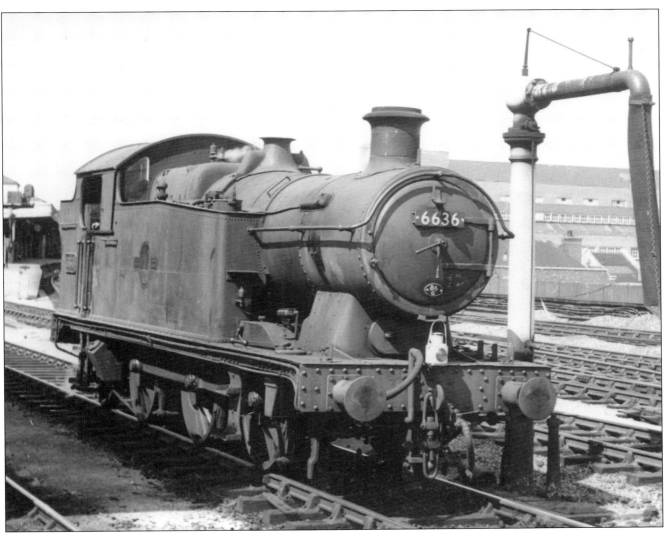

A visitor to Temple Meads, unfortunately on an unknown date but in the late 1950s, was 5600 class 6636 which was shedded at Pontypool Road for many years.

10

0-6-0 TENDER ENGINES

This section includes examples of GW and LMS locomotives of this wheel arrangement which were used on branch and local passenger and goods trains in the area.

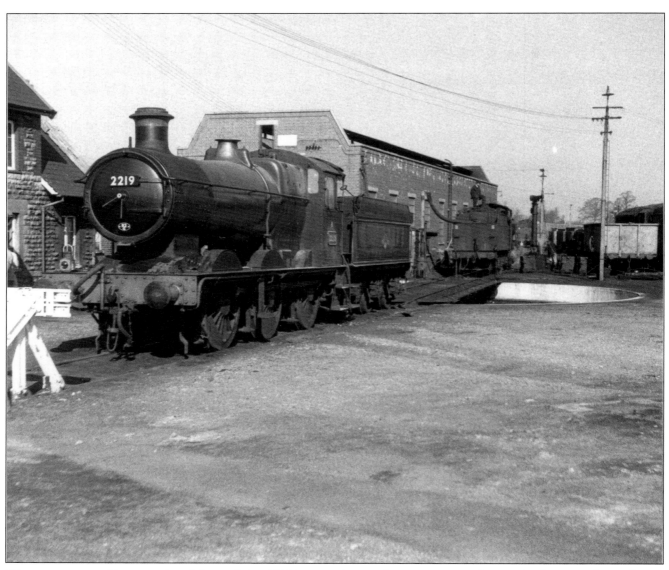

We commence with a couple of shots of the GWR 2251 class and see 2219 at its home shed at Templecombe on 18 March 1962. The engine which is just ex-works is working with a Collett tender. Despite the obvious bright sun, water that was dripping from this engine froze as it touched the ground! In the background a 4F 0-6-0 is having its tender's water supply replenished. The reflection centre right was off a sheet of ice. Maurice Dart

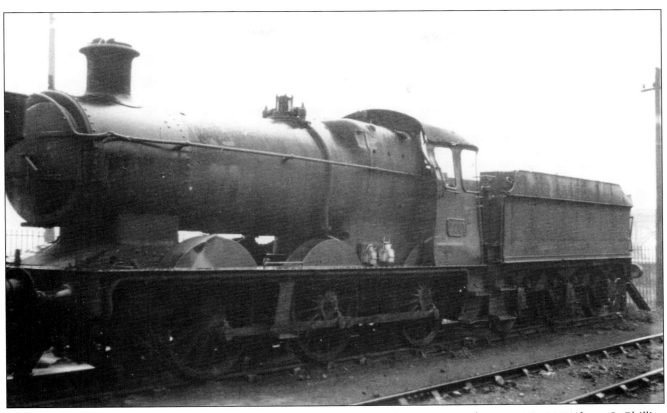

Stowed away in a siding on the remote side of Bath Road shed yard on 6 November 1949 is 2251 from St Phillips Marsh shed. The engine had suffered damage in a mishap (The GWR did not suffer accidents!) at Severn Beach as evidenced by its cabside and loss of safety valve bonnet. It was probably waiting to be admitted to Bath Road 'Factory' for repairs to be carried out. B.W.L.Brooksbank/Initial Photographics

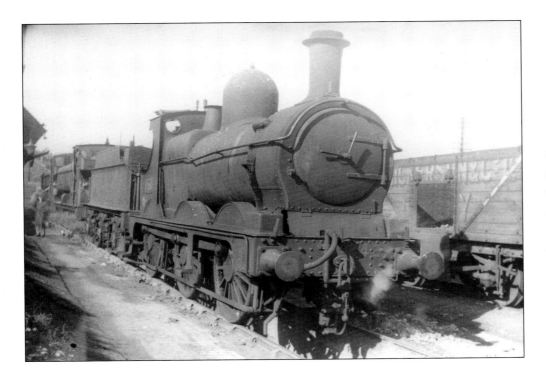

On the coaling line at St Phillips Marsh (Spam to enthusiasts) shed on 8 September 1948 is 2426 which was one of the aged Dean Goods 2301 0-6-0s which was shedded there. Built in February 1892 this loco worked until December 1953

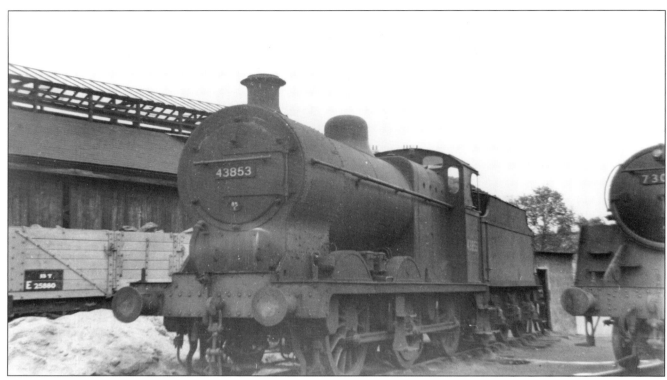

Now we turn to a few photos of LMS 4F 0-6-0s and 43853 from Gloucester Barnwood shed is in Bath shed yard on 25 May 1958. To the right is locally based BR Standard class 5 4-6-0 73051. On the left is LNER 6-plank wagon E25880. Maurice Dart

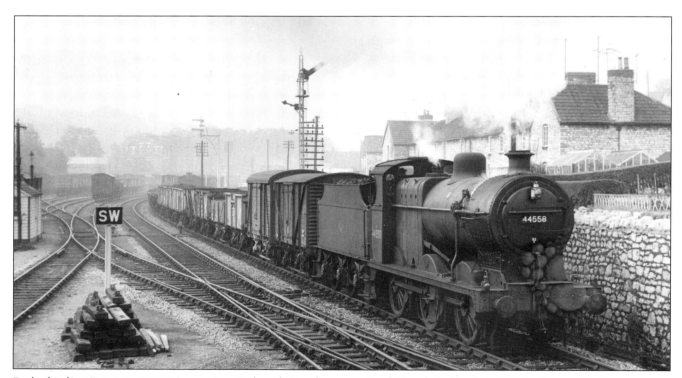

Bath shed's 4F 0-6-0 44558 is passing Radstock North on a mixed Goods in the late 1950s. Some BR Ore vans are at front of the train. Something very strange has been reflected by the camera's lens and appears on the lower right front of the engine. SW on the sign is an instruction to the locomotive crew to 'sound whistle'.

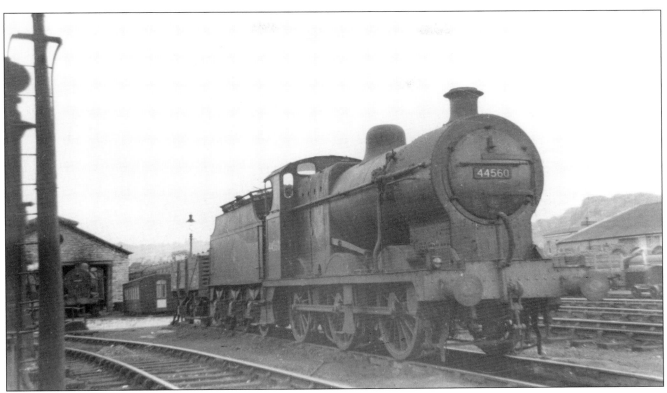

Bath's 4F 0-6-0 44560 is in the yard at its home shed on 25 May 1958. In the distance a Midland Railway 2P 4-4-0 is partly outside the shed. Maurice Dart

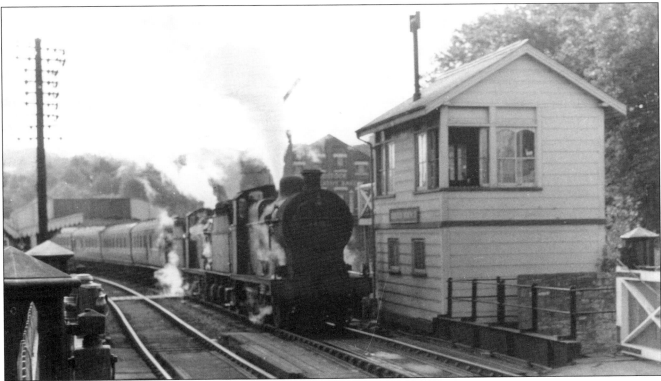

A northbound passenger service passes through Radstock North on 15 August 1959 double headed by a pair of 4F 0-6-0s which are 44561 and 44558 both from Bath shed. N.D.Mundy

11

0-6-0 TANKS

The GWR operated many variants of this type throughout their system. They were synonymous with that railway and carried out duties that ranged from yard shunting to working local passenger trains. On the SR this type was rare in the area covered but the LMS utilised them at Bristol and on the Somerset & Dorset system.

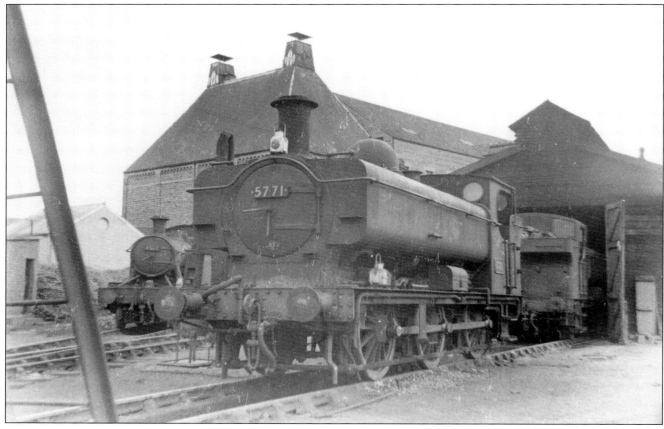

We commence this large section with views of the 5700 class locos and look at Frome shed on 25 May 1958. Nearest to the camera is 5700 class 5771 with 8750 class 3614 partly inside the shed. To the left is 4500 class 2-6-2T 4567. All of the locos were shedded at Westbury. The crest is farthur back than normal on the long welded tank side. Maurice Dart

Alongside piles of clinker is Taunton's steam-engulfed 5780 at home in the shed yard on 22 March 1959. The west end of the station platform can be seen to the right of centre. A high-ended wagon made of steel can be seen.

Maurice Dart

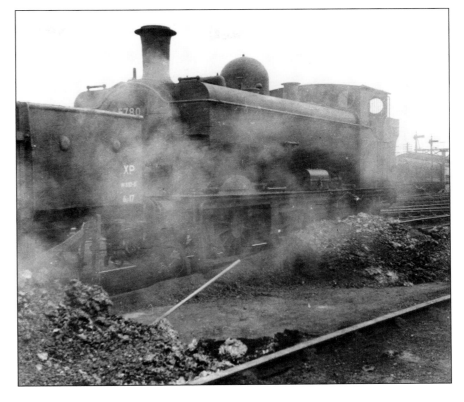

Nearest to the camera in this shot at Taunton shed on 29 September 1963 is 5798 which was withdrawn from service on 8 September 1962. Working back along the line the locos are 7400 class 0-6-0PT 7436, 8750 class 0-6-0PT 3669 which was withdrawn on 6 October 1962 but was later re-instated, 4300 class 2-6-0 7305 which was withdrawn 8 September 1962 and 2800 class 2-8-0 2871 which was withdrawn on 1 June 1963. All were allocated to Taunton shed. 3669 re-entered service on 30 November 1963 working from Exeter shed.

Maurice Dart/Transport Treasury.

The loco at the end of the coaling line at Weymouth shed on 26 July 1959 was the shed's own 5700 class 7780. On the right Is an ex LNER van fitted with extra external bracing. Maurice Dart/Transport Treasury

Our friend 7780 suffered a derailment at the entrance to the shed yard on 5 June 1963 and is seen just after it occurred. In the background is a Standard class 5 loco.

Here is 7780 in Weymouth shed yard on 9 June 1963 showing the damage caused by the collision with the Standard class 5 loco. The loco was withdrawn from service on 27 July 1963 following this collision. Official lists show this loco as transferred to Ebbw Junction shed, Newport on 19 June 1960 but obviously this move never took place.

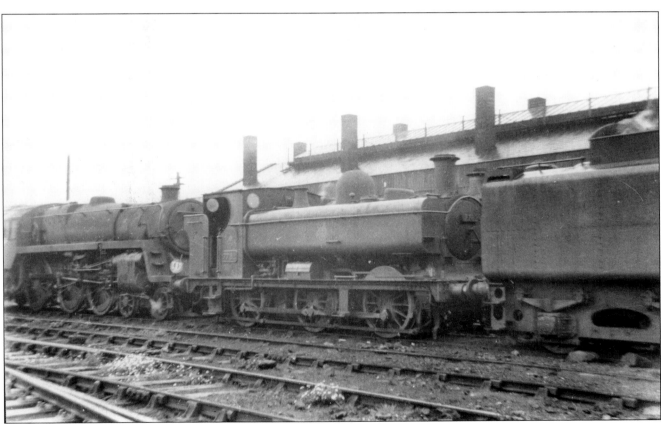

A line of engines at Weymouth shed on 26 July 1959 contained locally based locos 5700 class 7782 and Standard class 5 4-6-0 73022. Maurice Dart/Transport Treasury

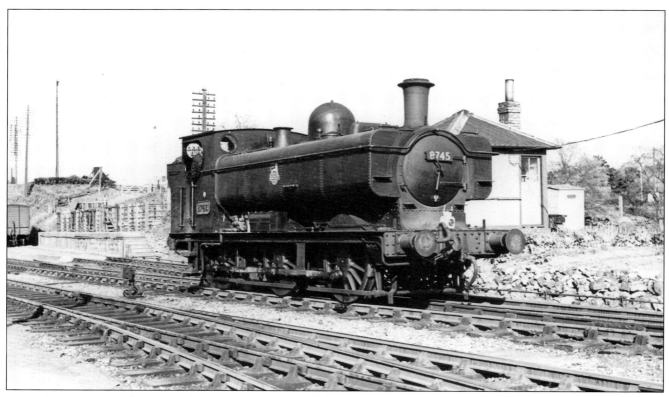

5700 class 8745 had been shedded at Yeovil Pen Mill for many years and when the shed closed in January 1959 it was transferred to Yeovil Town. However on 7 September 1960 it was shunting in the small yard adjacent to the site of Pen Mill shed. B.K.B.Green/Initial Photographics.

As the line from Yeovil Pen Mill to Weymouth passed under the SR main line from Yeovil Junction to Templecombe a spur line diverged right and climbed up to terminate at Clifton Maybank Goods station which was adjacent to the SR's Yeovil Junction station. In 1933 this rare but photographically imperfect photo shows a 5700 class loco at Clifton Maybank Goods station. The loco may possibly be 5718 which was shedded at Westbury in 1934. This is the only photo that the author has seen which was taken at this location. The photographer was on one of the platforms at Yeovil Junction. This site is now occupied by Yeovil Steam Centre.

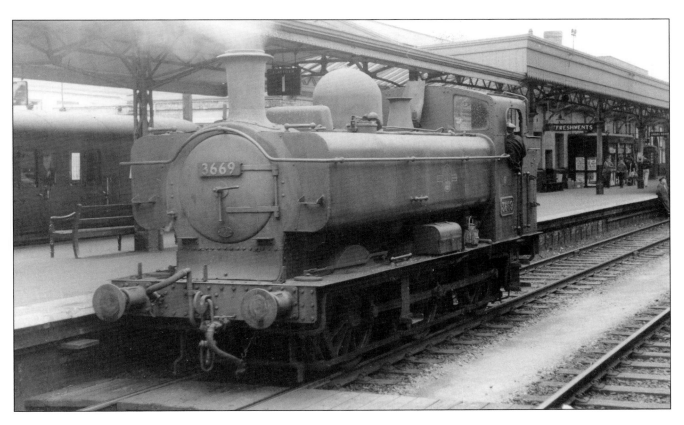

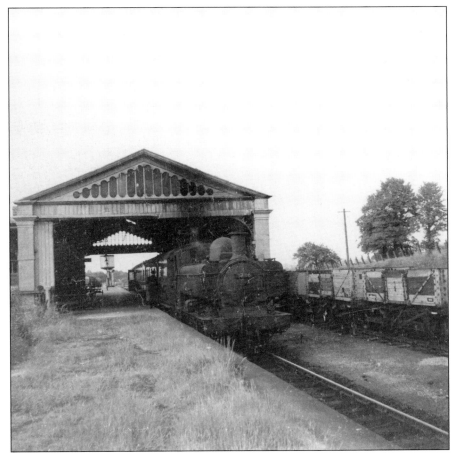

We now progress to the 8750 class which was a modernised version of the 5700 class. Shunting at Taunton in September 1964 is locally based 3669 which after re-instatement working from Exeter had obviously returned to Taunton shed.

After the regional boundaries changed ex GW locos worked the service from Chard Central to Chard Junction. Here Taunton shed's 3736 waits to depart from Chard Central with a train to Chard Junction on 11 June 1962. On the right are ex- LNER and ex-LMS 6 or 5 plank wagons.

Maurice Dart

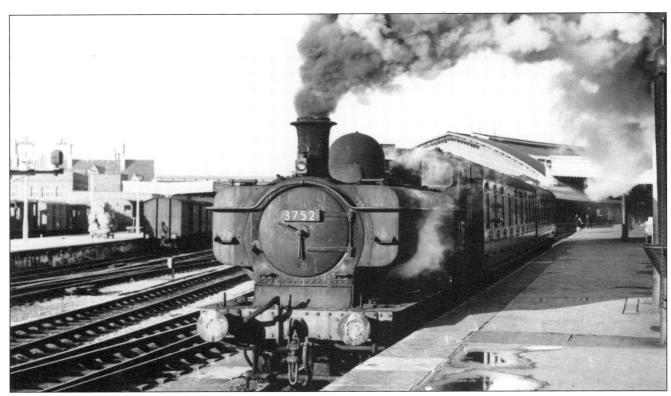

8750 class 3752 which was shedded at Barrow Road departs from the west end of Temple Meads on a local passenger train in the early 1960s. On the left are some Eastern Region Fish vans.

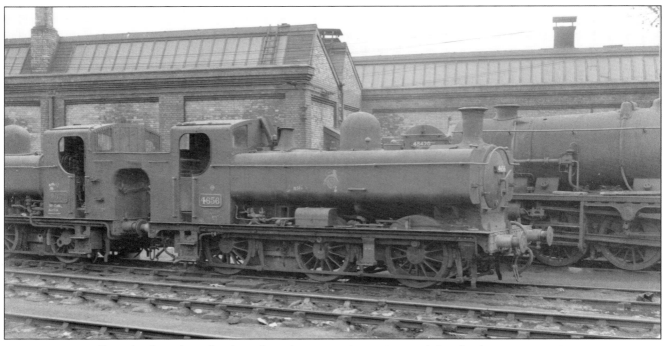

Locos were usually to be found on the three lines between the station and the shed at Taunton. On 6 August 1960 they included locally based 8750 class 9671 and 4656 together with St Phillips Marsh shed's Swindon built LMS 8F 2-8-0 48420. Both of the Panniers had previously been shedded at Laira at the same time so were very familiar to the author. Ken Davies

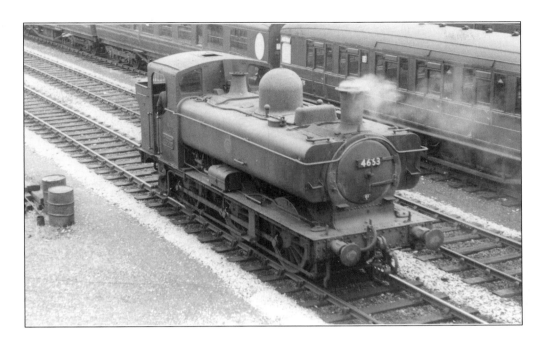

At Taunton performing a shunting movement in July 1962 is locally based 8750 class 4663. The train is composed of Eastern Region Gresley & Thompson carriages.

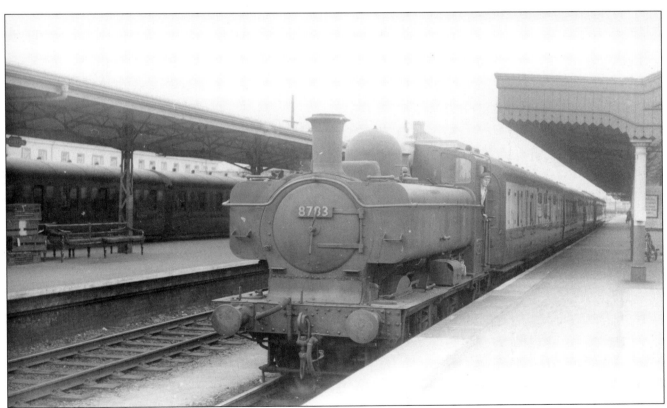

In 1962 ex St Blazey loco 8783 which was re-allocated to Taunton has arrived there on a train possibly from Minehead. The first vehicle is a Hawksworth Brake.

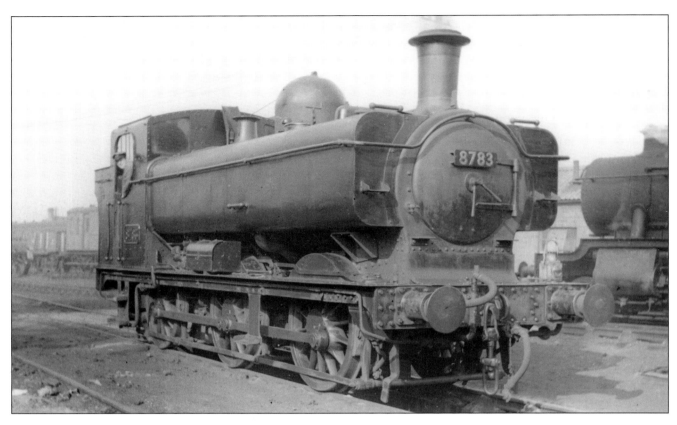

Here is another shot of 8783 this time in the yard at Taunton shed on 18 October 1962. The engine has not received a shed plate and GWR can still be read on the tank side.

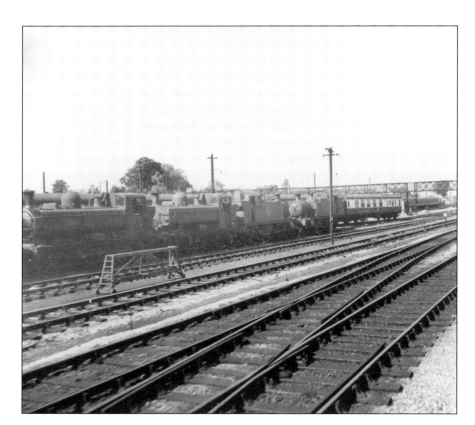

Four locomotives in the yard at Taunton shed were photographed from a passing train on 11 August 1962. From left to right they are 8750 class 8783 and 3746 which was an Exeter engine. Next in line are 4575 class 2-6-2Ts 5544 from Laira and local 5554.

Maurice Dart

A photo taken from a train passing Doctor Day's sidings east of Temple Meads on 30 March 1959 has 8750 class 9623 unusually from Newton Abbot shed as yard pilot. Creeping into the photo on the left is 2800 class 2-8-0 2847 from Severn Tunnel Junction. Doctor Day's Bridge Junction Signal Box is to the right. Apparently the location was named after a medical doctor who lived in a large house overlooking the site near the bridge. Maurice Dart

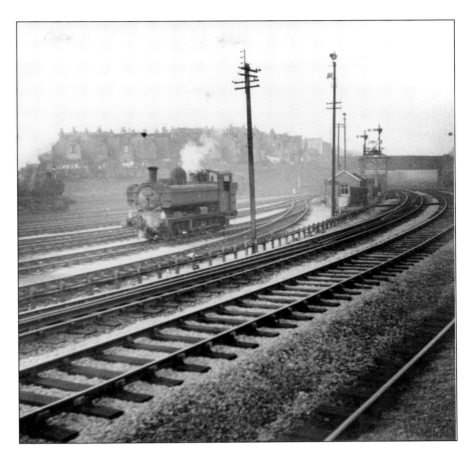

Taunton shed's 9647 heads a Goods through Ilminster towards Chard on 14 April 1962.

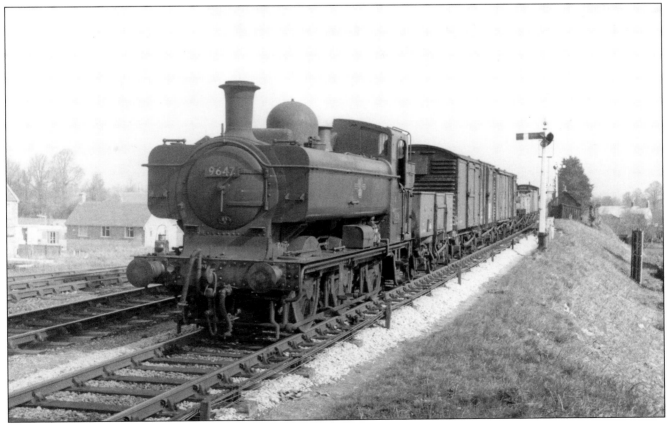

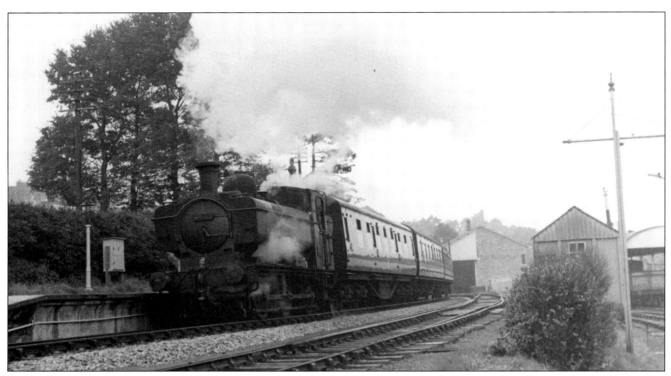

On 17 October 1960 9671 from Taunton shed has stopped at Watchet with a train from Minehead to Taunton. The Goods shed is to the right of centre. R.F.Dipwood

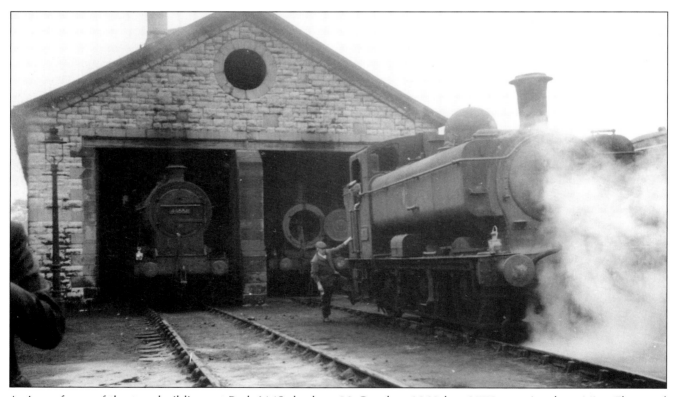

A view of one of the two buildings at Bath LMS shed on 29 October 1963 has 9770, previously at Nine Elms and before that at Laira for many years nearest to the camera. One of the locos inside the shed is 4F 0-6-0 44558. Both were shedded at Bath when photographed. R.K. Blencowe collection

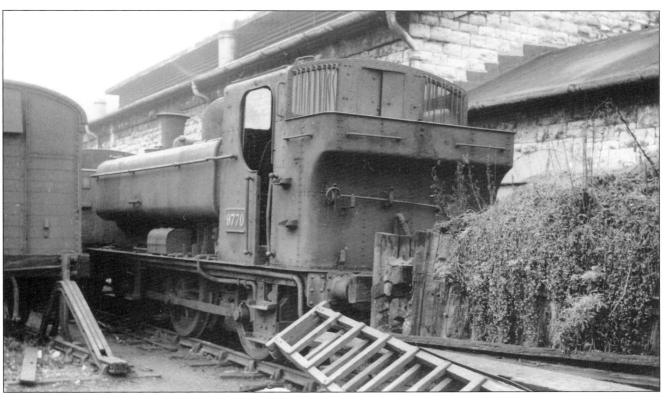

Here is Bath's 9770 again at the back of a line of engines alongside the shed building in 1963.

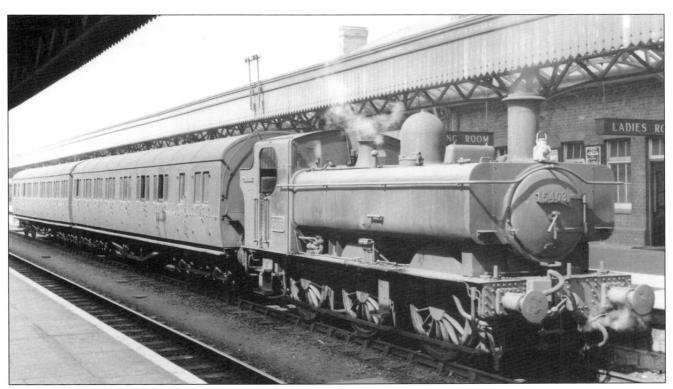

Next we see a few shots of GW 5400 and 6400 class Auto train engines which were slighter less powerful versions of the 8750 class. In the early 1950s 5403 from Westbury shed has arrived at Taunton on a two coach GWR 'B' set the front carriage of which is 6553W. The train is from either Frome or Yeovil Pen Mill.

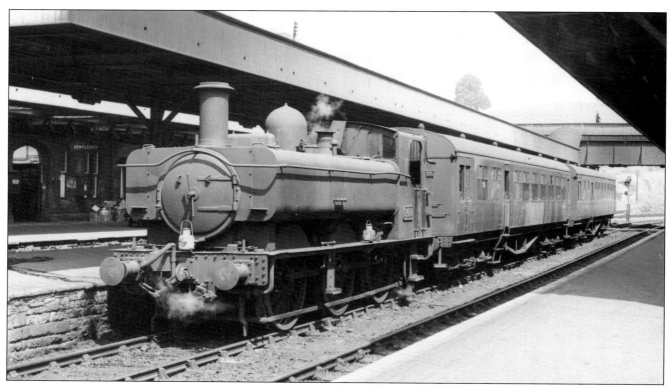

Ex-GW Pannier tanks took over the working of the services between Yeovil Pen Mill, Yeovil Town and Yeovil Junction. In 1963 locally based 5410 has arrived at Yeovil Town on an Auto working formed of BR Auto trailers from Yeovil Junction. The engine is devoid of front numberplate and shed plate. P.H.Groom

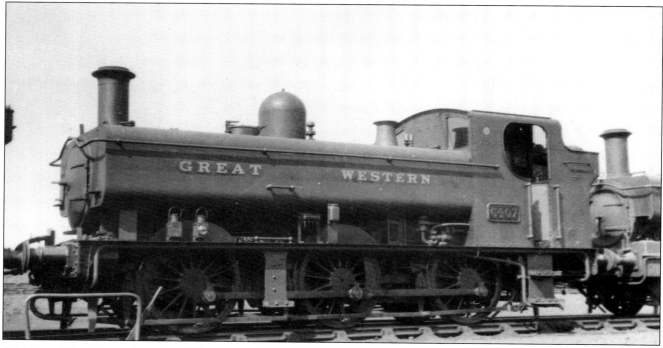

A String of Pannier tanks at St Phillips Marsh shed on 22 April 1934 contained 6407. As this engine was shedded at Laira and is very clean it is most likely returning from a visit to Swindon Works.

Locomotive & General Railway Photographs

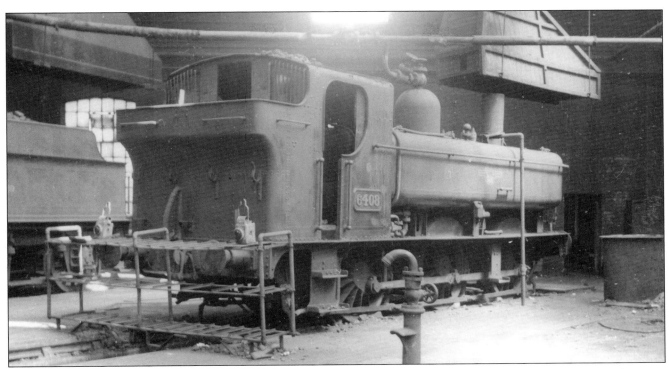

After 6408 was withdrawn from service at Tondu in February 1962 it was put to work as a Stationary Boiler at St Phillips Marsh shed, where it is inside one of the two roundhouses later that year. Notice the long stovepipe chimney which has been fitted to the engine.

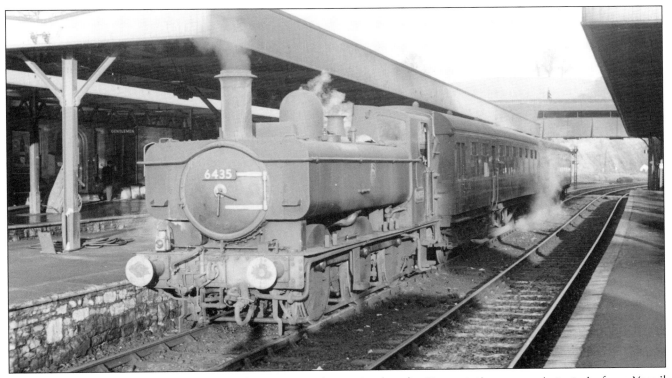

Recently transferred from Tondu to Yeovil Town 6435 has arrived at the Town station on an Auto train from Yeovil Junction on 28 December 1963. A replacement shed plate had not been fitted. The engine is in 'Green lined out' livery and is hauling BR Auto trailers.

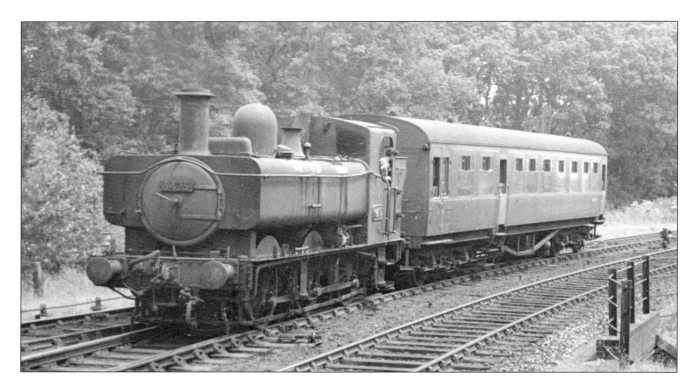

On 26 June 1964 6435 takes the Auto train out of Yeovil Town to run to Yeovil Junction. The engine which is still devoid of a shed plate is propelling a BR auto trailer.

Larry Crosier

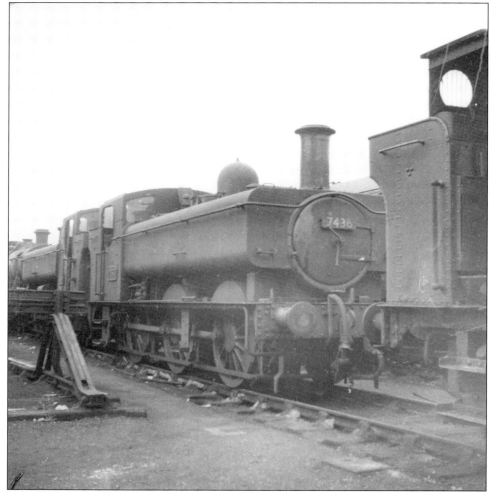

A line of locally based engines in a siding along-side Taunton shed on 29 September 1963 had non-Auto 7400 class 7436 nearest to the camera. Behind it are 8750 class 3669 and 4300 class 2-6-0 7305. The cab of 5700 class 5798 is to the right.

Maurice Dart

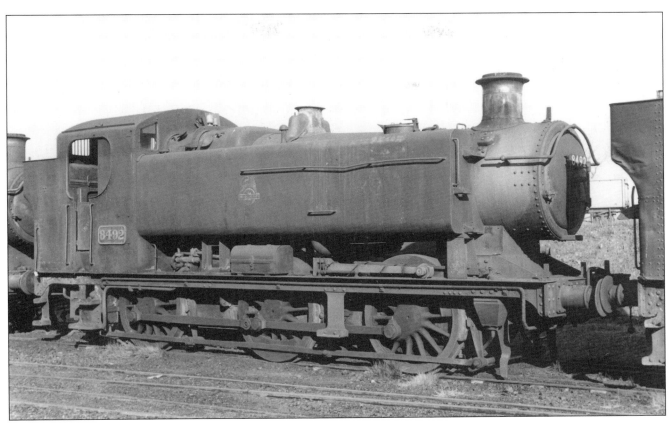

We now start to work our way through numerous other classes of GW 0-6-0 tanks. Awaiting coaling at St Phillips Marsh shed in the 1950s is resident 9400 class 8492. These were a heavier modernised version of the 8750 class. Stanley J.Rhodes

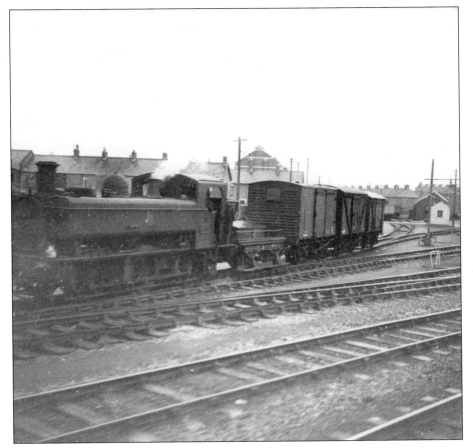

The 1600 class emerged from Swindon Works as replacements for older lighter Panniers. On 28 October 1957 Taunton shed's 1668 coupled to a GWR Shunter's truck was recorded from a passing train at Bridgwater East yard.

Maurice Dart

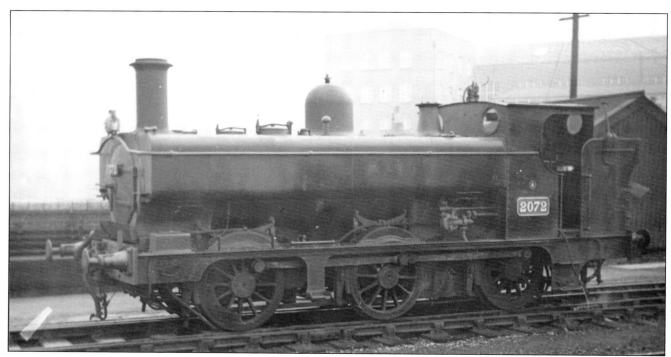

A very familiar sight from Temple Meads from the mid-1940s was Bath Road shed's 2021 class 2072 usually looking quite smart, acting as shed pilot. It is performing this duty in the early 1950s. Locomotive & General Railway Photographs

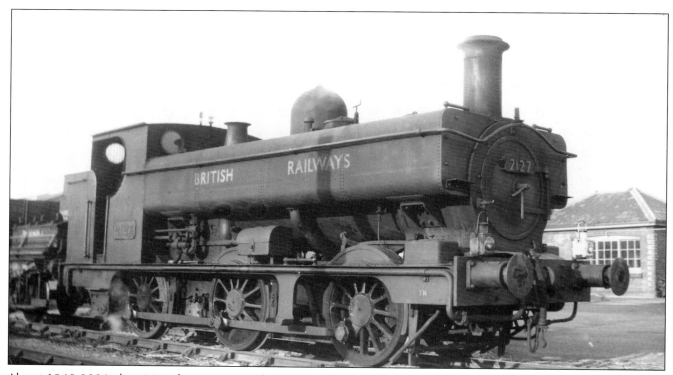

About 1949 2021 class 2127 from Taunton shed is shunting in Bridgwater East yard. The engine carries a smokebox numberplate but as shed plates had not been introduced it carries a TN shed stencil. It has BR sans-serif lettering on the tank but it had been overhauled at Derby Works. This engine which is coupled to a GWR Shunter's truck was a familiar sight shunting in the yards around Taunton. R.K.Blencowe collection

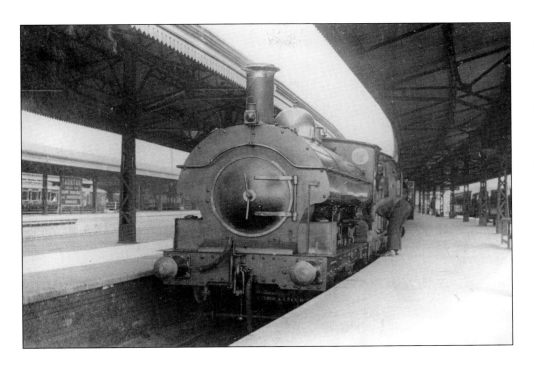

This photo was taken before December 1914 when Outside-Framed 1076 'Buffalo' class Saddle tank 1587 was fitted with Pannier tanks. It would have been shedded at Taunton where it was recorded being attached to a train which probably was bound for Minehead. This engine was withdrawn from St Blazey shed in January 1934.

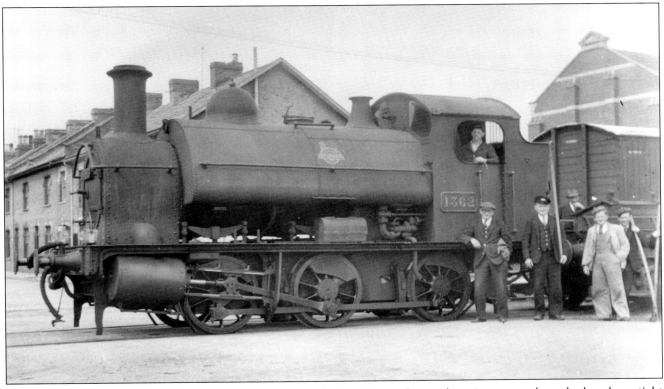

The GWR built two classes of short wheelbase six coupled tank locos for working in area such as docks where tight curves were to be found. The earlier 1361 class were built as Saddle tanks and were descendants of the Cornwall Minerals Railway locos. Several members of the class have operated from Taunton shed but the longest standing of those was 1362 which was recorded shunting on the Bridgwater Docks branch line on 26 May 1954 coupled to a GWR shunter's truck. All of the yard and shunting staff wished to be included in the photo. R.J.Buckley

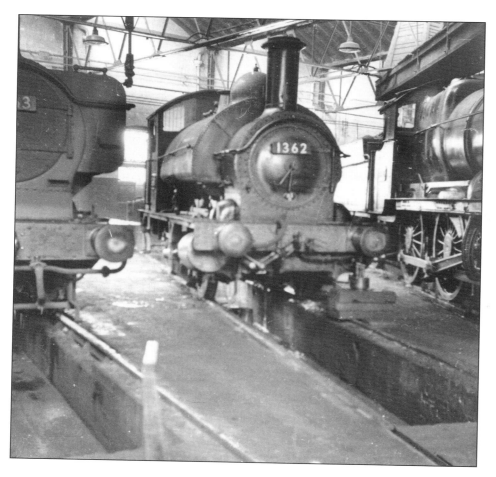

The centrepiece of this shot that was taken inside Taunton shed's roundhouse on 22 March 1959 is a very clean 1362. It is framed by two other Taunton engines. On the left is 8750 class Pannier tank 9663 with 4300 class Mogul 6323 on the right. Maurice Dart

North-east of Bridgwater another short branch line served the wharf at Dunball where 1362 is shunting on 8 May 1959. Some of the buildings on Dunball station can be seen..

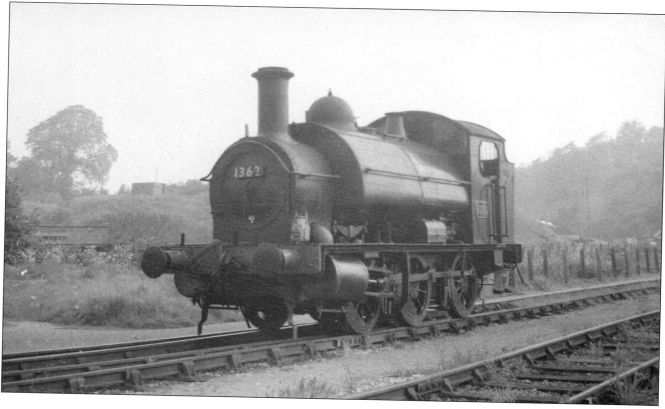

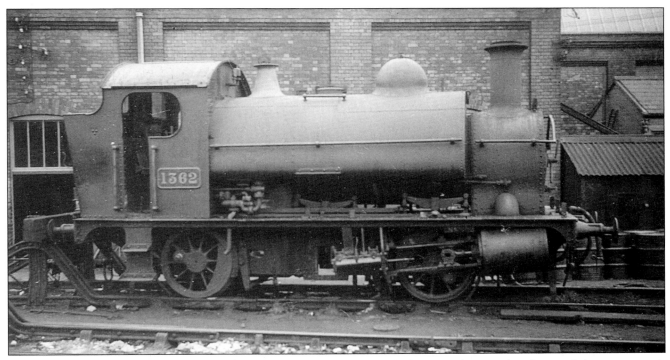

I make no excuse for using another photo of 1362 as there were only five members in the class and they were such lovely engines to see. So here is our friend outside the shed at Taunton in the 1950s with its centre pair of Driving wheels removed for attention. Kenneth Brown

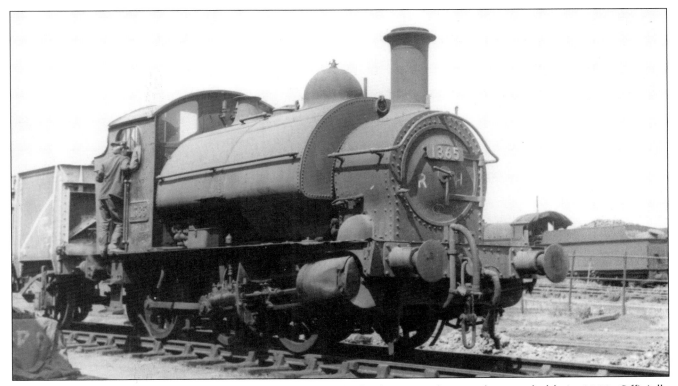

Here is a shot of 1365 on shed pilot duty at St Phillip Marsh shed on an unknown date, probably in 1962. Officially this engine only moved from Laira to Swindon shed but in this photo it has a 'painted on' 82B shed plate which was the BR code for SPM shed. So there we have yet another mystery

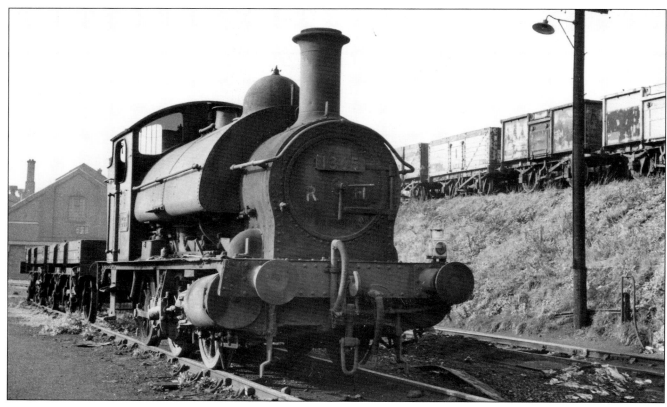

Here is confirmation that 1365 was at St Phillips Marsh shed as it was recorded in the yard there on 4 November 1962. It had not gained the 'painted on' shed plate. On the bank is Mineral wagon M619494 whilst two GWR two-plank wagons are behind the engine. B.K.B.Green/Initial Photographics.

This shot would appear to be unusual as it has two locos together at Dunball Wharf on 29 August 1958. Part of a 4575 class 2-6-2T is visible with Taunton's 1366 class Pannier tank 1366 as the main subject. Dunball station is centre right.

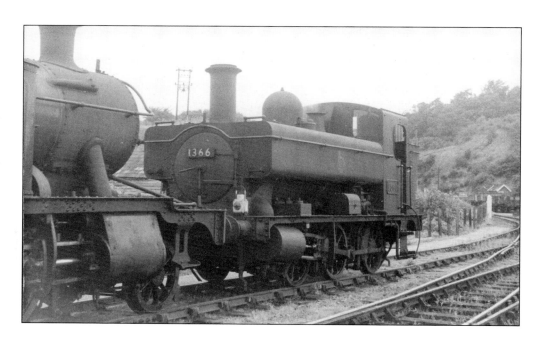

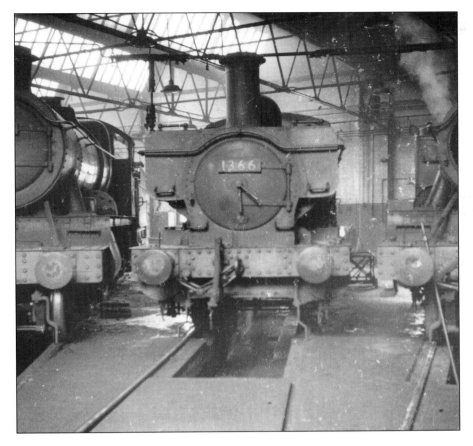

This scene in Taunton shed's roundhouse on 22 March 1959 contains three engines. 4300 class Mogul 6397 from St Blazey shed is on the left alongside two local engines. Centre is 1366 with 5101 class 2-6-2T 4159 on the right. Maurice Dart

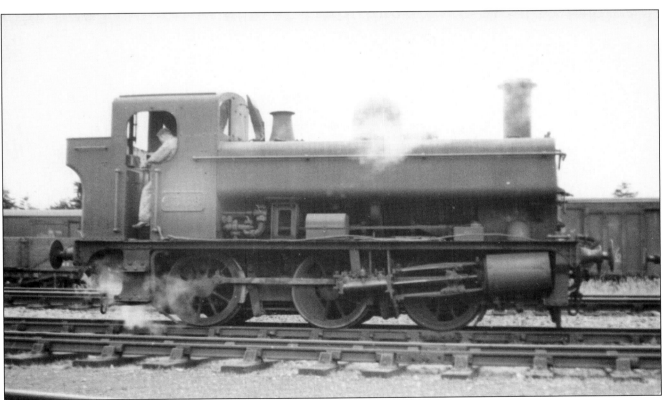

Weymouth shed's 1368 stands in the yard between shunting duties on 17 June 1950.

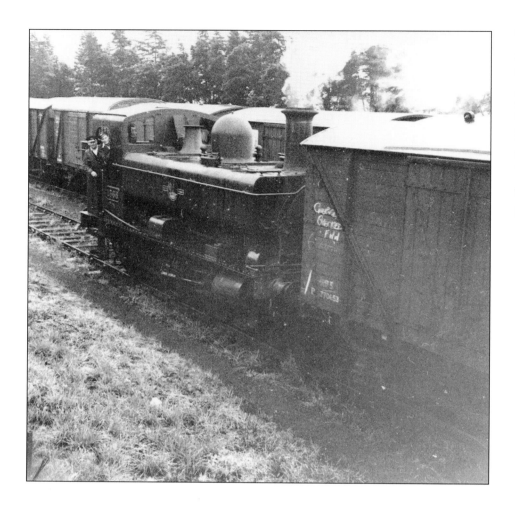

The same loco 1368 was recorded shunting in Weymouth yard from a passing train on 26 July 1959. It is coupled to BR 12T van B 770653. This engine had spent a couple of years at Taunton between the dates of these two photos.

Maurice Dart

During 1961 locally based 1369 was recorded waiting with a Boat train at Weymouth Quay. Despite being a Boat train the loco is carrying the headlamp code for a Stopping Passenger train. The leading carriage is a BR Auto trailer. This engine is still with us based at Buckfastleigh on the South Devon Railway

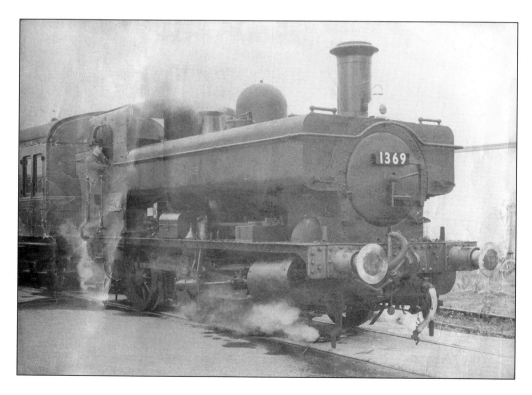

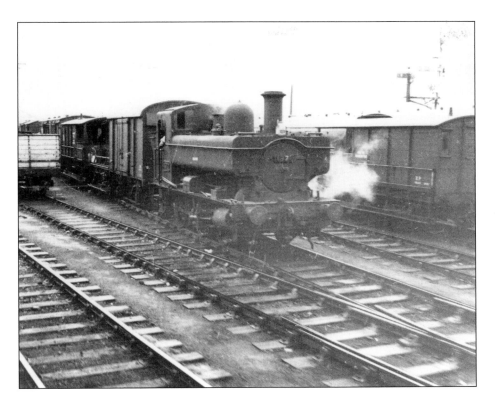

Another 1366 class was recorded from a passing train on 26 July 1959. 1370 was shunting a mixed rake of wagons in the well-filled yard.
Maurice Dart

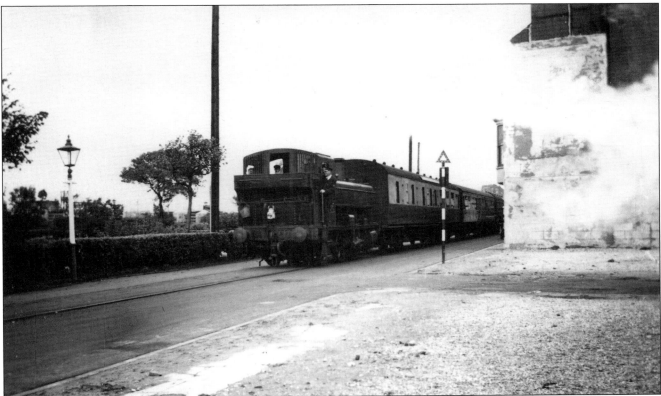

In October 1948 1371 is seen working a train from Weymouth to Weymouth Quay part way along the branch line which ran parallel to roads. This loco was allocated mainly to Swindon but obviously spent a short period at Weymouth shed. It was probably covering for one of Weymouth's engines that was receiving attention at a Works.
R.Cogger

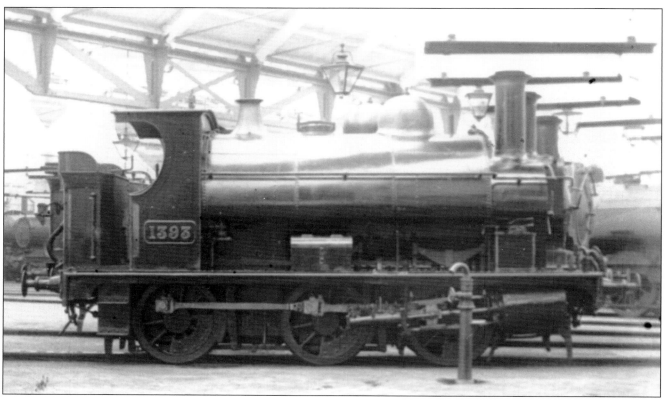

We now see photos of the predecessors of the 1361 and 1366 classes which were the GWR rebuilds of Cornwall Mineral Railways 0-6-0 side tanks. Ex Cornwall Minerals Railways no.2 which became GWR 1393 is inside one of the roundhouses at St Phillips Marsh shed in the 1930s. Apart from the cab the similarity with the 1361 class is apparent. Stephenson Locomotive Society

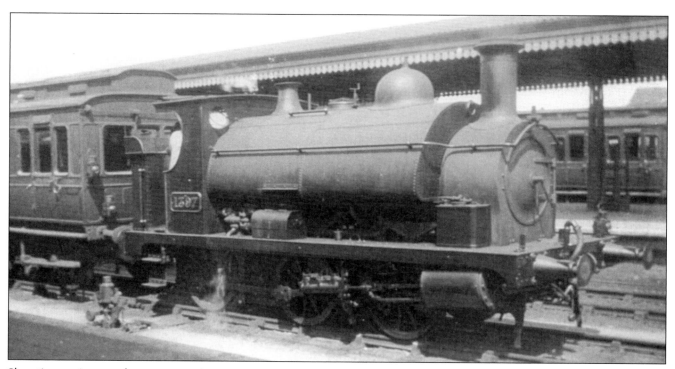

Shunting a vintage clerestory carriage at Taunton in 1922 is ex CMR no.6 which became GWR 1397.

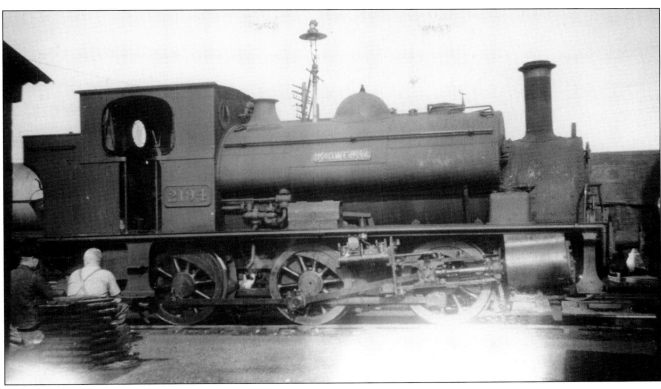

On 27 August 1947 ex Burry Port & Gwendreath Valley Railway 0-6-0ST 2194 'KIDWELLY' is stopped in the yard at Bridgwater between shunting duties. The author first saw this engine shunting in Fairwater yard, west of Taunton in 1946. Transport Treasury

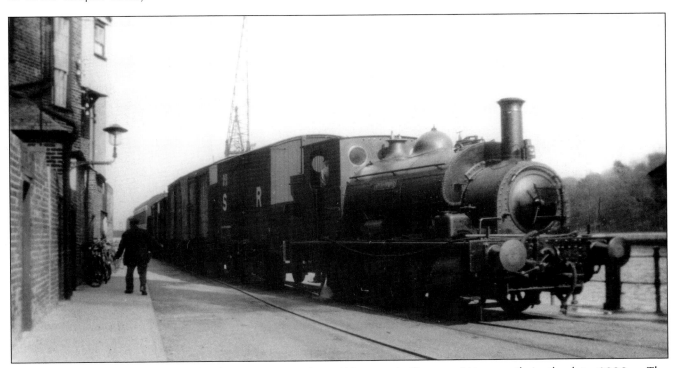

Ex BPGV 2195 'CWM MAWR' hauls a Boat train from Weymouth Quay to Weymouth in the late 1930s. The leading vehicle is a SR banana van. This engine was withdrawn from service in March 1939 but was reinstated in December of that year and worked until January 1953. It lost its name in the final years of its life.

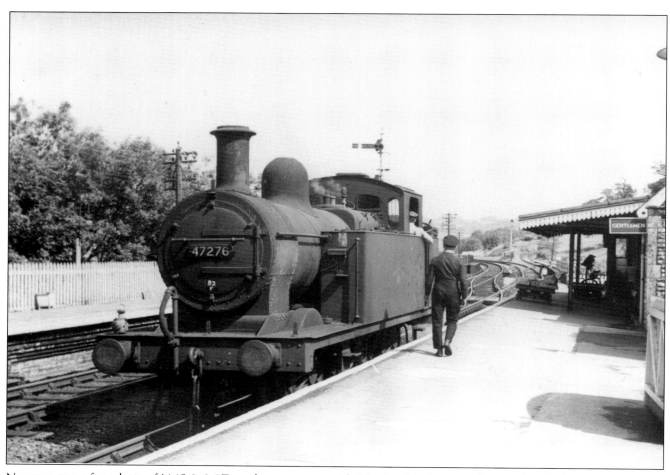

Now we see a few shots of LMS 0-6-0Ts and commence with 3F 'Jinty' 47276 standing in the platform at Midsomer Norton on 20 August 1965. The 82F shed code has been painted onto the smokebox door. The engine is fitted with a three link front coupling bolted through the coupling hook. The siding to Norton Hill Colliery which contains wagons is climbing away in the background.

There were three engines outside Radstock shed on 15 August 1959. Nearest to the camera are Jinties 47557 and 47316 and nearly hidden by them is Sentinel 4wVBTG 47191. All of these engines were allocated to Bath shed.
N.D.Mundy

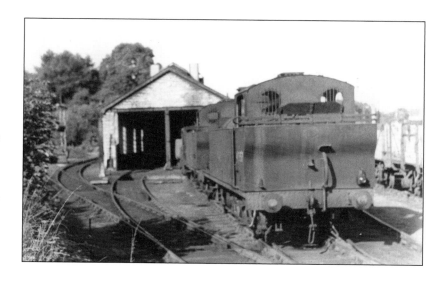

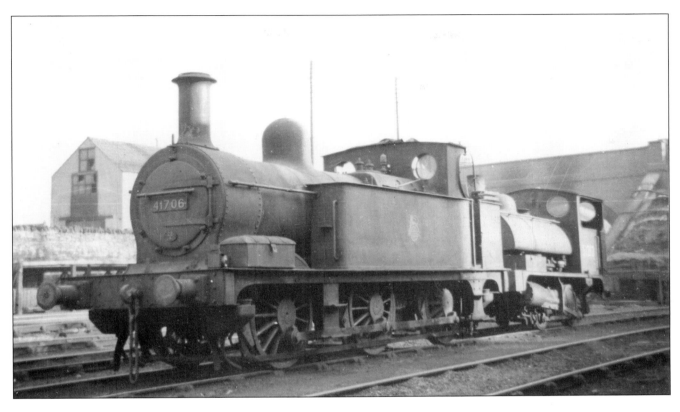

Two engines are in the yard at Barrow Road shed in the early 1950s. Nearest to the camera is MR 1F 0-6-0T 41706 with L & Y 0F 'Pug' 0-4-0ST 51212 to its rear. The author saw these locos at this shed in 1947.

On 30 March 1959 three engines were stored at the west end of Doctor Day's sidings and were recorded from a passing train. Centre is 1F 0-6-0T 41879 with 2P 4-4-0 40501 to the right, both of which were Bristol engines. The tender on the left was attached to 4P 4-4-0 40933 from Gloucester Barnwood shed. Maurice Dart

12

4-4-2 TANKS

Locomotives of this wheel arrangement only marginally crept into this book. Three survivors of the LSWR 0415 class worked the branch line from Axminster to Lyme Regis, of which only the last section lies within the area covered in this volume.

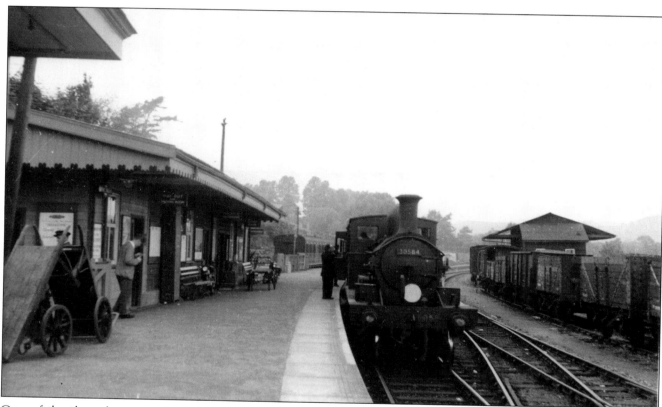

One of the three locos 30584, ex SR 3520, from Exmouth Junction shed has arrived at Lyme Regis in the early 1950s. The Goods yard contains numerous wagons but there appears to be a distinct shortage of passengers.

13
GWR 4-4-0s

Representatives of most of the classes worked over the company's lines in the area under review latterly on local stopping passenger trains.

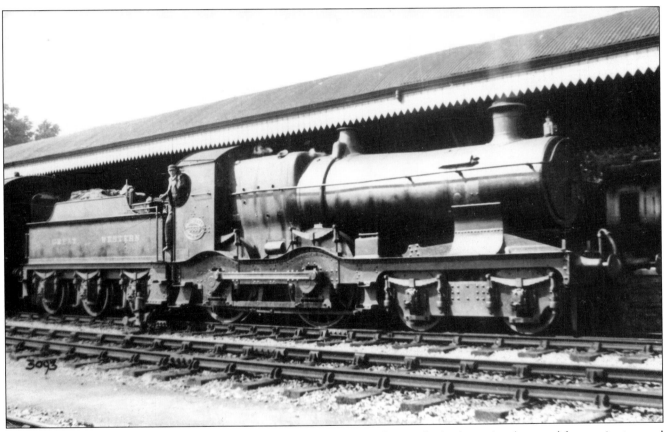

One of the earlier 'Bulldog' class 4-4-0s that were rebuilt from Dukes and which retained curved frames is stopped at Taunton on a Down stopping passenger train in 1929. Originally numbered 3347 the engine which became 3335 'TREGOTHNAN' retains its oval combined name and number plate and was probably working from Bath Road shed. The engine was de-named in December 1930 and received a normal numberplate. Withdrawn in July 1939 it was stored as a 'war reserve' and was re-instated in November of the same year. It worked from Exeter shed and was finally withdrawn from service in October 1948. Real Photographs

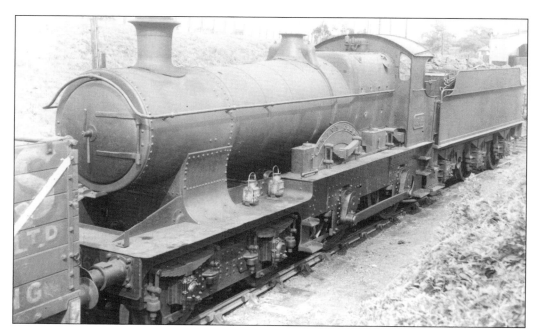

-'Bulldog' class 3364 'FRANK BIBBY' from Westbury shed is in a siding in the yard at Pen Mill shed, Yeovil on 17 August 1947. This engine was originally numbered 3416 and carried the name 'C.G.MOTT'.

R.J.Buckley

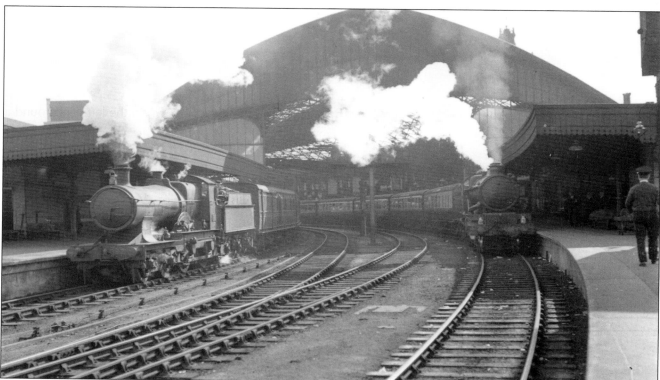

In this view at Temple Meads that was taken in 1938 or 1939 the passenger train on the left is headed by 'Bulldog' class 3378 'RIVER TAWE' which was a Bath Road engine. As the train is composed of SR stock it is most likely for Portsmouth. Originally numbered 3430 this engine was withdrawn in February 1939 and was put into store as a 'war reserve'. Re-instated in October of the same year the engine was sold to the War Office in December but the GWR retained ownership of the nameplates. Withdrawal from service occurred on 12 December 1945 but probably, as she was government property, cutting up did not commence until 15 June 1946 when government approval had been given. On an Up express on the right is 'Castle' class 4-6-0 5069 'ISAMBARD KINGDOM BRUNEL' from Old Oak Common shed. Lens Of Sutton collection/R.S.Carpenter Photos

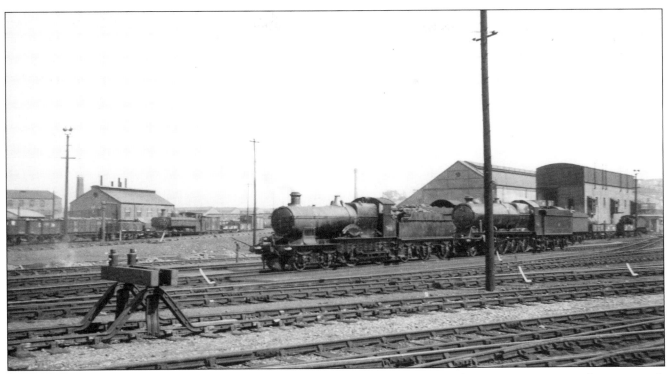

This view of Bath Road shed yard was taken from Temple Meads on 18 July 1935. Nearest to the camera is 'Bulldog' 3407 'MADRAS' from Cardiff Canton shed. This loco had originally been numbered 3469. Behind 3407 is 4700 class 2-8-0 4701 from Tyseley shed. A 'Large Prairie' tank is by the coal stage and a Pannier tank shunts behind the coal stage incline. The tall building behind the coal stage is the loco 'Factory'. In the left background a GW Bogie Coal wagon can be seen. Double buffers split the line in the foreground. R.S.Carpenter Photos

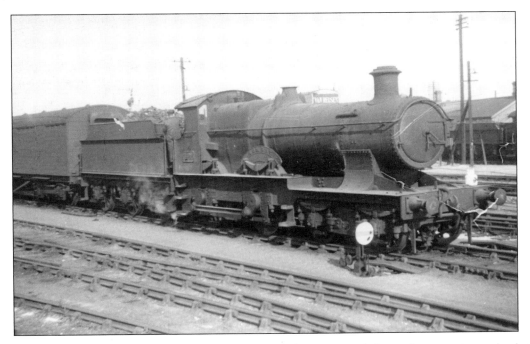

Heading a Down Parcels train into Taunton on 14 August 1947 is 'Bulldog' 3408 'BOMBAY' from Didcot shed. It originally carried the number 3470. The front vehicle is a LNER van. A 4300 class Mogul is in one of the Bay lines on the right and the top of the large water tower that was in the east yard can be seen above the Bulldog's boiler. This Didcot engine reached Exeter and Plymouth at this time and the author saw it on shed at Laira. There was a very good 'Bush Telegraph' system in Plymouth at that time so we always knew if a rare loco turned up.

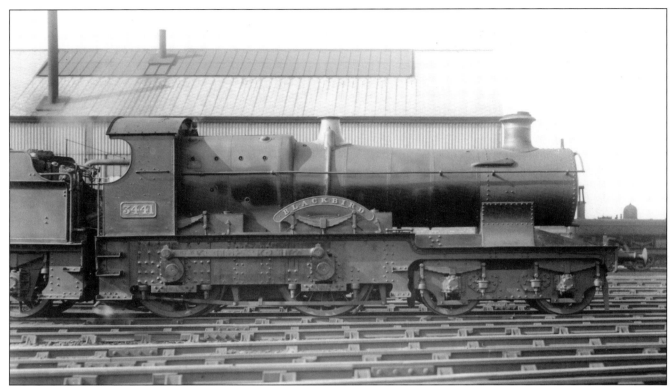

'Bulldog' 3441 'BLACKBIRD' is on one of the lines between the loco shed and the station at Taunton. This engine which was originally numbered 3731 had a spell shedded at Taunton in 1936 so that most likely dates the picture. It worked on the Barnstaple line and had a few spells sub-shedded there at Victoria Road. An elderly Pannier is in the background. R.K.Blencowe collection

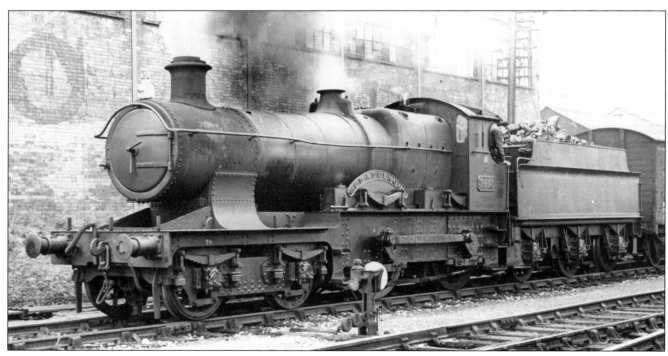

'Bulldog' 3443 'CHAFFINCH' from Taunton shed is stopped on a van train in Taunton yard on 8 June 1948. Originally numbered 3733 the loco has a TN shed stencil prominently on its frame. B.V.Franey

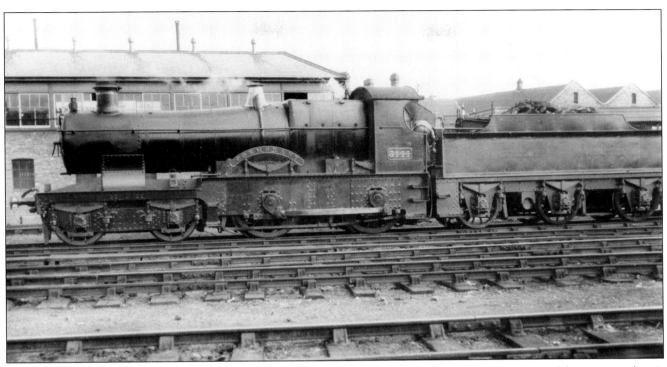

Another local 'Bulldog' 3444 'CORMORANT' is moving out of the station past the West signal box on a what is probably a Barnstaple branch train in the 1930s. This engine was originally numbered 3734. R.K.Blencowe collection

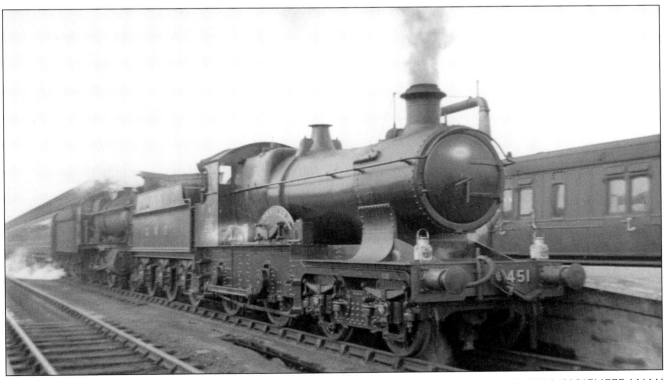

A Down express is stopped at Taunton on 12 October 1946. The 'Train engine' is 4-6-0 5921 'WYCLIFFE HALL' from Oxley shed, Wolverhampton. 'Pilot' engine is Exeter shed's 'Bulldog' 3451 'PELICAN' which was originally 3741. It has an EXE Shed stencil on its frame.

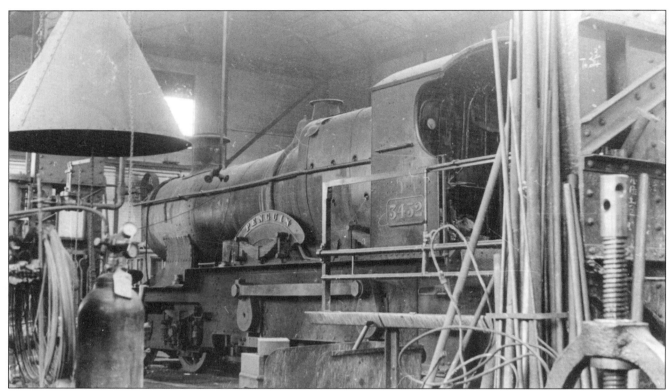

This is an unusual view of 'Bulldog' 3452 'PENGUIN' from Swindon shed receiving attention inside Bath Road's 'Factory' on 4 July 1947. Originally numbered 3742 this is another engine which reached Plymouth around this time which the author saw on shed at Laira. H.C.Casserley

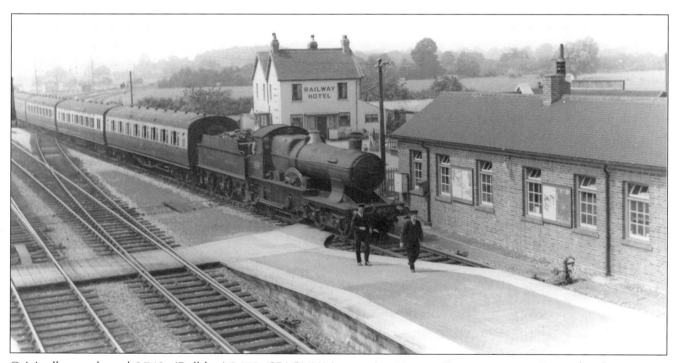

Originally numbered 3743, 'Bulldog' 3453 'SEAGULL' is entering Norton Fitzwarren on a Down local passenger train. This photo was probably taken between 1931 and 1934 when this engine was allocated to Taunton and had spells sub-shedded at Barnstaple. Lens Of Sutton

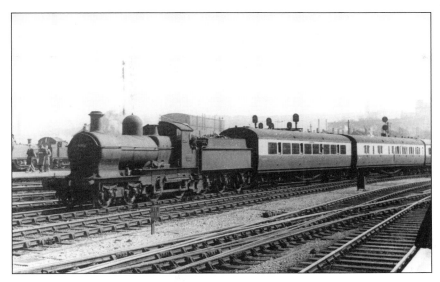

A surprise occurred early in 1953 when a few 'Dukedogs' were transferred from the Central Wales Division to Bath Road shed. Their stay lasted for around eighteen months. On 4 April 1953 one of them, 9016 which started life as 3216, brings a train from Weston-Super-Mare into Temple Meads past Bath Road shed. A pair of 4575 class 'Small Prairie' tanks are in the shed yard.

R.K.Blencowe collection

Here is 'County' class 4-4-0 3834 'COUNTY OF SOMERSET' which started life numbered 3477 backing out of Bath Road shed yard in the 1920s. This engine which was shedded at Bath Road at this time, has square drop ends and was withdrawn from Tyseley shed in November 1933.

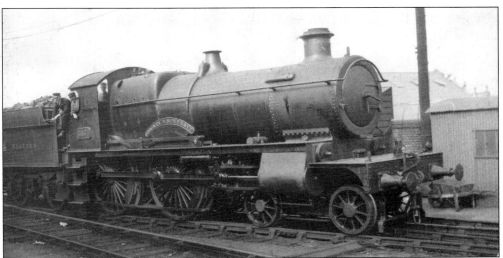

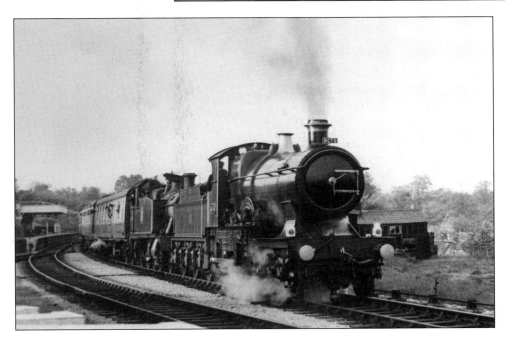

This photo which was taken on 28 April 1957 has famous 'City' class 3440 'CITY OF TRURO' piloting 4575 class 2-6-2T 5528 on a return special train. The train which was arranged by the Railway Correspondence & Travel Society has just departed from Pensford to run to Paddington via Frome. 3440 was based at Swindon and 5528 was a Bath Road engine.

R.J.Leonard

14

SOUTHERN 4-4-0s

Various representatives of these types worked on SR lines through the area covered in this book.

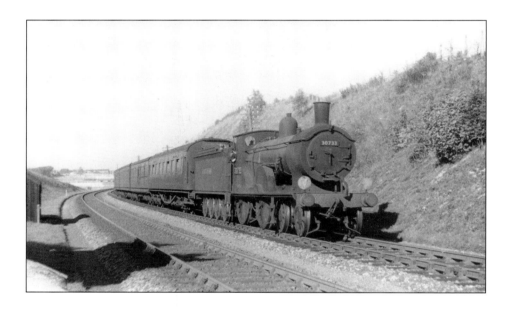

We start this short section with Drummond T9 class 'Greyhound' 30733 from Bournemouth shed hauling an Up local passenger train from Weymouth near Upwey in 1949. The engine has gained BR cabside and smokebox numbers but the tender still carries 'SOUTHERN'.

R.K.Blencowe collection

Large boilered L12 30424 from Dorchester shed pilots a Bournemouth U class 2-6-0 on the climb to Bincombe tunnel from Weymouth on 7 August 1950. The 11.30am relief Weymouth to Waterloo express is passing the delightfully named Upwey Wishing Well Halt. The L12's tender is still inscribed 'SOUTHERN'.

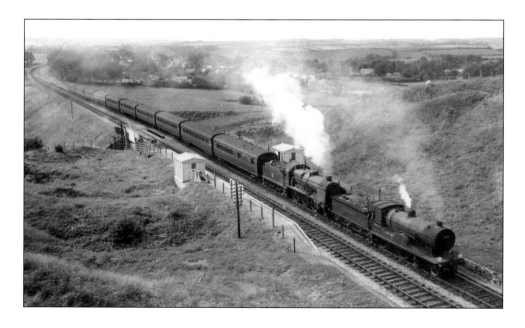

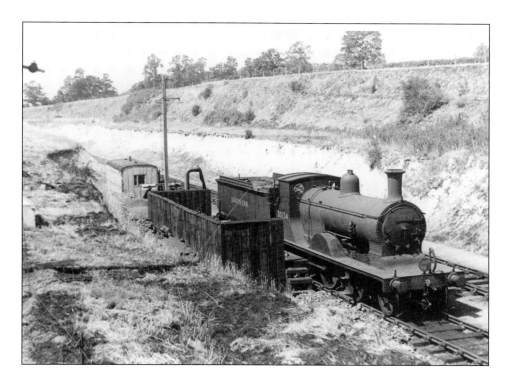

Yeovil Town shed's L11 30134 is sitting by the site of Templecombe LSWR shed on 8 July 1949. The site consisted of a siding beside the coaling platform and watering point with an old carriage body used to accommodate staff. The outer line formed a long headshunt. Both lines were in a shallow cutting so annoyingly only the top part of an engine that was stabled there was visible from main line trains. The site was quite a distance west of the main line station.

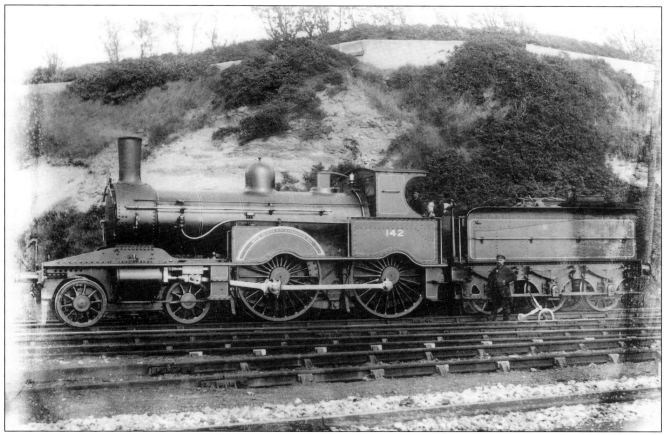

This undated photo has elderly 135 class 142 in the yard at Yeovil Town shed. The photo probably dates from the period when this engine was shedded at Exeter Queen Street from 1883 to 1892. It was withdrawn from service in December 1913. Note the builder's details painted on the splasher. S.K.Pacham/Southern Railway

15

LMS 4-4-0s

Several variants of this type worked over the LMS lines from Bristol and also on the S & D system.

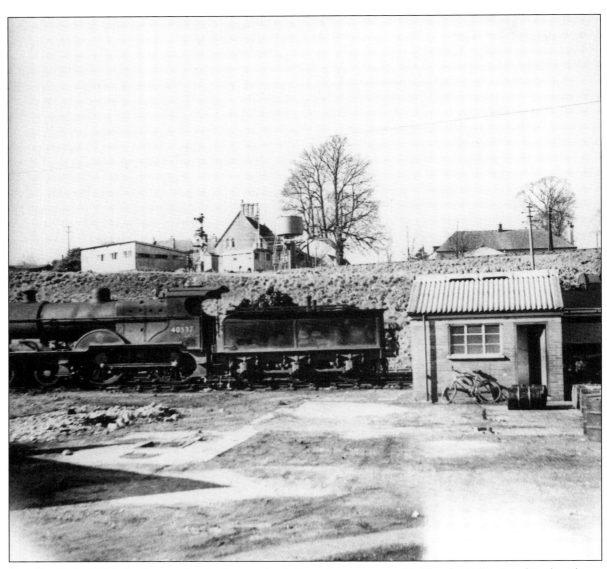

Ex MR 2P 40537 is in the yard at its home shed, Templecombe on 18 March 1962. It is fitted with an older panelled tender. This engine was withdrawn five months later. Part of the tender and cab of the shed's BR Standard class 4 4-6-0 75009 can be seen to the right. Maurice Dart

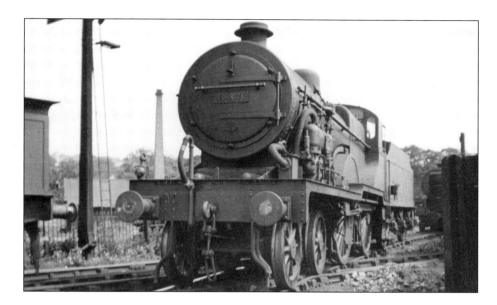

In the yard at Bath shed in August 1935 was 2P 40633 which was originally an S & D Rly loco. It is fitted with a Dabeg Water Feed Heater and appears to have a 22C Bath shedplate. Also it has Tablet changing apparatus fixed to the lower front of the tender for use on S & D lines.

Locally based 2P 40698 stands outside one of the two shed buildings at Bath on 25 May 1958. Ivatt 2MT 2-6-2T 41241 also shedded at Bath is alongside. Maurice Dart

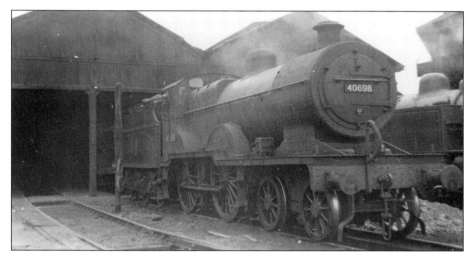

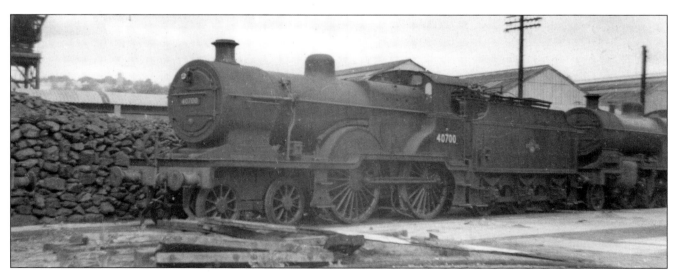

On the long siding alongside the coal stack at Bath shed on 25 May 1958 are local engines 2P 40700 and S & D 2-8-0 53802. Maurice Dart

16

0-4-4 TANKS

The SR used M7 class locos on the branch line to Yeovil and used O2s on the Melcombe Regis and other branch lines and around Weymouth. For many years ex MR locos were shedded at Highbridge for use on the S & D local branch lines.

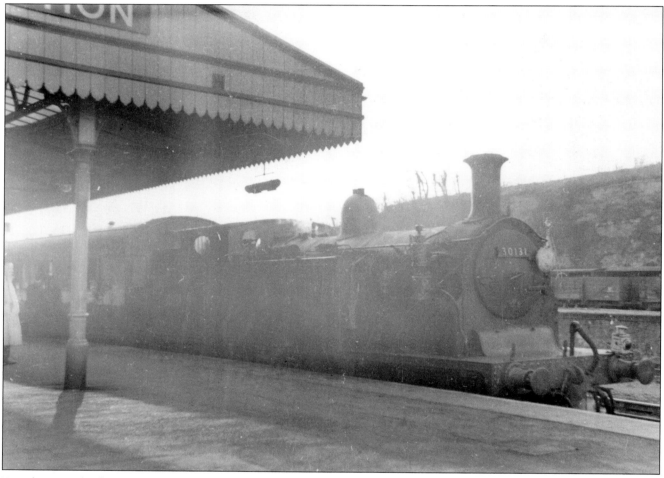

Yeovil Town shed's M7 30131 waits in the shadow of the platform canopy at Yeovil Junction on a late morning Motor train to Yeovil Town on 4 April 1958. Two lines of wagons and vans are in the Goods yard. Maurice Dart

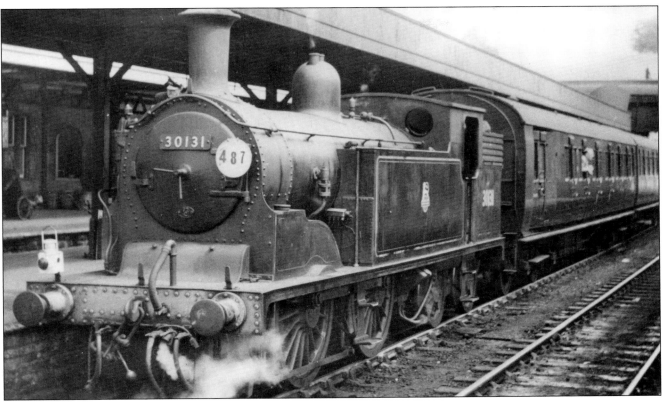

The same engine 30131 waits at Yeovil Town to work a return Motor train to Yeovil Junction on 11 August 1958.
R.H.Sargeant/Pamlin Prints

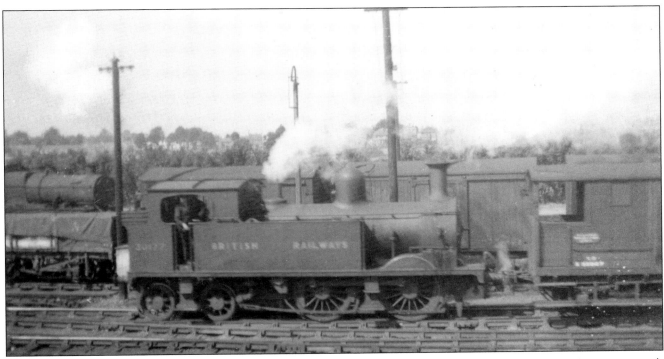

Dorchester shed's O2 class 30177 lettered 'BRITISH RAILWAYS' on the tank sides shunts in the yard at Weymouth in July 1949. The brake van is ex LSWR. In the left background part of locally based 4300 class 'Mogul' 5337 can be seen.

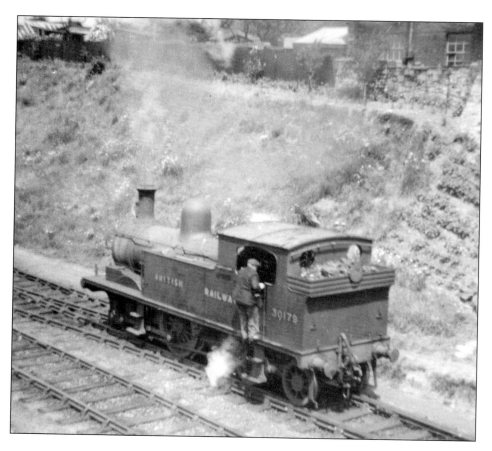

On 25 June 1949 Dorchester's O2 30179 is running around a train at Weymouth. It also carries the legend 'BRITISH RAILWAYS' on the side of its tanks. The fireman is preparing to descend from the footplate, probably to couple up to a train. The engine is painted in BR livery with SR style lettering.

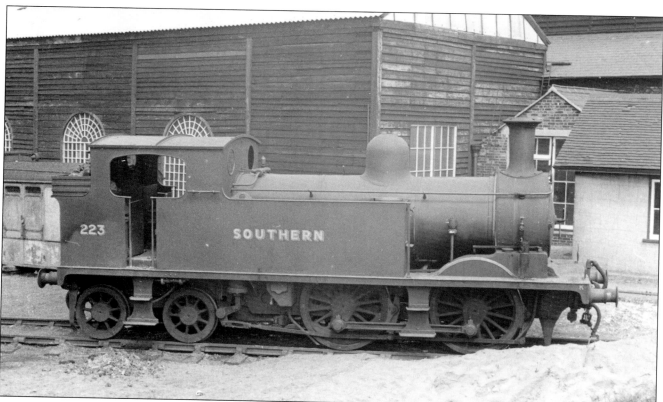

Standing in the yard alongside the shed at Dorchester on 27 June 1948 is locally based O2 223. J.H.Aston

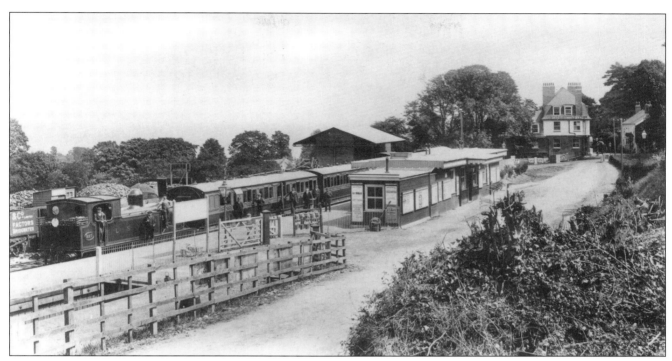

This vintage photo that was taken at Lyme Regis in 1907 shows Exmouth Junction shed's O2 class 227 waiting to depart on a train to Axminster. The carriages are in LSWR salmon with cream lining. The entire station staff are standing by the front carriage to be included in the photo. There is not a single horse drawn vehicle present in the station approach road. Pamlin Prints

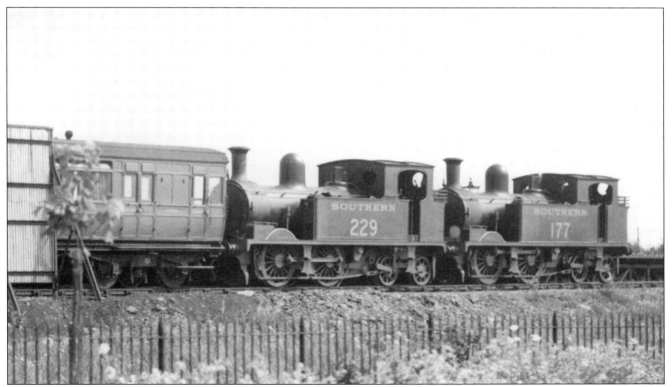

A train returning to Weymouth from Easton and Portland in the late 1930s is double-headed by O2s 229 and 177 both from Dorchester shed. The train is stopped at Melcombe Regis

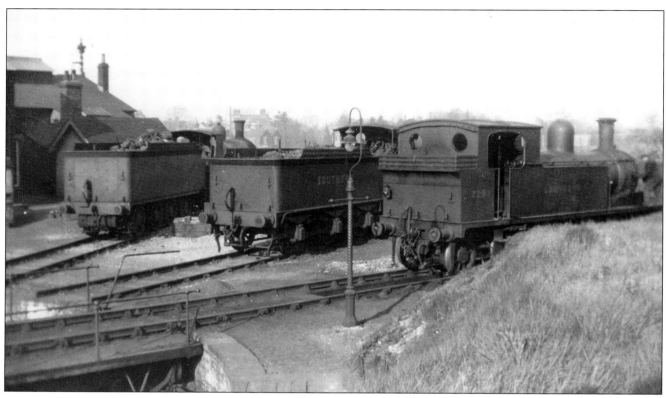

A trio of engines stand in Dorchester shed yard near the turntable in April 1949. Nearest to the camera is O2 229 with two 4-4-0s which could be K10s, L11s or T9s. A Scarsbrook/Initial Photgraphics

Complete with a 71J shedplate, MR 1P 58086 stands outside the shed/Works at Highbridge around 9.15am on 22 March 1959. As the shed had officially lost its allocation on 1 February 1958 from when it became a sub-shed of 82F Bath and had closed completely on 22 February that year, it was surprising to find this engine still carrying an old shed plate. It was even more surprising that a permit to visit the closed shed had been issued to the author! There was no shed staff present there. The engine was not officially withdrawn until 23 August 1960 when it was recorded as being shedded at Templecombe.

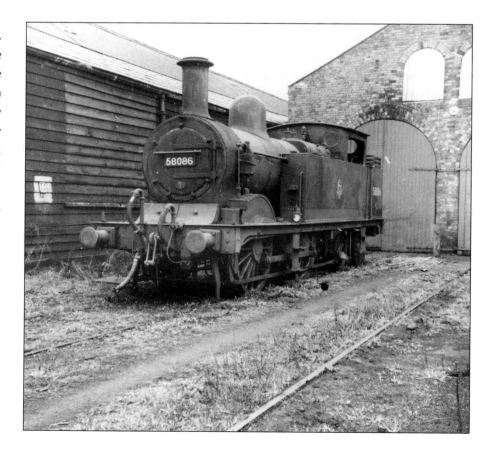

17

2-4-0 TENDER ENGINES

Some of these worked from Bristol over a period of years.

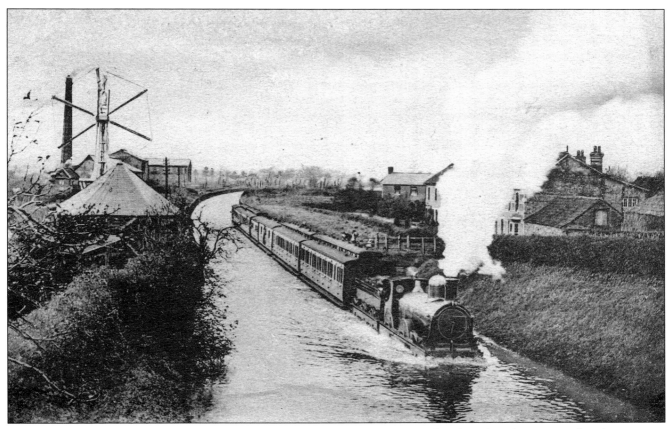

This is the only photo of this type in the selection. It shows a GWR 481 class loco heading an Up local passenger train near Creech St Michael Halt when floods covered the line in 1894 almost to the level of the locos. These locos were built in 1869 and were 'renewed' between 1887 and 1890 with one new loco added at the end of 1887. Withdrawal took place between 1905 and 1921. The complex of buildings behind the windmill are Creech Mills, behind which ran the branch line to Chard. Brice, Stationer, Taunton

18

2-4-0 TANKS

The GWR utilised this type on branch line trains and at times as shed and station pilots. Some probably worked on LSWR branches. The S & D had one specimen.

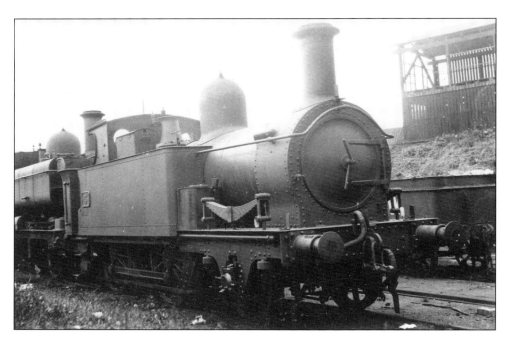

We start this short section with a look at a few GWR tanks and see 'Small Metro' no.5 stabled in the shed yard at Taunton in 1929. It was based there but also had periods at Barnstaple and emigrated to Ludlow from where it was withdrawn in 1932. It was numbered 1098 when built in 1869 but was renumbered to 5 in 1870. Real Photographs

Here is very clean 'Small Metro' tank 1455 at Minehead on a train to Taunton probably in the mid-1900s. A group of well dressed ladies are preparing to join the train. A pram is in the doorway of the luggage van. Several wagons and vans are in the Goods yard on the east side of the station.

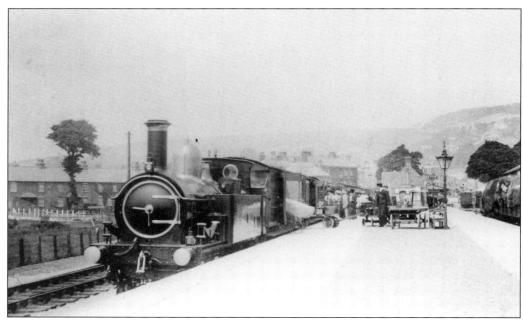

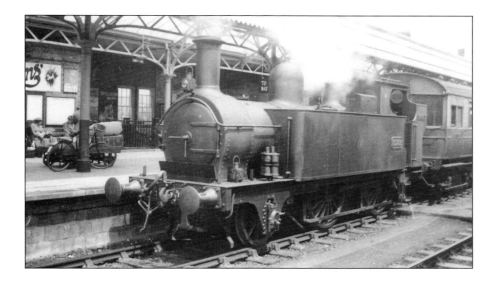

'Large Metro' tank 3582 is on an Auto train at Taunton station having probably arrived from Yeovil Pen Mill. This photo would have been taken in the mid-1930s when the engine was based at Taunton. This engine seemed to alternate between there and St Blazey shed. The author first saw it at Taunton in 1946 but it was withdrawn from St Blazey in November 1949.
Stephenson Locomotive Society

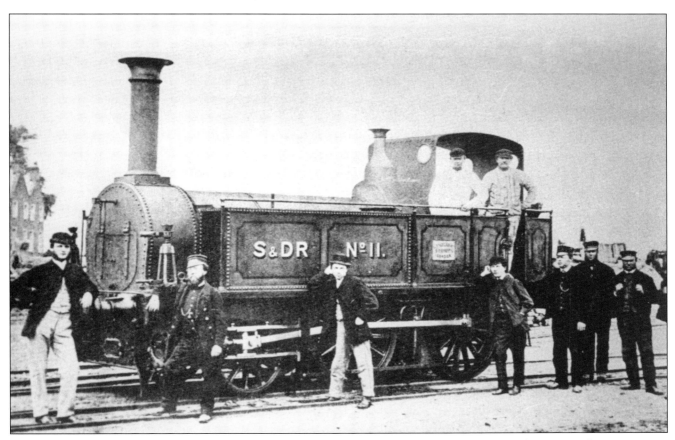

Here is the S & D Rly 2-4-0T which was specially bought in 1863 to work on the branch line to Wells. It was SDR no.11 and was the first of that railway's locos to be painted blue. Built by George England in 1861 it was exhibited at the Hyde Park Exhibition in 1862. When on the S & D it was locally called 'BLUEBOTTLE'. In 1871 it was sold to the LSWR, named 'SCOTT' and fluctuated between the Engineer's Department and the Locomotive Department. The engine actually worked on the Bodmin & Wadebridge Railway from 1874 to 1886. Transit to and from Cornwall was by sea. It was rebuilt completely in December 1887 and ended its days working on the Lee-On-Solent branch line. Final withdrawal came in April 1909. Railway Magazine

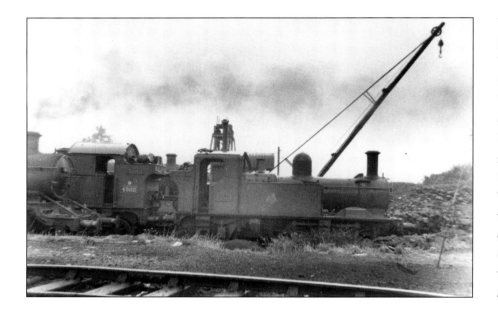

19

0-4-2 TANKS

Only the GWR is featured in this section as it used locos of this wheel arrangement on light branch line work. I always refer to the later 1400s as the 4800 class because they were known and numbered as such when built. They were renumbered in 1947 to make way for oil-burning 2-8-0s which were to be renumbered into the 48XX series.

This is a broadside view of the back end of the shed yard at Weymouth on 26 July 1959. Centre is 4800 class 0-4-2T 1453 to the left of which is 4500 class 'Small Prairie' tank 4562. Protruding in on the left is the smokebox of 5101 class 'Large Prairie' tank 4133. These were Weymouth engines. Behind these can be seen the outside cylinder and smokebox of 4-6-0 6842 'NUNHOLD GRANGE' from St Phillips Marsh shed.

Maurice Dart/Transport Treasury

A line of 'stored' engines at the east end of the yard at St Phillips Marsh shed on 15 June 1959 contained Bath Road shed's 4800 class 1454 along with its own 9400 class Pannier 9499. This last engine only entered service on 16 July 1955 and was withdrawn on 5 September 1959. What a terrible waste of capital investment occurred around that period.

Maurice Dart/Transport Treasury

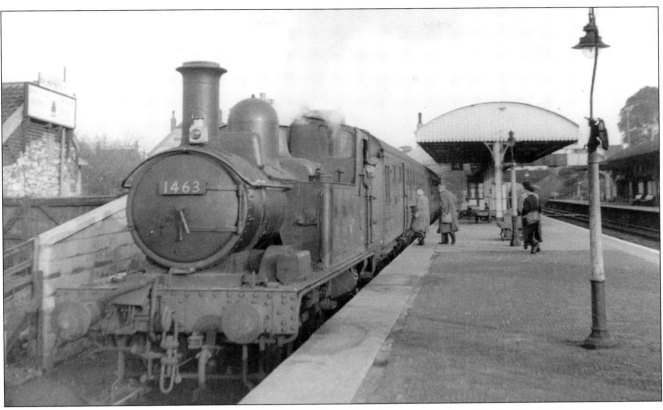

Bath Road shed's 1463 was sub-shedded at Yatton when this photo was taken in the late 1950s. Passengers at Yatton are boarding an Auto train with which the engine is waiting to depart. to Clevedon The engine is 'green lined out' with BR auto trailers. Lens Of Sutton

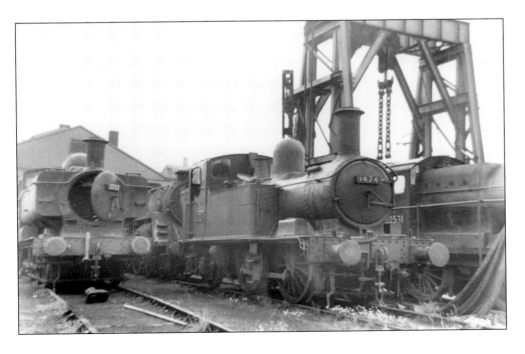

This is another scene at the back end of Weymouth shed yard on 26 July 1959. On the left is 8750 'Pannier' 3737 with its smokebox door partly open. Centre is 1474 to the rear of which the front of Standard class 5 4-6-0 73029 can be seen. These were Weymouth engines. On the right parts of SR Q class 0-6-0 30531 from Eastleigh shed are visible under the hoist.

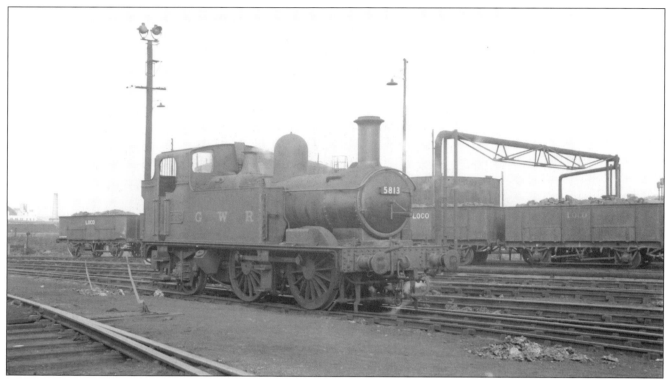

Now we see one of the batch of twenty locos that were not fitted for Auto train working. Bath Road shed's 5813 stands in the shed yard on 2 November 1949. This engine was often employed on shed pilot work and is still lettered GWR. The BRD shed stencil is at the top of the centre steps. A string of 4 wheeled 'Loco Coal' wagons are in the shed yard The left one of them is 53443. F.A Wycherley

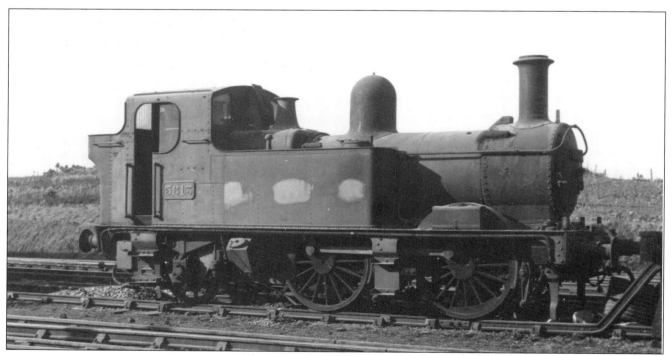

Now we see Bath Road's 5813 in the yard at St Phillips Marsh shed on 3 March 1957. The engine has not been repainted but the letters GWR have been obliterated.

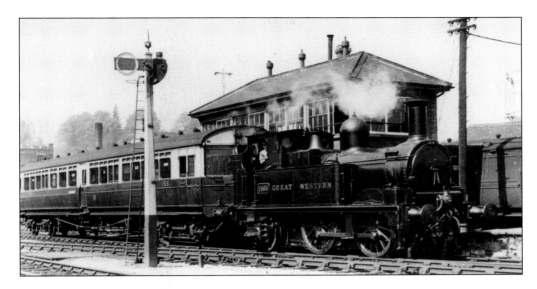

Now we have one of the older 517 class on an Auto train at Yeovil Pen Mill on 21 May 1935. This engine was from Weymouth shed and was withdrawn in January 1936. It is hauling GW Auto trailer 155. The signal box makes a prominent backdrop.
H.C.Casserley/Pamlin Prints

An unidentified 517 class loco is hauling a train on the line from Weymouth Quay to the Town station probably in the early 1920s. J.Lucking

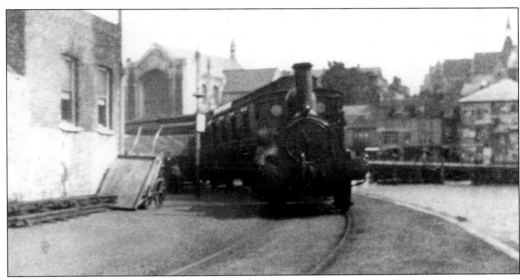

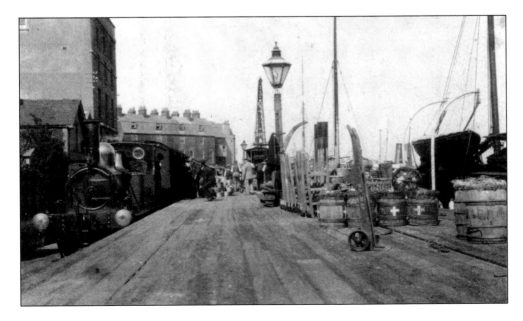

Another unidentified 517 class engine is on a train of vans being loaded with produce at Weymouth Quay in the early 1920s.
Lens Of Sutton

20
0-4-0 TANKS

The GWR used these small locos at Bridgwater, and the SR used them at Hamworthy/Poole Quay. They were used by the LMS at Bristol to work the line to Avonside Wharf and also on the S & D system at Radstock. In this section I have included multiple photos of several of the engines. I make no excuse for doing so as all were very unusual and exuded a distinct fascination. They could also be difficult to locate or photograph as when they were out working they tended to be at rather obscure locations. When back at sheds they were usually tucked away inside.

GWR 1338 AT WORK AND AT REST

This ex-Cardiff Railway loco became GWR 1338 was allocated to Taunton shed for many years. However it appeared at Taunton only for washouts or maintenance as it spent most of its time sub-shedded at Bridgwater. On a murky 25 September 1956 the engine is shunting at Bridgwater Docks.
A.C.Roberts

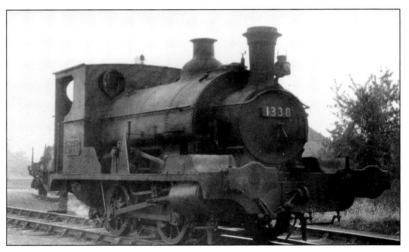

On a Spring day in 1957 the diminutive engine was actually sitting outside the shed at Bridgwater and was recorded from a passing train. The buildings in the background formed part of the MOD complex. Mike Daly

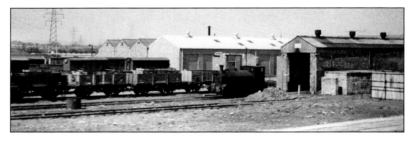

On 18 May 1957 the little engine was properly at home tucked away inside the roundhouse at Taunton shed with a Grange class 4-6-0 as a 'stablemate'. In the left background is former Private Owner 7 plank wagon P309161.

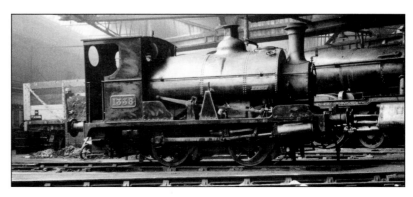

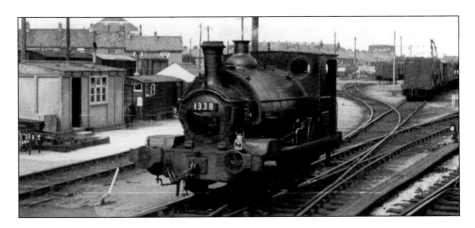

The engine was shunting in the yard north of Bridgwater station on 23 September 1957. The branch line to the Docks is curving left behind the engine. An old van body is among the buildings visible.

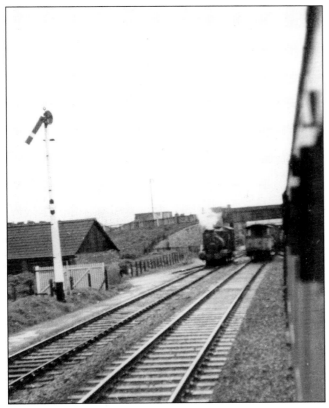

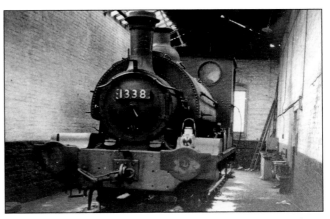

This is a very rare photo taken on 22 March 1959 of our little engine resting inside the single road shed at Bridgwater. A hose pipe is hanging out from the cab. The other occupant was Pannier 1668 which was almost snug against the shed door, which was closed. I had visited Taunton shed that morning with a permit and asked the Foreman where 1338 was. He laughed and replied 'Oh, he's in the MOD depot, you wont be able to see him'. After visiting Highbridge shed I decided to investigate the possibility of accessing the shed at Bridgwater. I achieved this by surreptitiously climbing through two ordinary three strand railway bank wire fences between which I walked on the grass beside the shunting line for a short distance. I found the shed door closed but luckily the small door at the bottom of the main door opened and admitted me. I just had room to squeeze past the front buffer of 1668 to find my prize. As I was leaving and heading for the fence I became aware of a mass of people who were leaving work at the MOD depot so I joined onto the rear of them and followed them out through the main gate. Maurice Dart

This is a distant shot taken from a passing train on 28 October 1957 when the engine had emerged from the depot area and was shunting alongside the main line. As the engine was propelling the van backwards there was no time to wait for a closure shot. For the record on the other end of the Goods train which is standing on the Up west end loop were two Panniers which were Taunton's 8750 class 9670 piloted by 1366 class 1366. It was probably a local working from Taunton serving Bridgwater yards, Dunball Wharf, Huntspill MOD exchange sidings and Highbridge. There is a 5ft arm on the signal. Maurice Dart

This is GWR 0-4-0ST 1391 'FOX' shunting at Weymouth around 1906. It was built by the Avonside Engine Co in 1872 for the West Cornwall Railway and was their Works no.913. The WCR became part of the GWR in 1876 and this engine spent several years employed on engineers and ballast trains in South West England. Following those

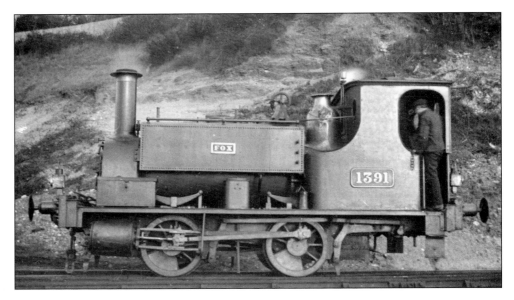

duties it spent a period at Weymouth and was sold in 1912 to the Gloucester, Carriage & Wagon Co. They eventually sold it to Cashmores of Newport for scrap in 1948. The other seven ex West Cornwall Railway engines had all been scrapped by 1881.

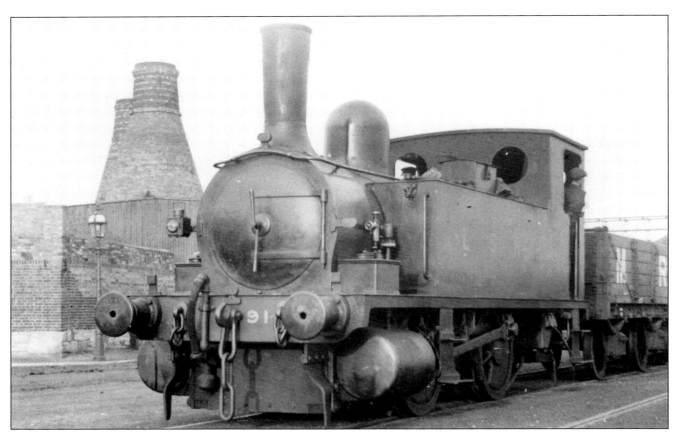

Now we look at a few of the powerful SR B4 class tanks and see 91 shunting at Hamworthy Quay in the early 1920s. The leading vehicle is a Midland Railway 5 plank end door wagon. Factory buildings border the lines on the north side. The engine which retains its original chimney would have been sub-shedded at Hamworthy Junction from Bournemouth shed.

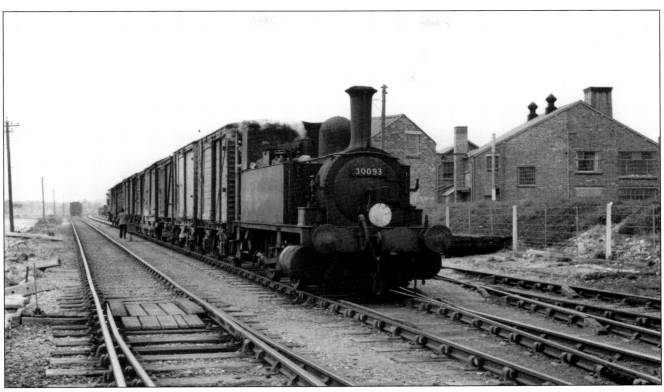

Bournemouth's 30093 shunts a long string of vans at Hamworthy Quay in the 1950s. Hugh Davies Photographs

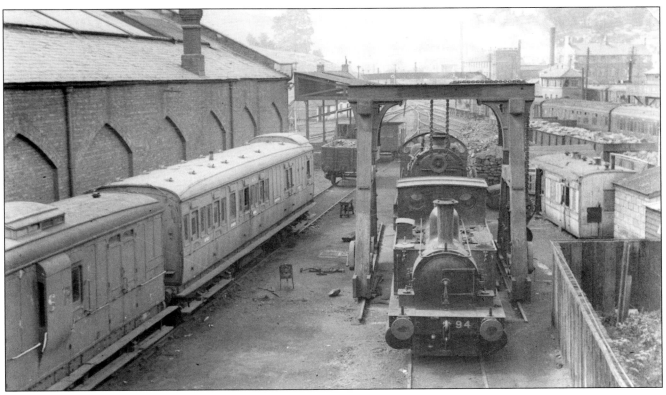

A B4 was a rare visitor to Yeovil Town shed where 94 is in the yard with a U class 2-6-0 to its rear on 13 August 1946. The B4 had called in for a rest whilst returning from a visit to Eastleigh Works. It was on its way home to Friary shed, Plymouth where it was a familiar sight to the author.

LANCASHIRE & YORKSHIRE RAILWAY 'PUGS' AWAY FROM HOME

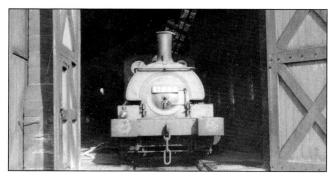

11202 wearing a 22C shed plate is at home looking out of one of the sheds at Bath around 1946.

(Above Right) Bristol Barrow Road shed's 51212 stands in the shed yard in the early 1950s. Behind the telegraph pole is former Private Owner 8 plank coal wagon no.P50301 fitted with side and bottom doors. Notice the coal stacked inside the cab. Mike Daly

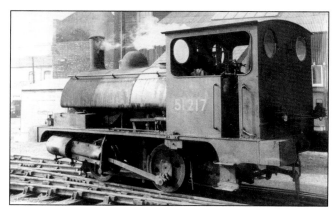

The allocation of Pugs to Barrow Road varied a little over the years. In 1960 51217 is shunting at Avonside Wharf. Rex Conway Collection

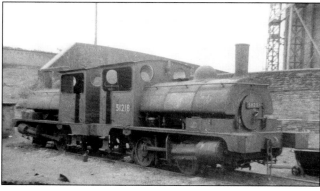

In December 1959 both of Barrow Road's Pugs, 51217 and 51218 were at the back of a siding alongside the shed. 51218 is wearing the later BR crest but the LMS livery is showing through in places. Rex Conway Collection

It was and still is unpredictable just what locomotives may turn up anywhere on the railway. This is an example when 51244 was recorded whilst approaching Barrow Road on a train from Avonside Wharf in the 1950s. This engine was allocated to 25C Goole shed. The engine is coupled to ex SR 8 plank mineral wagon S34635. Mike Daly

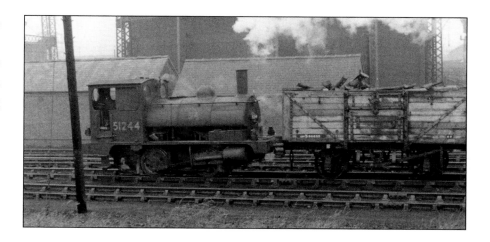

SENTINEL LOCOMOTIVES IN SOMERSET

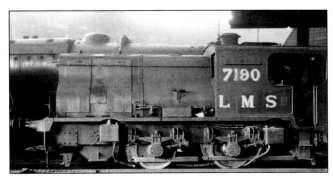

When the author saw this engine in the roundhouse at Barrow Road shed in 1947 he stared at it in bewilderment as he had not seen a 'Sentinel' before. The shape was unlike anything he had previously seen! Anyway, here is Barrow Road's 7190 inside the roundhouse there on 10 November 1946.

B.K.B.Green/Initial Photographics

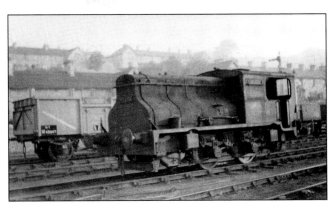

Our friend, by now numbered 47190 moved to Bath shed from where it was frequently sub-shedded at Radstock where it is engaged in shunting near the North station on 12 September 1959. On the left is ex LMS 16T steel mineral wagon M621647. N.D.Mundy

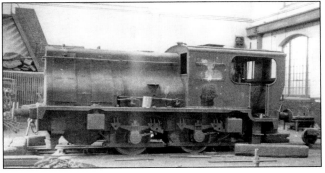

By November of that year 47190 was back at Barrow Road shed inside the 'Factory' for attention. It is in a scruffy condition with the number barely legible. The author saw it here in this position in this state. Mike Daly

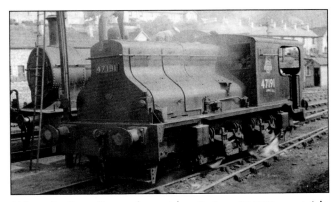

(Above) Standing alongside Jinty 47465 outside Radstock shed on 4 June 1955 is the other Somerset Sentinel 47191.

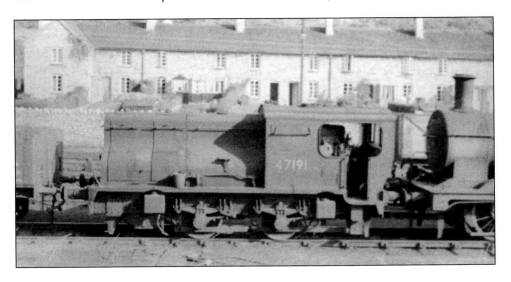

Here is the same engine 47191 standing in front of a Jinty in Radstock shed yard on 15 August 1959. It was withdrawn from service a few weeks later on 8 September. N.D.Mundy

SERVICE LOCOMOTIVES and OIL BURNERS

The GWR used a small shunting loco in the Engineer's depot at Taunton and others worked in the area at times. On the SR a small loco was stationed at Yeovil junction for a time to shunt in the Engineer's yard. All classes of GWR Oil-burners passed through the area on the main lines during the period when they were converted from burning coal circa 1946 to 1950.

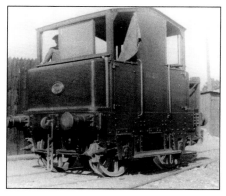

Here is 4 wheeled petrol loco Motor Rail 3821 which was built in January 1926 and became GWR no.24. It was used mainly at Taunton Engineer's Depot where it was recorded working on 26 August 1948. It remained there with a few trips away to other places until 1959 and was broken up at Swindon Works towards the end of November 1960. R.K.Blencowe Collection

PWM 650 was one of five 165HP 0-6-0 diesel electric shunters built by Ruston & Hornsby for BRWR. It was in the yard at St Phillips Marsh shed on 8 May 1955. These engines tended to move around the system and spend periods at various locations.

B.K.B.Green/Initial Photographics

For fourteen years after it had entered service PWM 652 was allocated to Taunton where it worked in Fairwater yard pre-assembly depot. It is under repair in the small Maintenance shed at Taunton on 11 December 1966. The nose of class O3 D2140 is to the right of the PWM. Maurice Dart

This small Ruston & Hornsby Type 48DS diesel electric shunter was delivered new to the British Aeroplane Co.Ltd. at Weston-Super-Mare in 1946. BR purchased it on 11 December 1948 for use at Folkestone Warren Sea Defence's site. It worked at Broadclyst Sleeper Depot from July 1959 until September 1964. Then it moved to Taunton Engineer's yard and on to Yeovil Junction in April 1967 where it was photographed on 28 February 1971. A GWR Fruit van is in the background. Maurice Dart

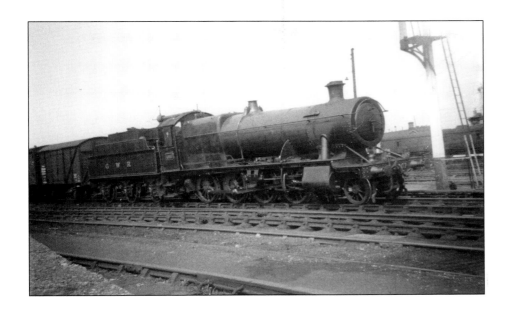

We move now to shots of GWR oil-burners and start with 2-8-0s. Waiting for the signals to clear at Taunton East yard in July 1947 is 2800 class 4807 from Laira shed. The engine ran as an Oil-Burner from June 1947 to July 1949 when it reverted to its original number of 2848. It carries the LA shed stencil. The train is the 3.30am from Tavistock Junction yard to Bristol Goods. Roger Venning

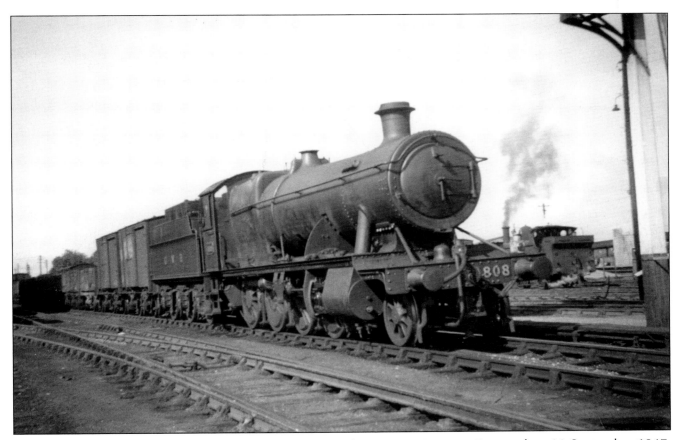

Also carrying an LA shed stencil Laira's 2800 class 4808 takes water at Taunton East yard on 30 September 1947. It was working the 5.45am Tavistock Junction to Avonmouth Goods. Originally numbered 2834 this engine ran as an oil-burner from July 1947 until January 1950. The ancient Pannier tank shunting in the background looks very familiar to the author who guesses that it could well be Taunton sheds 850 class 1909 which always seemed to be working that duty when he passed by. Roger Venning

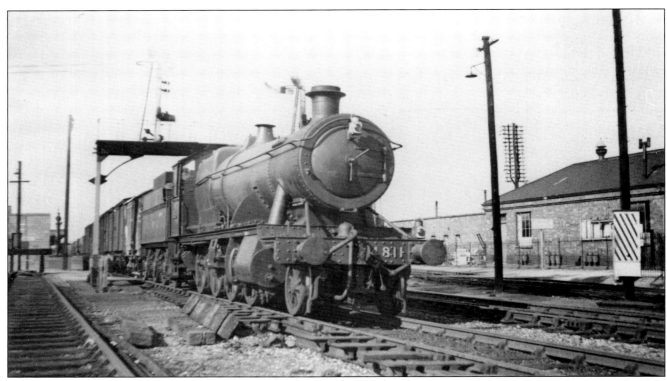

Here is Laira's 2800 class 4811 passing through Taunton on an Up goods in October 1947. This engine ran as an oil-burner from September 1947 to June 1949 and was originally numbered 2847. Roger Venning

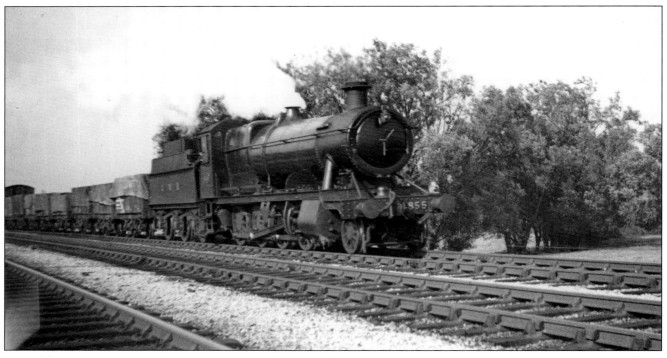

Another Laira engine, this time 2884 class 4855 passes Bathpool, Taunton on the 5.45am Goods from Tavistock Junction to Avonmouth on 23 September 1947. This engine was originally numbered 3813 and ran as an oil-burner from July 1947 until June 1949. These four engines were seen by the author at Laira newly converted and were spotless and repainted green. Roger Venning

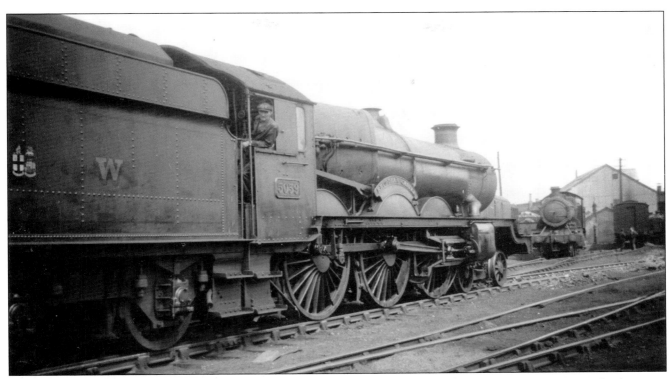

The Castles which were converted to burn oil retained their original numbers. Old Oak Common shed's 5039 'RHUDDLAN CASTLE' is backing out of Taunton shed yard in July 1947. It will pick up the stock to work the 4.35pm Stopping passenger train from Taunton to Bristol Temple Meads which will depart from no.9 Bay platform. The engine ran in this condition from December 1946 to September 1948. *Roger Venning*

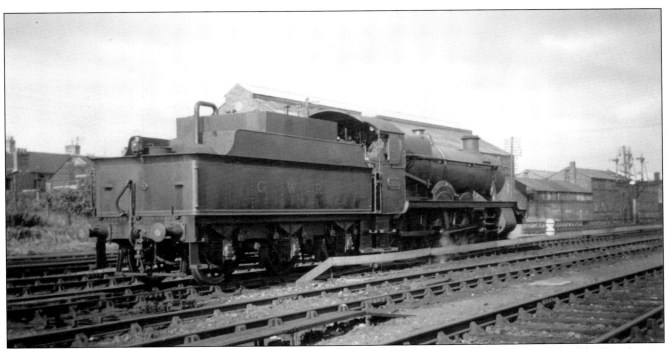

We end this section with 'Hall' class 3950 'GARTH HALL' from Bath Road shed also leaving Taunton shed to pick up the stock for the 4.35pm 'Stopper' to Temple Meads on 28 June 1947. This engine ran as an oil-burner from June 1946 until October 1948 and originally was numbered 5955. *Roger Venning*

22

DIESEL RAILCARS and a GAS TURBINE

The GWR used diesel railcars around Bristol on the branches through Somerset and also on the Weymouth line. Both Gas Turbines passed through Taunton and worked to Bristol from Paddington.

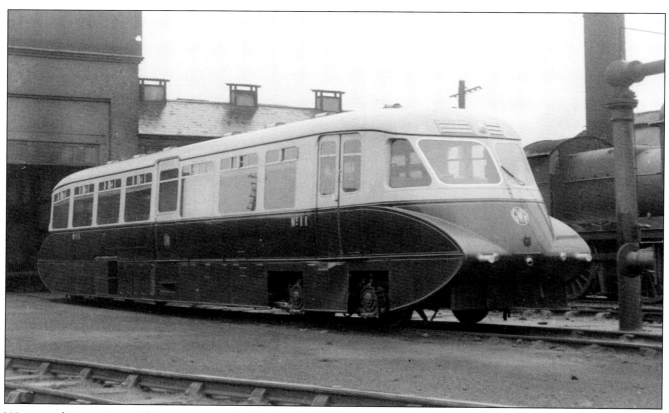

We start this section with No.11 one of the semi-streamlined railcars. It was allocated to Weymouth where it is sitting outside the 'Factory' on 20 September 1936. A 4300 class 'Mogul' is partly in view.

R.J.Buckley/Initial Photographics

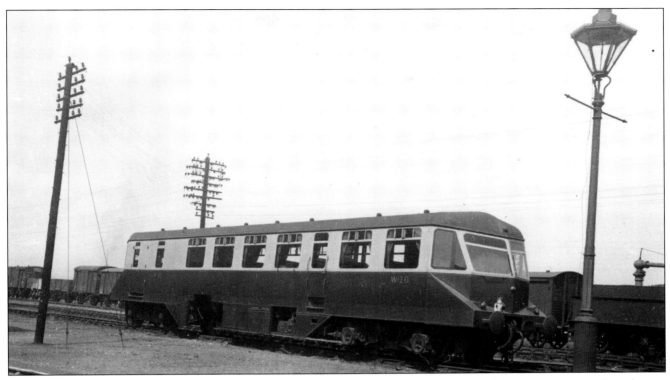

In the large yard at St Phillips Marsh shed in June 1949 was one of the later type of railcar. W20 appeared to change allocation between here, Yeovil Pen Mill and Weymouth. This railcar has been preserved and can be seen on the Kent & East Sussex Railway. C.H.A.Townley/J.A/Peden

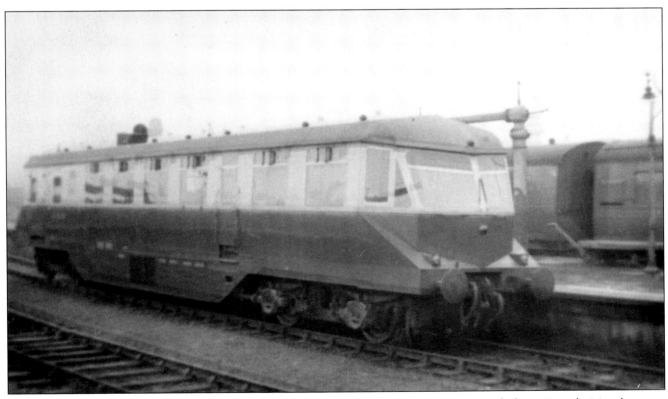

On a wet day in the mid-1950s St Phillips Marsh shed's W23W is departing eastwards from Temple Meads

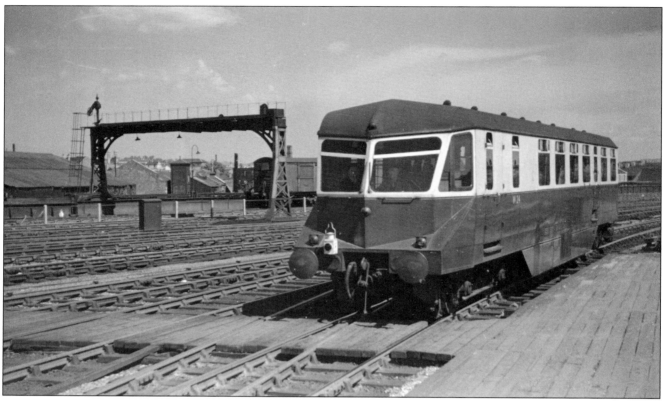

Another St Phillips Marsh railcar, W24 is entering Temple Meads in 1955.

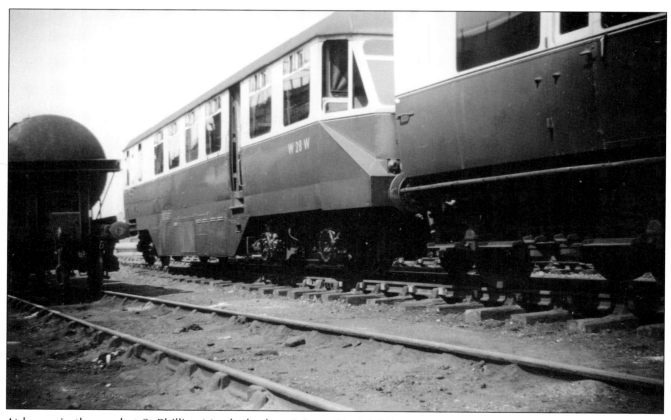

At home in the yard at St Phillips Marsh shed on 2 June 1956 is W28W. Transport Treasury

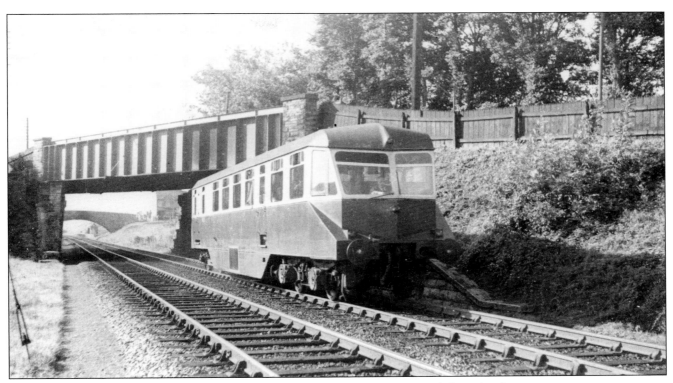

Here is W28 again, this time on a service from Weymouth which has just left Radipole.

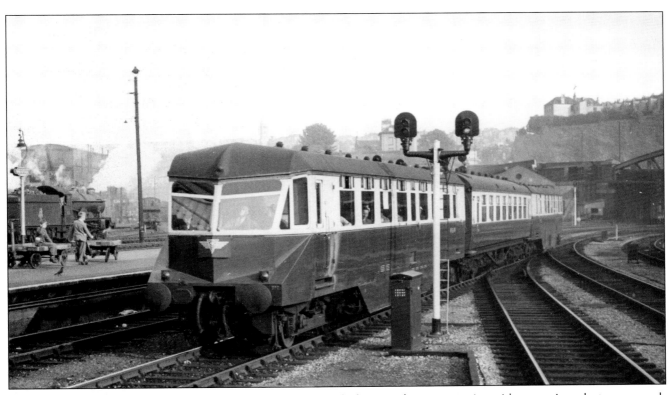

The last four railcars were single ended and were intended to work as two pairs with a carriage between each railcar. Entering the west end of Temple Meads in June 1953 is St Phillips Marsh shed's W36W with W35W at the rear. The leading railcar is carrying the AEC crest. Photomatic/Rail Archive Stephenson

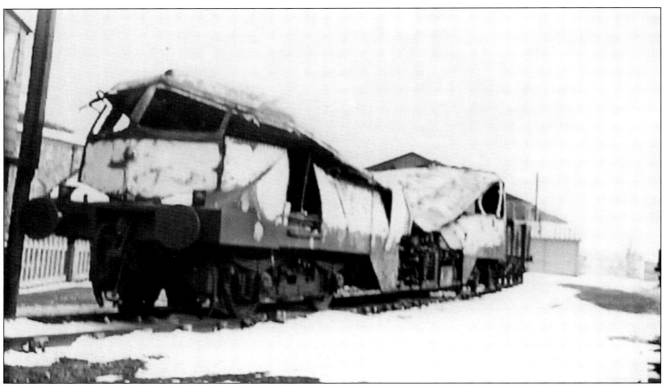

The other pair were also based at St Phillips Marsh but unfortunately No.37 caught fire and was burnt out on the night of 17 February 1947. The remains are seen stabled in a siding at Cheddar the next day. Afterwards, at first No.22 ran with No.38 but then No.33 was modified to a single ended railcar to work permanently with No.38.
Brian Hillier

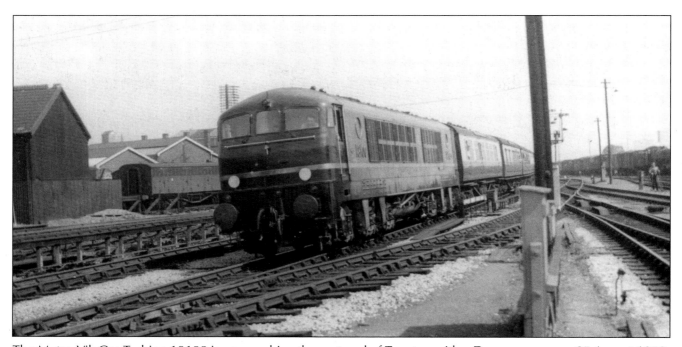

The Metro-Vik Gas Turbine 18100 is approaching the east end of Taunton with a Down express on 25 August 1952. A 2884 class 2-8-0 on a goods in the East yard is visible centre right. On the left is a GWR inside framed 'Syphon G' van. A.R.Goult

23

BROAD GAUGE, SHED and DEPOT SCENES, and MISHAPS

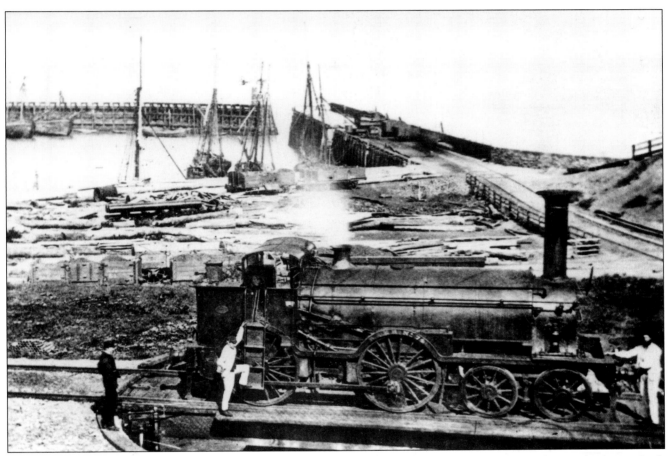

We see Broad Gauge Bristol & Exeter Railway 4-4-0ST No.74 on the turntable at Watchet Harbour. The loco which became GWR 2047 has been fitted with cab sheets. It entered service in August 1847 and was withdrawn during May 1892.

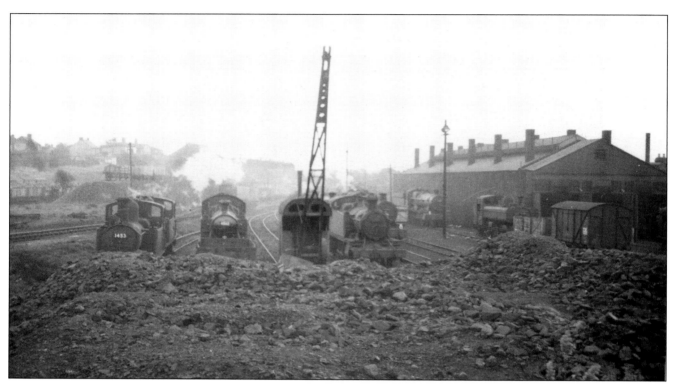

This view of Weymouth shed yard dates from the mid-1950s. On the left are two 4800 class 0-4-2Ts the nearest of which is 1453. Next right is 4500 class 2-6-2T 4562. Then, working right from the crane there is a 5101 class 2-6-2T, a 4300 class Mogul, a Hall and an 8750 class Pannier. In the background behind 4562 a Bulleid Light Pacific is moving around.

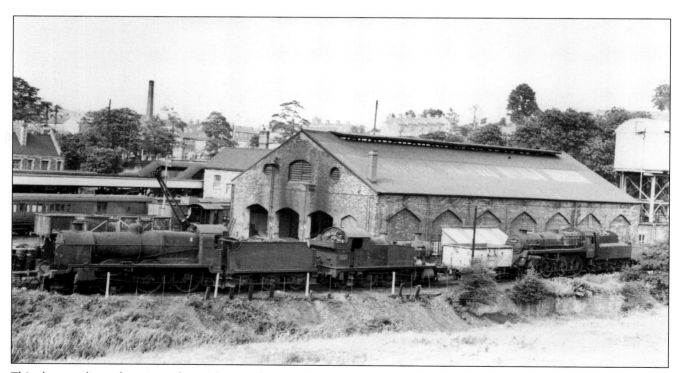

This shows a line of engines alongside Yeovil Town shed in the early 1960s. From left to right they are U class Mogul 31802, 4575 class 2-6-2T 5563 and BR Standard class 4 4-6-0 75003.

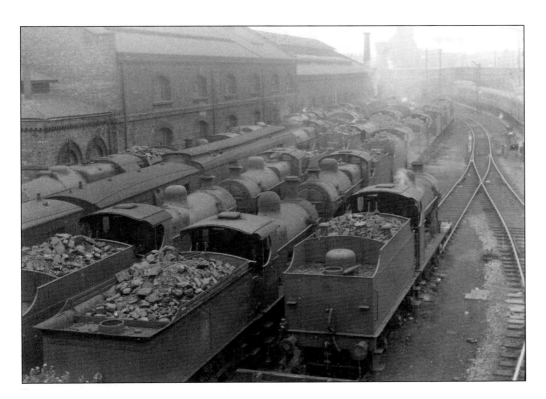

This is how Barrow Road shed storage sidings looked in 1963 as an express bound for Gloucester passes. The engines comprise a mixture of 3F and 4F 0-6-0s, Crabs, Black 5s, Jinties and possibly 8F 2-8-0s. Only one can positively be identified which is withdrawn 3F 0-6-0 43593 which is in the bottom left corner.
Mike Daly

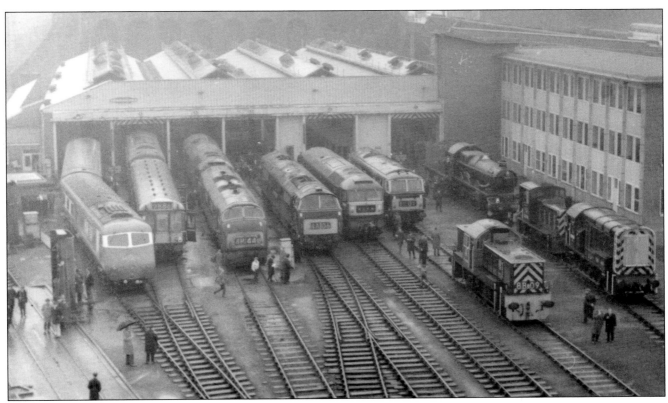

This is a view of Bath Road shed/depot when an Open Day was held on 22 March 1965. Working from left to right we see The 'Blue Pullman; a DMU; a Warship in front of a class 47; a Western; a class 47; a Hymek with a D95XX a little way in front; and 4-6-0 7029 'CLUN CASTLE' in front of which are an 03 and an 08 diesel shunter.
Terry Nicholls

On 11 November 1890 a Down GWR Narrow Gauge Goods train stopped at Norton Fitzwarren to permit shunting to be carried out. A Broad Gauge pilot loco on the train detached and waited on the Barnstaple branch. When completed the train by request moved to the Up line to permit a Down Fast goods to pass. The driver of

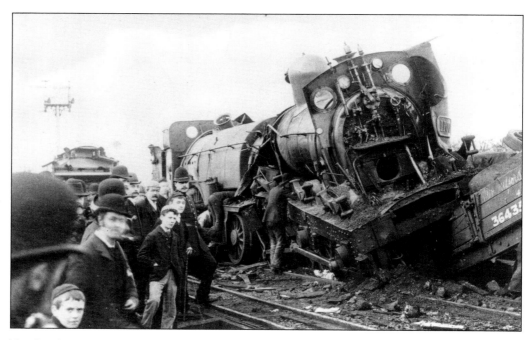

the stabled train changed his leading lights twice. The signalman had become confused and thinking that he had recessed this train into a siding he signalled a fast Up Broad Gauge Boat train from Plymouth through the station. The Up train which consisted of two light carriages and a van hauled by 2-4-0T 1100 ran into 4-4-0ST 2051 head-on at around 60 mph. Ten passengers were killed and nine were injured. Locomotive & General Railway Photographs

This is the only photo in this book without a locomotive but it depicts an incident which involved a train in which the author was travelling on 31 March 1956. I departed from Plymouth North Road on the Up 'Devonian' hauled by Laira's 6027 'KING RICHARD I' heading for Sheffield. At 11.28 as we approached Durston there a loud bang followed by a very violent brake application. Between the front seven coaches and the rear five coaches the Buck–Eye couplings had pulled out and the vacuum pipe had severed as the train 'Divided'. The hinges were torn off their hooks on the corridor connections. I was travelling in the seventh coach. After a discussion the front portion set back and the train was re-coupled. We departed at 11.48 without vacuum on the rear five coaches and connecting doors between the two parts of the train had been locked shut. As the discussion as to how to proceed was taking place I walked back along the coach and took this photo looking out of the end of the seventh coach at the rear portion which had stopped farther back along the platform in Durston station. The amazing thing is that it took only twenty minutes to rectify the situation and get the train moving again. The mind boggles at what the outcome would have been with today's legislation! Maurice Dart

24

DIESEL LOCOMOTIVES

A representative selection of many, but not all, of the types that worked in the area is included in this section. Starting with the Western Region Diesel Hydraulics we progress through Diesel Electric types and end with some shunters

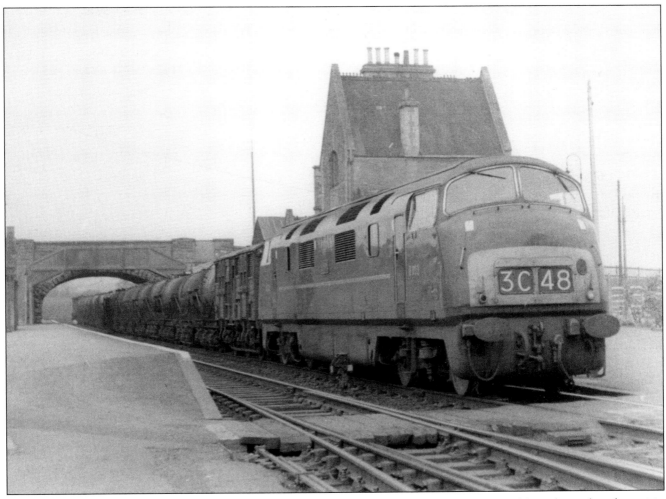

Swindon built 2200hp 'Warship' class diesel hydraulic D803 'ALBION' from Newton Abbot depot heads an Up Milk train through Crewkerne on 8 May 1965. Immediately behind the engine is a GWR 6 wheeled Special Cattle van.

Dumped in a yard on the opposite side of the line to Marsh Junction diesel depot on 23 July 1972 was withdrawn 1100hp diesel hydraulic 6319. Maurice Dart

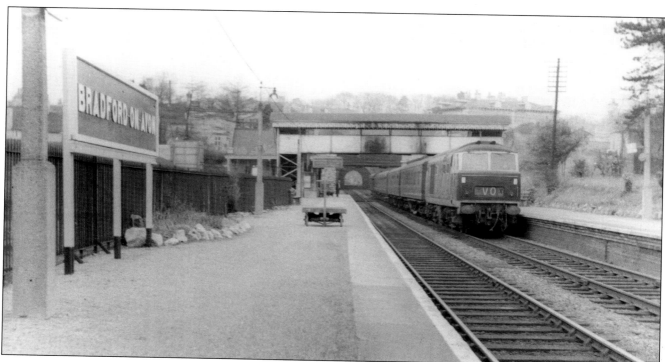

1700hp 'Hymek' diesel hydraulic D7016 from Bath Road depot enters Bradford-on-Avon with a train from Salisbury to Bristol or Cardiff via Westbury and Bath in the 1960s. The 159yd Bradford tunnel is in the background. The engine is not carrying a yellow 'warning' panel. Lens Of Sutton

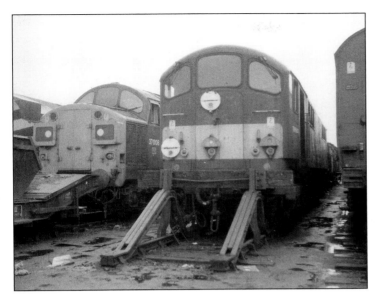

Central in this photo that was taken on 14 May 1978 is an almost head-on view of a loco that started life as 1200hp diesel electric D5705. After working for almost ten years it was withdrawn on 7 September 1968 and was sent to Derby Research Centre during December of that year. It was renumbered to S15705 in Departmental stock and was used at various locations before withdrawal again around 1971/72. It was back in service at Gloucester by 18 September 1974 and moved around the Swansea area. At Danygraig it was converted to an unpowered carriage heating unit. It moved to Bristol for use in the carriage sidings and was finally withdrawn in September 1977 and was stored at Bath Road depot until August 1979. It moved to Swindon Works where asbestos was removed and has since been preserved. On the left is part of 1750hp diesel electric 37008 from Thornaby depot, Teeside. The engine started life as D6708, then became 37008, since when it became 37352 before reverting again to 37008.

Maurice Dart

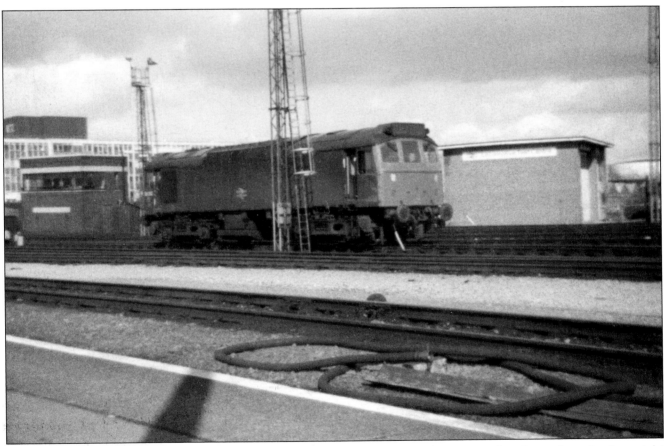

Here is 1250hp diesel electric 25230 by the throat of Bath Road depot in the 1980s when it was based at Longsight and at Crewe. It was originally numbered D7580.

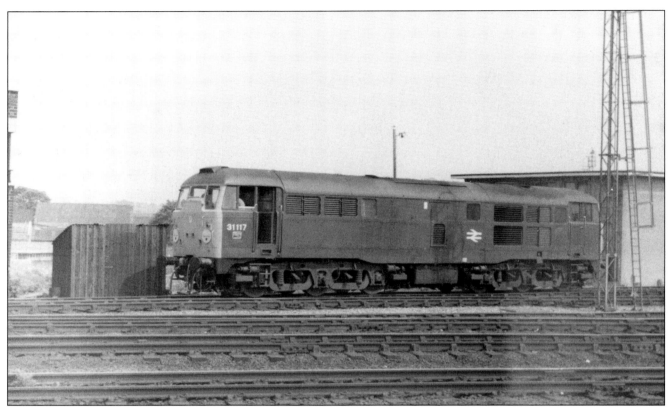

In the yard at Bath Road depot in the 1980s is 1470hp diesel electric 31117 from Old Oak Common depot. Its previous number was D5535.

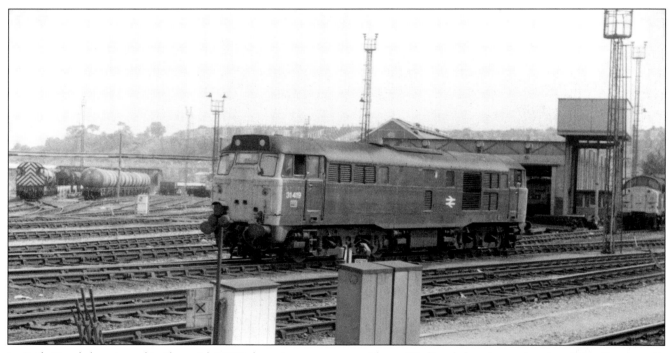

In Bath Road depot yard in the mid-1970s keeping company with an 08 diesel shunter and a class 37 is the depot's own 1470hp diesel electric 31419. This engine started life as D5697, then became 31267 before becoming 31419. It changed again to end as 31519.

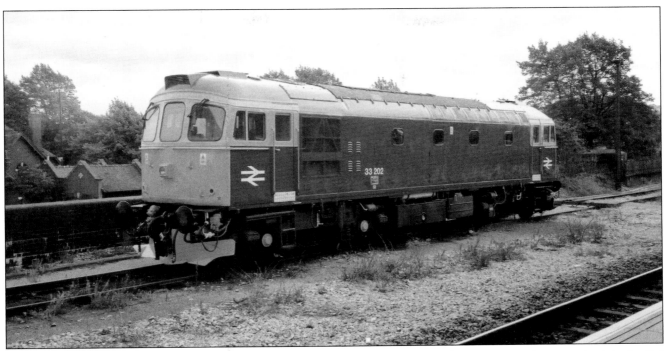

Gloucester based 1550hp diesel electric 33202 stands opposite Temple Meads station on what was the inlet/outlet road for Bath Road depot on 2 September 2007. Originally numbered D6587 this is one of the 'Slim Jims' that were built with slightly narrower bodies for working through tunnels on the line to Hastings. Maurice Dart

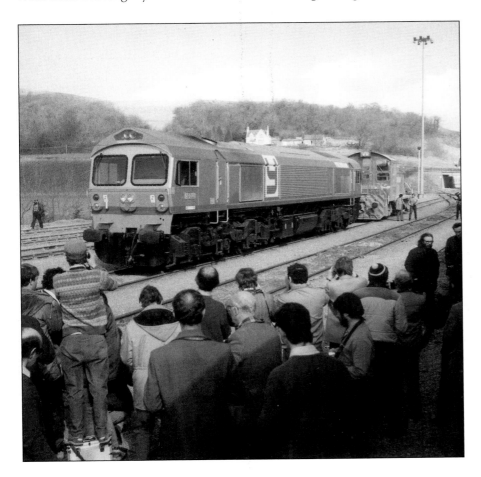

On 8 March 1986 recently arrived 3300hp diesel electric 59003 is near the loco depot at Merehead Quarry. In the background is General Motors diesel electric 'Switcher' 44. The photo was taken during a stop by a Railtour arranged by the Railway Correspondence & Travel Society's West Of England Branch. Maurice Dart

Stabled in the not normally accessible location of Doctor Day's Wagon Works on 23 July 1972 was 350hp diesel electric shunter 3835. It was originally D3835 and later became 08668. This loco has been preserved. Two 'Pipe' wagons are behind the engine. This site is now occupied by Barton Hill depot. Maurice Dart

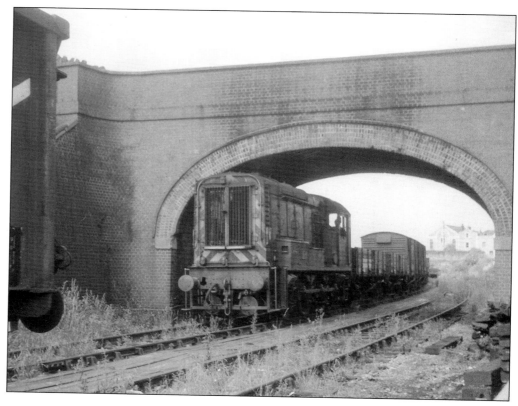

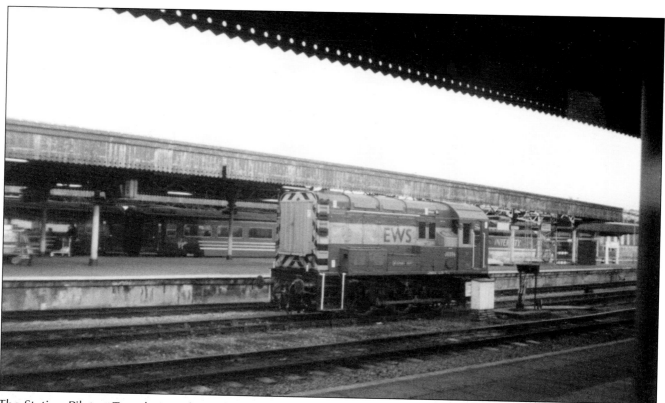

The Station Pilot at Temple Meads on 26 March 1999 was 350hp diesel electric shunter 08896 'STEPHEN DENT' in EWS livery. This engine was at first numbered D4126. When photographed it was working from Barton Hill depot. Maurice Dart

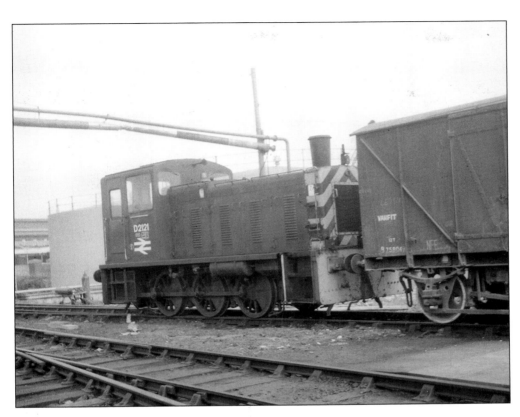

In the yard at Bath Road depot on 23 July 1972 is locally based 204hp diesel electric shunter 2121 ex D2121. It became 03121. The engine is coupled to a BR van B758049 which should have had a planked body with doors but both are plywood. Maurice Dart

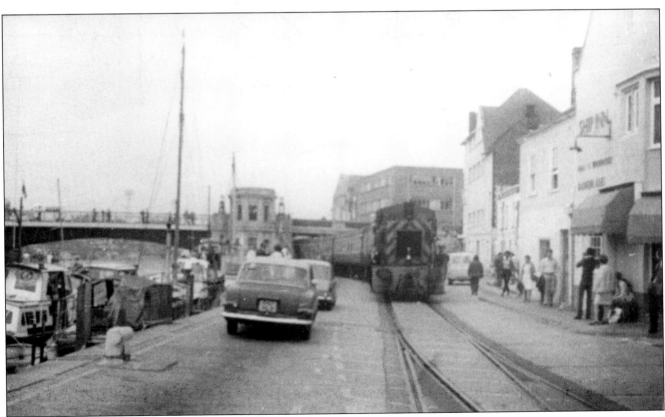

An unidentified 204hp diesel electric shunter is heading a Boat train from Weymouth down the line to Weymouth Quay in the late 1960s.

25

INDUSTRIAL LOCOMOTIVES

A small selection of these interesting locomotives is included taken at three locations in Somerset.

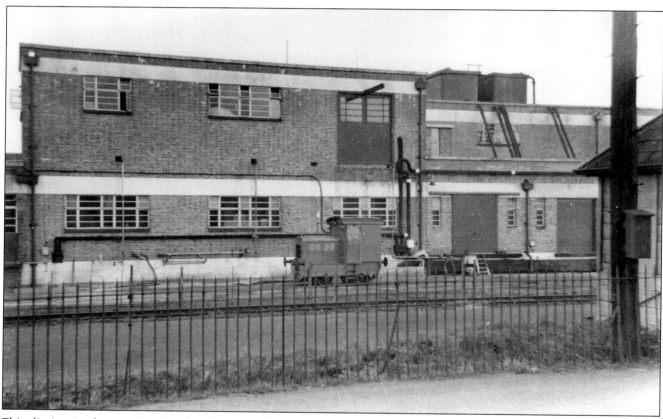

This diminutive locomotive is a 4w diesel mechanical which shunted at United Dairies Ltd at Chard Junction. Later it became Unigate Foods Ltd. Photographed from a passing train on 4 April 1958 it was built by Ruston & Hornsby in 1937 and was their Works no.183062. It passed to the West Somerset Railway in January 1976 but has since moved to a location which is unknown to the author. Maurice Dart/Transport Treasury

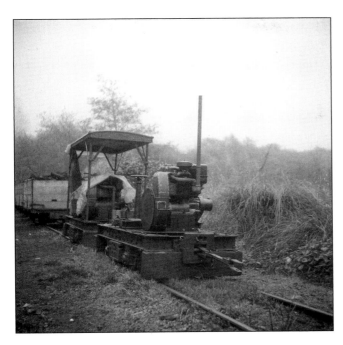

On 23 October 1965 the author took part in a visit to the Eclipse Peat Co's. 2ft gauge Railway at Ashcott arranged by the West of England branch of the Railway Correspondence & Travel Society. At the works loading ramp area there were two locos in a siding. The nearest one is 4wD Lister 42494 built in 1956, behind which fitted with a canopy shelter is 4wD Lister 34758 built in 1949. Both of these had previously been petrol locos. Maurice Dart

A stop was made in the workshop/factory area to examine some locos. Nearest to the camera is 4wD Lister 13621of unknown vintage. The peculiar looking loco at the rear is 4wD Motor Rail 10633 the year of construction of which is not known. Maurice Dart

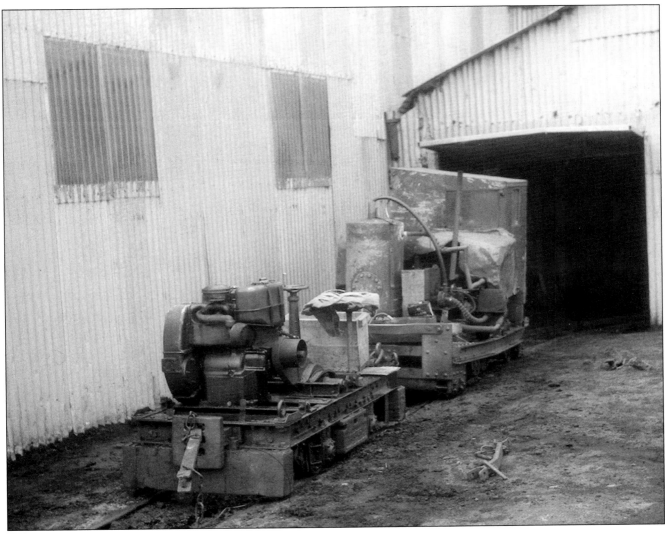

Also at the factory was 4wD Ruston & Hornsby 222097 built in 1944.
Maurice Dart

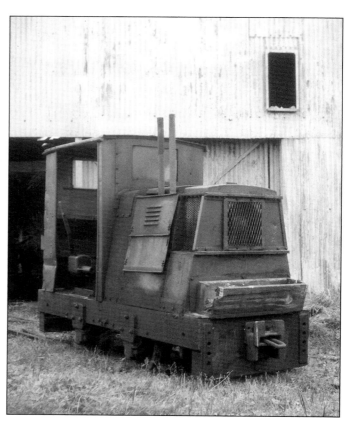

The party toured most of the system on a special train of open wagons that was hauled throughout by 4wD Lister 25366 dating from 1944. This loco which had previously been driven by petrol proved to be heavy for one remote section of the route way out in the Peat Fields. The rails below the engine started to slowly sink into the peat, so further progress proved impossible and the ensemble had to slowly reverse back to a passing loop where the engine ran round the train. This photo was taken after the train had stopped and the driver had proclaimed 'We are bogged down, we should have changed over to a lighter engine for this section'.
Maurice Dart

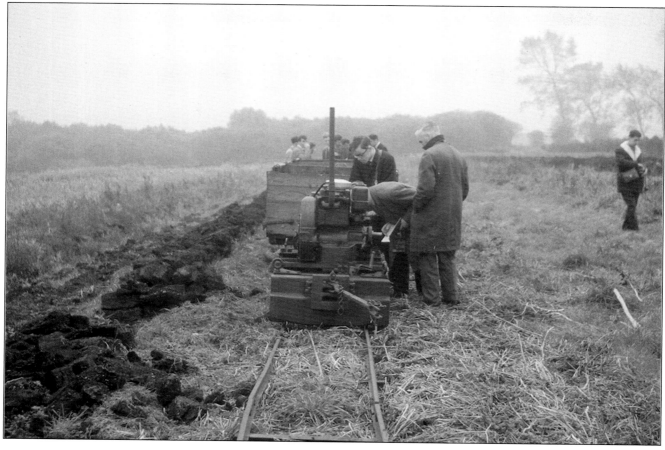

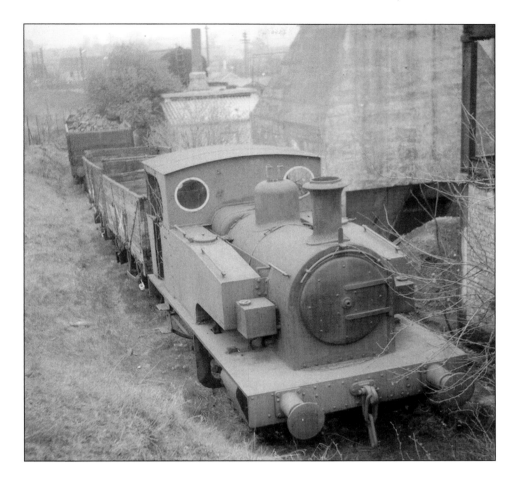

We end this section and the book with two photos taken during a privately arranged visit to Kilmersdon Colliery on 8 April 1971. Out of use at the back end of a siding at the rear of the colliery loco shed was this 0-4-0T built by the Hunslet engine Co. in 1931. It was their Works no.1684. This loco has been preserved, first it was at Bleadon & Uphill Station Museum on closure of which it has moved to a location unknown to the author. Maurice Dart

The working engine that day was this 0-4-0ST that was built by Peckett in 1929 and was their Works no.1788. BR 16 ton steel mineral wagon B227622 can be seen. The author was given some rides on this loco to the top of the rope-worked incline and back. This engine moved for preservation to the site occupied by the Somerset & Dorset Railway Circle at Radstock locomotive shed but it now resides with the Somerset & Dorset Railway Museum Trust at Washford station. Maurice Dart

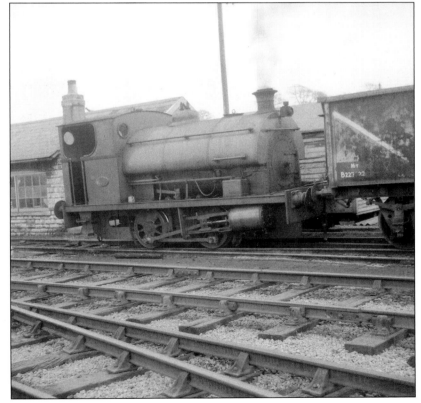

INDEX TO LOCATIONS